THE COMPASSIONATE
IMAGINATION

THE COMPASSIONATE IMAGINATION

How the arts are central to a functioning democracy

MAX WYMAN

Cormorant Books

Canadian Heritage | Patrimoine canadien

Canadä

Canada Council for the Arts | Conseil des arts du Canada

ONTARIO CREATES | ONTARIO CRÉATIF

ONTARIO ARTS COUNCIL
CONSEIL DES ARTS DE L'ONTARIO
an Ontario government agency
un organisme du gouvernement de l'Ontario

Ontario

We acknowledge financial support for our publishing activities: the Government of Canada, through the Canada Book Fund and The Canada Council for the Arts; the Government of Ontario, through the Ontario Arts Council, Ontario Creates, and the Ontario Book Publishing Tax Credit. We acknowledge additional funding provided by the Government of Ontario and the Ontario Arts Council to address the adverse effects of the novel coronavirus pandemic.

LIBRARY AND ARCHIVES CANADA CATALOGUING IN PUBLICATION

Title: The compassionate imagination : how the arts are central to a functioning democracy / Max Wyman.
Names: Wyman, Max, 1939- author.
Identifiers: Canadiana (print) 20230236847 | Canadiana (ebook) 20230236863 | ISBN 9781770866997 (softcover) | ISBN 9781770867000 (HTML)
Subjects: LCSH: Arts and society—Canada. | LCSH: Democracy—Canada.
Classification: LCC NX180.S6 W96 2023 | DDC 700.1/030971—dc23

Library of Congress Control Number: 2023936696

Cover design: Angel Guerra
Interior text design: Marijke Friesen
Manufactured by Friesens in Altona, Manitoba in May, 2023.

MIX
Paper from responsible sources
FSC® C016245
www.fsc.org

Printed using paper from a responsible and sustainable resource, including a mix of virgin fibres and recycled materials.

Printed and bound in Canada.

CORMORANT BOOKS INC.
260 ISHPADINAA (SPADINA) AVENUE, SUITE 502,
TKARONTO (TORONTO), ON M5T 2E4
www.cormorantbooks.com

For Susan Margaret Mertens, without whom ...

The way to freedom and order in the future will lie through art and poetry. Only imagination, discovering man's self and his relation to the world and to other men, can save him from complete enslavement to the state, to machinery, the base dehumanized life which is already spreading around us.

— Louis Dudek, from his introductory essay in *Cerberus*, a collection of poems by Dudek, Raymond Souster, and Irving Layton, the first publication of Contact Press, Montréal, 1952

A personal note before we begin ...

AUGUST 2013. AN ordinary enough call. Our family doctor wanted me to come in to discuss the results of my recent routine blood test.

He sat me down and showed me the charts. The readings showed that I probably had Chronic Lymphocytic Leukemia. This was not necessarily bad, he said; CCL is very slow growing, and no treatment was recommended, just "watchful waiting." Still, leukemia? Hmm.

He sent me for more blood tests, which suggested a different form of leukemia. He sent me for a liver and spleen ultrasound and referred me to an oncologist. The oncologist and several of her specialist colleagues looked at my tests and scans and decided I had lymphoma, a form of blood cancer (they were unable to pin down a precise definition: lymphomas come in about fifty different varieties). A biopsy confirmed that the lymphoma was in the bone marrow. Normally, a cancer that reaches the bone marrow is considered Stage Four, the worst of all the stages, but blood cancers don't form tumours in the way other cancers do. In any case, they were pretty sure it was "indolent" (a common medical term, apparently) rather than aggressive, so they would monitor it with monthly blood tests. A precise diagnosis was still unavailable. If the blood numbers became problematic or I became more symptomatic they would start treatment.

When I asked the oncologist for the survival chances in a worst-case scenario she said "years." My wife Susan took

that as doctor code for one or two years, but my later reading suggested that if it's caught early, survival rates are six to eight years.

Still, cancer? It was like dropping a watermelon onto concrete: everything scatters, wet bits everywhere, hard to pick up. For a while I couldn't think straight. I wasn't sure what was real and what was dream.

In the immediate aftermath of the diagnosis I wrote a little quatrain:

> I'm seventy-four and I've got cancer
> There go my plans to be a dancer
> Life's big question, now I know the answer
> It's heigh ho and off you go

Heigh ho and off you go. It was gallows humour, nothing more. I didn't believe that bleak message about life's pointlessness, not for a moment. The key word about the diagnosis, after all, was indolent. The lymphoma was lying in wait, taking its time. Lamentation and the rending of garments would do nothing to help.

I named the disease The Grim Creeper and started to write this book. It was time to try to extract something useful from what life had taught me.

— M.W., Lions Bay, May 2023

TABLE OF CONTENTS

Overture

In music, an opening statement that often refers
to themes explored later.
Also: an invitation to participate.

I CALL THIS book *The Compassionate Imagination* because after more than fifty years watching Canadian creativity come into glorious flower, I am convinced that the arts and culture — in general, and in Canada specifically — have a unique power to reawaken our sense of decency and empathy toward one another and to regenerate a sense of common purpose in our increasingly splintered existence.

Like it or not, we are at the end of the world as we knew it. The COVID-19 pandemic shook loose everything we thought was stable in society — health, work, community, family, friendship — and woke us all to the need for fundamental, systemic change. The systems under which we have operated are out of balance and close to toppling: the rich continue to get richer; the poor, poorer; the weather worse; and forests are burning at a faster rate than at any time in recorded history. Too many factors make us feel we have nothing in

common: social media, political differences, economic disparities, tribalism. The old *cordon sanitaire* of Canadian decency and diffidence is fraying to the snapping point. Mutual trust has evaporated like the morning dew. We shout when we should be listening.

In a world where political, social, and economic polarities are becoming more and more sharply defined, where democracy and autocracy are pitted in a global battle for control of the way we live, it is time to rebalance our moral and spiritual priorities. Any hope we might have for a return to the world as it was (or how we remember it to have been, which is not necessarily the same thing) is mere whistling in the wind. Institutions need to be reshaped. Inequities demand remediation. Justice systems must be recalibrated. We need a vision of a world beyond the balance sheet, beyond the creeping normalization of greed and mistrust: a vision that is not only functional, something we are prepared to settle for, but inspirational, something to which we can aspire.

However we might act or speak, we all have an understanding of our interconnectedness. We know that what binds us is stronger than what divides us. We all have within us the capacity to care. And it's impossible not to see the shifts that occur in our understanding of human existence as we build wisdom on knowledge and experience. A generation ago, for instance, we treated addiction as a moral failing. Today, we see it as a medical condition and, seeing it through a different lens, marshal our resources in a different way to deal with it — and in doing so make the world a better place. Change of that kind is part of a rising tide of concern — the Me Too movement, Black Lives Matter, climate activism, the rights of

girls and women — for the less material aspects of our lives and the lives of others. Movements like this, and the growing popularity of mindfulness and other meditative practices, reflect our search for meaning and decency in our world and our lives, the desire that many feel to jettison what is obsolete and rediscover the relevance of the human particular. To act with compassion.

But change on the scale the world needs now, in the manner we need now, won't happen until we ratchet down the anger and the fear, dismantle the barriers between us, and find again that middle ground of generosity and shared humanity where we can come together to imagine a better, more inclusive, more humane society. It is time to call on the best within us: Lincoln's better angels of our nature, the human condition at its noblest. It is time for a change of heart.

Art lets us sense the pulse of human commonality that throbs beneath the surface of our days. It tells us that difference is not something to fear. It fosters fellow-feeling and engenders compassion. It cuts through the wall of ego and privilege that we allow to separate us from our better selves. It puts us back in touch with the empathy, decency, and care I believe we were born with.

This book lays out a solid framework of advocacy and argument on which to build a new Canadian Cultural Contract between the government of Canada and the people it serves, affirming art and culture as the humanizing core of Canadian civil society and an essential public service, and embedding in public policy art's unique and deeply human properties of imaginative exploration and emotional and spiritual enrichment.

Ginger groups from Canada's cultural sector have lobbied for years for the creation of a national Ministry of Culture, on the same level of influence as the ministries that oversee other portfolios Canadians consider important. But however much they murmur encouraging words about the economic and social benefits of what they insist on calling the "cultural industries," our political leaders have historically had an uneasy relationship with the arts and culture. They make me think of Victorian captains of industry, fingering their collars and stroking their mustachios as they slip the annoying child a coin or two and send it off to play. They pay dutiful lip service to the importance of culture as part of our national fabric. They make sure the sector gets resources sufficient for basic survival, though it has been argued that this is a deliberate strategy to keep cultural workers on starvation rations so they don't get ideas above their station. Politicians send our artists and their creations off around the world to polish our image as a civilized partner in the choreography of soft power. They put them on our postage stamps. During the pandemic, they even coughed up a little extra to help the arts sector counter the crippling effects of the economic shutdown.

But none of them has grasped the central nettle, which is the need to see the arts and culture not as a frill, not as an outlier, not as a tool, but as a central and necessary element of our nationhood. In the prosperous and educated world of rationality and accountability that the Enlightenment bequeathed us, and which our governments claim to perpetuate, the artist is an outsider, the supplicant conjuror with his begging bowl. (The former director of the Canadian Opera Company, the late Richard Bradshaw, one of the most vociferous advocates

for substantial increases to public arts funding, used to try to shame the federal government into action by pointing out that the entire budget for the Canada Council for the Arts was roughly equal to the amount received by the three opera companies in Berlin, whose residents also had access to 7 orchestras, 50 theatres, 170 museums, and 300 galleries.)

Crisis, however, has a way of clarifying the mind; in the wake of the tectonic social, political, and economic shocks of the first two decades of this new century we may find ourselves ready in surprisingly large numbers to reconsider the way we prioritize and support our social systems.

The new Canadian Cultural Contract will rehumanize our ways of living together by reactivating the compassion and understanding that is stirred when we make and share art, allowing us to:

- Liberate the power of the collaborative imagination, by giving the visionary ferment of Canada's diverse creative community a place at the decision-making table as we seek solutions to the stark challenges of our time.
- Achieve a far more equitable spreading of the cultural wealth, in the form of expanded granting programs and an individual cultural credit that will empower all Canadians to enjoy the richness of our cultural expression.
- Ensure that Indigenous ways of knowing and creating are integrated into the decision-making and funding processes.
- Rebalance the scales of our education systems, affirming the role of the humanities alongside the sciences in educating the whole person, turning STEM into STEAM by adding an A for the Arts.

At the operational core of this new contract will be the Canadian Foundation for Culture: an arm's-length structure that will serve as the coordinating and resource hub for the strands that make up the Canadian cultural tapestry. Infusing its spirit will be a commitment to the democratization of the arts — or, if that is too political a term, to the enrichment of society through the general availability and appreciation of everything that cultural engagement can bring to the individual life.

The principal reason why there is so little political and public appetite for funding the arts is because for generations, our children — and the adults they become — have not been given the necessary tools to understand the arts, the reasons to appreciate them, or the encouragement to engage with them. The result is a persistent disconnect: the idea that culture is a connoisseur's club you can't get into without the right credentials. This sense of exclusion is by no means as strongly felt as it once was — the days of city councillors objecting to using public money to support "galloping galoots in their underwear," as once happened when a grant application from the Royal Winnipeg Ballet came before the Winnipeg municipal council, have long gone. But we still have far to go.

Developing an informed and engaged audience is part and parcel of a cultural policy — in fact, it's essential to it. A motivating force for the new Canadian Cultural Contract is the need to cultivate broad public taste for what culture can provide — not by making vanilla statements about art's significance, but by demonstrating practically what the benefits are for the individual and making those benefits available to all. Experience shows that while many people are ready to

express their admiration and enthusiasm for art, far fewer follow through by buying a book or a painting or a theatre ticket — or even naming culture as a spending priority at election time. But, as Walt Whitman wrote, "To have great poets there must be great audiences, too." Great audiences are built by welcoming them.

The new Canadian Cultural Contract will ensure that Canadians will be encouraged and enabled to engage with art and culture: as audience members, of course, but also, to the extent that they feel inclined, as creative individuals. We have allowed a line to be drawn between professionalism in the arts and the art we make for personal pleasure. But, like so much in life that we try to reduce to an either-or choice, these forms of art are not polar opposites.

I'll never be a serious professional actor (though I have performed bit parts in television and movies), my likelihood of playing Chopin in public is nil (though I studied piano assiduously as a child), and my sole foray into public dance performance was as an exemplar of the non-dancer (in a production called *The Show Must Go On*, by the French choreographer Jérôme Bel). You would be right to think of me as a mere dabbler, an amateur at best, but, my goodness, how much poorer my life would have been without the encouragement and guidance I was given when young, the availability and access that I found as I grew up, and the insight and understanding that exposure to the creative imaginations of others have given me.

I am far from alone, and my argument here is a simple one: everyone should be given the opportunity to experience the richness of personal self-realization allowed by engagement

with art. In the age of TikTok, Instagram, and YouTube, we do ourselves no favours by excluding amateurs and community groups from the big cultural picture. Of course there is a difference between the serious artist and the Sunday painter, but they are both important, and the interests of both should be recognized and honoured.

This does not for a moment diminish the importance of professionalism. Later I will argue that a clear line of distinction must be drawn between professional arts critics and the amateur enthusiasts whose opinions are available in overwhelming profusion on social media. I support anyone's right to have an opinion, but if you present yourself as a critic, you must buttress that opinion with persuasive evidence and argument that goes beyond a five-star rating and a thumbs-up emoji. The fact that this is precisely what today's consumers demand is another argument for giving consumers better access to, understanding of, and comfort with the art form on which they are offering their opinions. It's a moral imperative as well as a political one; and the solutions reach far deeper than a superficial affirmation that art is good for you. Everyone should have the fullest possible opportunity to exercise their right to enjoyment of the arts in whatever manner they see fit. In some cases, it is not about making art at all, but rather simply the expression of what Vancouver playwright Marcus Youssef calls "the unmediated, non-idealized versions of ourselves in all our complexity."

Arguments are sometimes made that we need to slice the cultural funding cake in a different way, so that smaller communities as well as the major centres, and underfunded cultural minorities, get a fairer share. But recent experience

in the UK suggests that simple decentralization and redistribution of funds isn't necessarily the answer. In 2022, Arts Council England (ACE), which makes its funding decisions supposedly at arm's-length from government, was ordered by the Conservative government to reduce support for organizations in the capital, London, by fifteen percent. This was to ensure, as then-culture secretary Nadine Dorries explained, "that everyone, wherever they live, has the opportunity to enjoy the incredible benefits of culture in their lives." The move was part of a four-year "levelling up" agenda meant to counter growing discontent with the UK's economic and social imbalances. The resulting cuts by ACE included the withdrawal of all funding from the London-based English National Opera and several London theatre companies. This deliberate, political thinning out of cultural choice for Londoners in order to spread it more thickly in the provinces — robbing Peter to pay Paul — drew an outraged response from the cultural community, which was being shown in real time just how precarious its existence was and how arbitrary the decisions on its future were. Dorries later called the decision to cut the ENO "a stunt ... lazy and political ... If there ever was a case for arm's-length bodies to be brought under political control, ACE have just made it." The ENO was later given a funding reprieve but told to start planning for a new base outside London by 2026.

"Levelling up" power and resources is an admirable aim, and one we should certainly pursue in Canada. But if we truly believe in "the incredible benefits of culture" in our lives, the more logical approach is the addition of resources, rather than a redistribution of the same small pot. How much

more admirable it would be if the UK government had said, "We recognize the inequities that you're trying to remedy, we share your vision of the importance of art and culture in our world: here's an extra bundle of cash to help you do it."

This holistic vision of art as a necessary component of our individual lives, accessible to us all, is the animating pulse of this book. It flows from the firm conviction that it is through the rich and exuberant tumult of our shared imaginations that we discover who we are and explore what we want to do and who we want to be, and that through that shared imagination we will reprioritize the decency and empathy that is at the core of all that is best about the complicated human business of living together.

THE END OF THE WORLD
AS WE KNOW IT

How Art and Culture Can
Build a Better Canada

*The arts are essential to any complete national life. The State
owes it to itself to sustain and encourage them ... Ill fares the
race which fails to salute the arts with the reverence
and delight which are their due.*
— Winston Churchill, "Between Tradition and Innovation,"
speech to the Royal Academy of Arts, London, 1953

CLOSE TO HALF a century before COVID-19 cut its vicious
swath of human and economic devastation through the
world, the Massachusetts Institute of Technology issued a
study that suggested that without limits on economic growth
and resource exploitation, society was on course to collapse
in the mid-twenty-first century. The findings, published in
1972 by the Club of Rome, were widely pooh-poohed. It
wasn't news the world was ready to hear. Greenpeace, which
had grown out of the protest movements of the 1960s, was
only a year old; its global environmental activism was yet to
gain purchase.

Almost fifty years later, Gaya Herrington, an advisor to the Club of Rome and an analyst of systems dynamics at the accounting giant KPMG, checked how accurate the MIT prophecies had been. She set data from ten variables — population, fertility rates, mortality rates, industrial output, food production, services, non-renewable resources, persistent pollution, human welfare, and ecological impact — against various MIT scenarios. She found that if we maintain business as usual, pursuing continuous growth, the dark forecasts made in 1972 will have been right on the mark. We will see declines in industrial capital and agricultural output within this century; the number of people on public assistance will increase. Under one scenario, industrial growth, food production, and the overall standard of living will decline steeply around 2040.

In 2020, in a presentation at the World Economic Forum, Herrington said the next ten years would decide the long-term fate of human civilization. A sustainable and inclusive future is possible, she said, but our societal priorities must change. That won't be easy, she acknowledged, and transitioning out of current models will pose challenges. But "changing our societal priorities hardly needs to be a capitulation to grim necessity," she said. "Human activity can be regenerative, and our productive capacities can be transformed." The transformation of our societal priorities and the regeneration of our productive capacities through a refreshed and modernized engagement with arts and culture is what this book is about.

To set that transformation in process, we need to start thinking about how government might conduct itself more

generously while performing the duties we have delegated to it. Societies need laws and a structured economy to keep them from collapsing into anarchy and chaos, and we entrust politicians, judges, and the governmental bureaucracies with the task of establishing and maintaining these systems, in what is understood to be the social compact. But in a democracy such as ours, the people are ultimately thought to be in charge.

It's when we become convinced that the power is no longer in our hands, or that our voices are being ignored, that the trouble begins. The abstract notion of freedom is a powerful motivating force for those who think they don't have it. The sense of injustice can quickly concentrate into moral fury. Passions become raw. The objects of such anger are dehumanized. They become social and political enemies, branded according to fears and prejudices. We demonize the Other.

From the Nazis to modern demagogues, opportunists and extremists have undermined the stability of the social compact by exploiting the resentment and fear that is felt by individuals who believe the System has failed them. We see the evidence in the steady rise of extremism, and the growing acceptance of it, around the world and here in Canada. The Ottawa trucker blockade of 2022 was a product of the misguided moral fury of people who claimed their freedoms were being unfairly constrained, while calling for the resignation of the government and the assassination of the prime minister. In its turn, the blockade itself provoked a retaliatory form of moral fury, both in the nearby residents whose lives were affected by the noise and harassment, and in the wider citizenry that called for the truckers to be "taught a lesson" with the laying of criminal charges and financial penalties.

How we counter this trend involves a long-term commitment to a society guided by different principles. Government, or the state, is still our best means of caring for the human family and protecting it against the forces of unfettered and rapacious capitalism. But competitive individualism is what keeps the capitalist state in business, so we need to remind government that there's more to life than a thriving economy. Increasing numbers are calling for a new form of participatory democracy, where power and resources are spread more broadly and equitably.

Of course the economy is important; the world's industrialized economies make us safer, healthier, better fed, and better cared for than our ancestors. And in an era of economic uncertainty and soaring costs in areas such as food, health, education, and public safety, it becomes easy for politicians to argue that culture is a dispensable frill and that those working in the field of arts and culture should live or die, like those in any other business, according to their success in the marketplace. Going short on indulgences in times of restraint is something we're supposed to understand.

But cultural activity should not be assessed solely by common business metrics. The economy has no concern with matters of the spirit and the imagination, with compassion and the non-material; when we look at human progress solely from an economic perspective, we cruelly circumscribe our understanding of human potential and, indeed, our understanding of human history.

In many eras, events have provoked the realization that if we want better outcomes, we need different guiding principles. In 1919, in the wake of the horrors of the First World

War, "the war to end all wars," the Nobel Prize–winning French writer Romain Rolland published a ringing manifesto, *Declaration of the Independence of the Mind*. In it, he called for a new commitment to use art and the intellectual life not as nationalist propaganda and tools for division, as they had been used during the war, but as non-political ways to bring the world together and celebrate universal truths and the shared human spirit. Dozens of his international artist and intellectual friends — among them Albert Einstein, Bertrand Russell, and Hermann Hesse — co-signed the document. Their message echoes still. The causes of our current divisiveness, disharmony, and disrespect for the Other, both at home and internationally, are different. But the effects — and the need to achieve the social and spiritual transformation that Rolland and his friends called for with such passion — remain the same.

As this book will show, the cultural sector delivers value both for the individual and for society that far outweighs its cost. The arts contribute not only to the economy, the environment, and public health but also — and equally importantly — to the social harmony of the world in which we live. As we come to a new and better understanding of these values, it becomes time to incorporate the cultural perspective into the framing of public policy and set our course toward a form of social prosperity in which human fulfillment trumps marketplace economics.

POLITICAL ECONOMIST ELINOR Ostrom, in her 2009 Nobel Prize lecture, said that she believed "humans have a more complex motivational structure and more capability to solve

social dilemmas" than rational-choice theorists have given us credit for. The key to unlocking these capabilities, she said, is building the right institutions. The institutions and policies that we have relied on for half a century, built on the belief that governments should "force (or nudge) entirely self-interested individuals to achieve better outcomes," no longer work. "A core goal of public policy," she said, "should be to facilitate development of institutions that bring out the best in humans." To explain and understand the world of interactions and outcomes occurring at multiple levels, we have to be willing to deal with complexity instead of rejecting it.

This places a new emphasis on the engagement of the imagination and invites the creation of new institutions to facilitate that engagement. If we are serious about achieving better outcomes and bringing out the best in humans, as Ostrom put it, as well as using technology to foster new forms of economic development, we will need fresh resources of imagination. "Considering today's wide and interdependent array of risks," wrote Klaus Schwab, founder of the World Economic Forum, and investment advisor Thierry Malleret, in 2022 at the height of the Russian invasion of Ukraine, "we can't afford to be unimaginative ... For decades now, we've been destabilizing the world, having failed to imagine the consequences of our actions on our societies and our biosphere, and the way in which they are connected. Now, following this failure and the stark realization of what it has entailed, we need to do just the opposite: rely on the power of imagination to get us out of the holes we've dug ourselves into."

One of our best and most available tools for dealing imaginatively with complexity is the process we call the arts.

Art explores the layering beneath the apparent. It makes immaterial concepts graspable. Artists play and tell stories; the images and metaphors they make, and the ambiguities they find, prod us into thinking about new approaches and seeing other points of view. By allowing us to experience the universal in the specific, and by admitting us to the minds and imaginations of other people, art frees us to imagine possibilities beyond our personal boundaries. It gives us insight into our roles in the world and what might we be expected to contribute. How should we relate to others? What does power do to the people who have it? How do we balance the conflicting forces of social duty and personal interest? How did man-made law become synonymous with justice? How do we now define honour? How thin is the layer that separates civilized society from anarchy and chaos?

From the earliest times, we've turned those questions into stories. Stories are the narratives we construct to explain the enigmas of our realities — and the realities of others. The Greeks and Shakespeare may have been writing about the distant past, but their plays have as much of a modern moral bite as *Sophie's Choice* and *The Handmaid's Tale*. Agamemnon's agonizing decision to sacrifice his daughter to appease an angry god and promote the greater good — triumph over Troy — was mirrored in *Game of Thrones*.

By encouraging us to think about these things, to live through them in our imaginations, art fosters empathy; it invites tenderness. The need for connection with other human beings lives in all of us. Yet in a time of constant confusion and renewal, we seem more than ever alone. We spend our days as background extras in thousands of other human existences:

crossing the street in front of them, being the blurred face seen on a passing bus. Art gives us that human connection. It lets us know we're part of humanity in its defiant defencelessness.

Love thy neighbour? Maybe that's a bridge too far, though I'd like to think not: love, in the sense of caring for humanity, is at the heart of what we are looking for. Love is the basic building block of compassion, and compassion is what brings us together to make a better, more livable, more resilient community. Compassion doesn't come from nowhere, of course; it is activated when our minds and emotions become engaged with something that touches or moves us in some way. That's where art has such value. It makes us aware of lives beyond our own. It shows us the individual inside the Other.

Art also encourages us to step aside from the hurtling every day and to pay attention. None of us can savour more than a sample of the torrent of experience offered by life. Art plucks our sleeves and says: *look. Listen. Feel.* It invites us to do what the American poet Mary Oliver describes as the work that matters — "which is mostly standing still and learning to be astonished." It gives us the grace of reflection, contemplation, understanding. The dizzying rush recedes; we look within ourselves, and balance is restored. It also gives us new ways and new confidence to think together about the challenges that confront us. New ways to imagine. To ask, "what if?" It brings out, as Ostrom put it in her Nobel Prize lecture, the best in us.

This is what we trust it to do. This is what we need it to do.

AT THE MOMENT of my birth (May 14, 1939) in a small town in the English Midlands, the presses of *The Times* of London were rolling off a thirty-two-page supplement on Canada for the following morning's edition. In those broad pages, *The Times*, like a fairy godmother in a story-ballet, laid out the issues that would engage me for most of my adult life. "Come out to Canada," urged the humourist Stephen Leacock. The Governor General, Lord Tweedsmuir (the novelist John Buchan), bravely proclaimed that "there is no greater saga in all history than that of Canada's steady triumph over time and space."

Anyone looking for evidence of steady triumph in the field of the arts would have been less than convinced. Donald W. Buchanan reported that only one theatre company existed in the whole of English Canada. Grattan O'Leary complained about the lack of anything that "the most ardent Canadian patriot can characterise as a national literature." Sir Ernest MacMillan lamented the inability of the young country "striving for unity against geographical divisions, racial cleavages and economic incompatibilities" to produce "music with a distinctive national flavour." In the hulking shadows of the two colonizing cultures and the behemoth to the south, the cultural identity of the nation was still waiting to be forged.

On a snowy April morning almost three decades later, I stepped off the *Empress of England* onto the Québec City quayside, one of thousands of immigrants who chose Canada as their future that Centennial year. A short train ride away, in Montréal, Centennial's most important marker, Expo 67, was about to open its gates to the world. A friend arranged a private tour of the site a couple of days before it opened;

I was dazzled by the creative audacity and intoxicated by the promise.

In the fifty-six years since then, I have had the blessed good fortune, as a critic, biographer, and historian, to sit in a front-row seat to watch Canadian culture emerge as a vital force in our communities, our cities, across our nation, and on the world stage. Sometimes I've had the chance to help it along. The "national literature" that Grattan O'Leary was so anxious to see is now on proud display. Art forms that didn't exist in 1967 are mainstream, and new ones are still emerging. The cultures of Canada's Indigenous, racialized, and immigrant communities are challenging the priorities of the colonizing powers. And it's no longer just a crack that's letting the light in. The work of our writers, choreographers, playwrights, singers, actors, musicians, and visual and media artists makes headlines and sets trends internationally. Canadian arts educators lead the world in the campaign to transform the way we learn. Canadian artists set the international standard in the field of art for social change.

I've also seen, first-hand, how perfunctory Canada's own acknowledgement of this richness has been, as if there's something shameful and un-Canadian about what art does. When our leaders are asked to support the production of art, the gnarly gristle of this deeply human activity is shoved into the bureaucratic Accountability Blender (there's one in every government office) and assessed for the measurable value it can deliver. Why does this happen? Because demonstrable value for money is a key metric of government spending. As the British writer and arts manager John Tusa put it: "The

arts stand naked and without defence in a world where what cannot be measured is not valued; where what cannot be predicted will not be risked ... where whatever cannot deliver a forecast outcome is not undertaken."

It wasn't always this way. When the idea of public funding for the arts first began to gain traction, in the post-war mid-twentieth century, the arguments were less rooted in culture's economic impact and more in the importance of protecting and fostering the work of our artists. "The things with which our inquiry deals are the elements that give civilization its character and its meaning," said the founding document of Canadian cultural policy, the 1951 report of the Royal Commission on National Development in the Arts, Letters and Sciences. But by the end of the century, hastened by the economic downturn of the 1980s, the primary rationalization for cultural funding had become its measurable economic and social usefulness. As recently as the spring of 2022, when the federal government called a "national culture summit" on the post-pandemic future of arts, culture, and heritage in Canada at the National Arts Centre in Ottawa, the focus was squarely on culture's economic and social values: "promoting long-term competitiveness and growth; the return of visitors and engaging new audiences; the role of digital platforms in arts, culture, and heritage sectors; and the contribution of cultural sectors to reconciliation, combatting climate change and building an open and more inclusive society."

In such a climate, it is not surprising that, for all the pious bromides, culture is nowhere on the agenda at election time.

IN MY DAYS as a member of the board of the Canada Council for the Arts in the late 1990s, I would ask politicians and government officials what they thought was the best way to frame arguments for more financial support for the arts in Canada. Their advice was simple, and it was always the same: "Make it about jobs and the economy." Pragmatism is a dangerous seducer for anyone looking for ways to justify — perhaps excuse is a better word — a decades-long attitude of deliberate neglect. But the non-profit arts sector has, by necessity, become adept at marshalling figures to prove its economic worth, and would undoubtedly receive less support than it does now without those arguments. So, let's take a moment to follow that advice.

A 2019 Statistics Canada report showed the direct economic impact of the culture industries in Canada in 2016 (the latest year in which census numbers have been analyzed in this way) was $58.9 billion, a 16 percent increase over the numbers for 2010 and equal to $1,611 for every Canadian, or 2.8 percent of national GDP. That's more than agriculture, forestry, fishing, and hunting ($39 billion), accommodation and food services ($46 billion) and utilities ($46 billion), and eight times more than sport ($7.3 billion). The StatCan definition of culture included audiovisual and interactive media, visual and applied arts, writing and publishing, live performance, private heritage and library resources, and sound recording. The numbers don't include the impact of government-run organizations ($7.6 billion) or education and training ($3.7 billion).

A Hill Strategies analysis of the 2016 Canadian census showed that the country's 726,600 cultural workers (4 percent of the overall Canadian labour force) included 158,100 artists,

greater than the labour force in automotive manufacturing (146,200) and utilities (136,400). Cultural workers overall had median individual incomes of $41,000, or 6 percent less than all workers, but the median income of the country's artists was $24,300, or 44 percent less than the $43,500 median for all workers. Within the artist bracket, some occupations reported much less: median income for dancers was $15,800, or 64 percent lower than the median income of all workers; musicians and singers earned $17,900 (59 percent lower), actors and comedians $18,500 (57 percent), and visual artists $20,000 (54 percent).

Not figured into these numbers is the toll taken by the COVID-19 pandemic. A snapshot survey of close to 5,000 Canadian artists and content creators, taken by Canadian Heritage in 2021, showed that close to a third of them reported loss of creative income during the pandemic, with musicians and performing artists doing particularly badly, losing 83 percent and 79 percent of income respectively. More than half — 56 percent — of all the artists surveyed applied for federal emergency support.

The spinoff effect of all this activity has been exhaustively documented. Cultural activities create work for a broad range of other workers — restaurant staff, dry cleaners, hairdressers, taxi drivers, and a host of other small-business folk — and generate more than enough tax revenue to cover government investment. Culture helps the world go round. But it's not a direct cause-and-effect process. Not every work of art can be shown to have an impact on the economy or public health. To apply instrumentalist criteria to, say, the abstract expressionist paintings of Jean-Paul Riopelle or the short

stories of Mavis Gallant would consign many great works of art to the garbage can of history. When we concentrate only on the impact that cultural spending has on the growth of GDP and the generation of jobs, on health, on livability, when we argue for arts and culture on purely instrumental, value-for-money terms, we set the cultural sector in a losing battle for the public dollar against all the other money-sucking problems that beset modern society.

According to a KPMG global survey of CEOs in 2021, the five top risks facing business are climate/environmental risk; disruptive tech risk; supply chain risk; cyber risk; and regulatory risk. The cultural sector is uniquely equipped both to demonstrate these risks and to offer alternative solutions. I'm not speaking here of the sector's own suppleness and economy of operation, which has always perforce been its go-to modus operandi and might put a bull of Bay Street to shame. I'm not speaking of analytical papers or academic assessments, which all have their place in the decision-making process. I'm speaking about the act of art itself: the artist's willingness to give an idea a good shake, look at it through a dozen different lenses, then stand it up in an unexpected outfit and say, "Well?"

Also in 2021, while arguing that the pandemic "has demonstrated that what matters most to Canadians is not always easily measured or described on economic or financial terms," the Department of Finance decided to measure the life satisfaction and sense of meaning and purpose of Canadians through what it called a Quality of Life Framework. The aim was to gather evidence to give decision makers and budget planners a better understanding of what influences

individual perceptions of well-being. Indicators included prosperity, physical and mental health, social involvement, the environment, and governance. Several provincial and territorial governments have also partnered with projects like the University of Waterloo's Canadian Index of Wellbeing, a citizen-led initiative to develop a measure of societal progress that isn't simply related to the GDP. Outside Canada, many countries use similar frameworks to set priorities and help shape policy decisions, prominent among them New Zealand, which in 2019 introduced a Wellbeing Budget using quality of life indicators.

What was not included as an indicator in Canada's Quality of Life Framework was engagement with arts and culture, though that should come as no surprise. As long ago as 2006, a report from a federal advisory committee on the sustainability of cities and communities made the important point that the discussion had so far omitted culture. "We easily understand the importance of economic, social and environmental sustainability to the wellbeing of and future of our cities and communities," the report said. "Cultural sustainability ties together the other three dimensions, and is essential to community success." Others have written extensively about this "four pillar" model of sustainability. Australian cultural analyst and commentator Jon Hawkes, for example, argues that effective public planning can only be developed on a framework that includes a cultural perspective.

Civic pride, sense of place, diversity, and inclusion are not the only social benefits of a healthy and active cultural sector. Many studies have shown how engagement with art reduces demands on the health care system, is an effective tool in

dealing with mental health, and helps build self-confidence among the incarcerated.

Two decades on, Richard Florida's thinking on the influence of the creative sector, laid out in his 2002 book, *The Rise of the Creative Class*, may be out of fashion — Florida himself downplayed its importance in a 2017 follow-up book — but his essential arguments about the value of creative activity in attracting innovators to a city or region remain true. A massing-together of opportunities for cultural experiences does make a community more attractive to the kinds of people who will enhance it with creativity of their own, and a recent report by the UK's Arts and Humanities Research Council (AHRC) calls for more attention to how arts and culture feed into the creative industries, support the innovation system, and attract talent and investment to communities. These, it argues, are the distinctive contributions of arts and culture to the economy, and they should be better understood.

Culture can also burnish the nation's image abroad and is often used to oil the engines of international trade. (I remember being at a reception on a hot summer night in Kuala Lumpur following a performance by the Royal Winnipeg Ballet and overhearing the head of Malaysia's Petronas oil company tell the Canadian High Commissioner, "If you people can build pipelines as well as you can dance, we should talk business.")

These instrumental benefits for society often have ripple benefits for the cultural sector as well. The Winnipeg company lived off its reputation as the world's most-travelled ballet troupe for decades. The United Arab Emirates decision in 2021 to spend U.S. $6 billion on cultural and creative projects over the next five years to help switch its economy from

oil to tourism had an obvious instrumental intent, but it also meant they would feed a lot of artists. Qatar commissioned forty new public artworks from local and international artists to commemorate its hosting of the 2022 FIFA World Cup. They joined sixty existing public artworks to create what was described as "a sweeping outdoor museum experience" at shopping areas, educational institutions, and transportation hubs throughout the country. At the height of the pandemic in 2021, Toronto's city government launched a public art program, scattering 350 new works of art across the region, funding close to 100 arts organizations, and giving work to 1,500 artists. Partly it was a make-work program to stop artists leaving the city; partly it was about bringing people together; partly it was, as then-mayor John Tory said, because "there's a need to bring the city back to life and there's nothing like the arts and culture to do that."

It has been suggested that one of the reasons the arts and humanities are less valued than the sciences is their lack of a hard, credible centre: the work isn't based in methodical testing and research, and the outcomes don't affect political decision-making in the way that, say, climate science affects emissions targets. But far from being purposeless, art is a form of research and development in itself; and, in that sense, it is a soul companion to pure science. It is a different form of research and development from the kind you might find in a chemistry laboratory. The element of play is strong. Artists use story and metaphor and image and performance to explore and provoke new ways of thinking. They don't offer guaranteed outcomes, because they can't, but they consistently go where none have gone before. Like the practitioners of the

pure sciences, they pursue ideas for their own sake, hoping that what is discovered will in some way amplify our understanding of the world around us. They imagine alternatives, innovate, jar us out of complacency and stale thinking.

At the University of British Columbia, artists, physicists, and astronomers are collaborating on research into the nature of dark matter. The program, *Ars Scientia*, brings the Stewart Blusson Quantum Matter Institute, the Department of Physics & Astronomy, and the Morris and Helen Belkin Art Gallery into partnership to explore what is possible when scientific knowledge is fused with art's ability to probe unknown realms.

Important factors are at play here. Psychiatrist Iain McGilchrist argues in his book, *The Master and His Emissary*, that much of modern society's dislocation and discontent can be explained by the notion that the rational functions of the brain — the aspects controlled by the left hemisphere — have been allowed to crowd out the intuitive, leading us to prioritize economic growth over human fulfillment. To overcome our obsession with unbridled growth and clear the way for a more equitable world in which individual well-being and potential are given priority, we need to rebalance our brains.

The increasing obsolescence of work makes this argument significant. The doomsday predictions of worldwide unemployment as a result of our increasing dependence on technology — from, for instance, economist Jeremy Rifkin in *The End of Work* in 1995 and two MIT economists, Erik Brynjolfsson and Andrew McAfee, in *Race Against the Machine* in 2011 — were perhaps exaggerated. But the trend is gathering speed. We're still on track to lose nearly half of existing jobs

to computerization by 2035. Yet for many, work is where we find purpose and fulfillment, the place where we build our character. How do we go about replacing that? What happens when we suddenly find ourselves at leisure? How can we best manage — and take advantage of — all that free time and energy? We need to start planning. Culture can help, in ways that go far beyond simply keeping people occupied.

"For the first time in history," said Bertrand Russell, reflecting almost a century ago on the impact of the Industrial Revolution, "it is now possible ... to create a world where everybody shall have a reasonable chance of happiness." Universal happiness has yet to occur. Globalization, the great cultural homogenizer, hasn't turned out to be everything it was cracked up to be. In terms of culture, it often carries a negative force. But the opportunity to make that right is here. In the words of Alex Himelfarb, who was Canada's top civil servant under three prime ministers, decades of austerity may have brought us a measure of financial health and resiliency, but those benefits came at the expense of human health and resiliency.

"Governments need now more than ever to ensure that essential services are universally available and affordable," he said on his popular public-issues blog in May 2022. "The pandemic laid bare the painful — even fatal — human costs of decades of squeezing public spending, especially for the marginalized, poorest, and most vulnerable. We learned the hard way that our lack of preparedness, our stretched healthcare system, the holes in our safety net and weak labour protections not only put our health at risk, they also cause real damage to our social fabric and our economy." Investing in caring, he

wrote, "is good for us, good for the economy, and good for the planet. It helps put our fractured society back together and develop shared wellbeing ... What's needed now to build a more just and sustainable future is not more market but more democracy, more public investment, more engaged civil society, a rethinking of risk, and a rebalancing of power."

An essential contributor to that more just and sustainable future — perhaps even the guide we can follow toward that future — will be a new embrace of arts and culture in the form of the new Canadian Cultural Contract.

Of course, the role of the state in fostering the arts has always been contentious; currently, Canada occupies the middle ground between the Anglo-European model, which tends to rely primarily on state sponsorship for the arts, and the American model, which emphasizes private support. (These are general characterizations; many variations on the mix exist.) For some, even the middle ground is too much. Vancouver's humanitarian anarchist George Woodcock, one of the twentieth century's most vocal advocates for Canadian artists (and a good friend of George Orwell), was always suspicious of government's willingness to use its support of culture to engage art and artists for political ends. In his 1985 book on the state and the arts in Canada, *Strange Bedfellows*, he called for the private sector to greatly increase its funding to lessen the impact of government contributions — though he warned that, whether the patron is public or private, "sooner or later they seek to impose their standards, and then it becomes necessary to be resolute in biting the hand that feeds."

Increased private support would certainly be welcome, and reluctance to have the feeding hand bitten is surely one

reason why culture still ranks far below health organizations, social service organizations, and hospitals in the Canadian corporate sector's list of charitable priorities. But that doesn't let government off the hook.

Governments have always had wide freedoms to spend public money in ways they consider effective and wise, and the cultural sector now needs the support of enlightened political and bureaucratic leadership that recognizes that the common civic good includes fostering and funding cultural activity. It is not and never should have been a matter of either-or. In a compassionate society, the provision of access to arts and culture is neither an imposition of taste nor an act of charity. It is an investment in the health of the community and the nation, like roads and schools and hospitals. It's not something we underwrite off the side of the desk with the dribs and drabs that are left over when everything else has been taken care of; it's part of everything else.

If you are asking how we can afford to do the things this book proposes, when so many other priorities clamour for our attention, you are asking the wrong question. The money is there; the central issue is how we decide to spend it.

Educating the Heart

Societies never know it, but the war of an artist with his society is a lover's war, and he does, at his best, what lovers do, which is to reveal the beloved to himself and, with that revelation, to make freedom real.
— James Baldwin, "The Creative Process"

THE PURISTS WILL tell you that art exists for its own sake, and that its very "purposelessness" is enough. That notion is fine if we are only thinking about the artist's intentions, or lack of them, but it falls apart as soon as the artwork is out in the world. We are all free to construe what we read or hear or look at — give it purpose — however we see fit.

Beyond the instrumentalist arguments, art brings us into contact with values and standards that are timeless: justice, decency, balance, everything that is fine and true about the human condition. What culture brings to our shared life can't be counted in jobs and spin-off multipliers or plotted on a graph: its inherent, ineradicable importance as a source of wonder and joy, its ability to help us know each other better, trust each other more openly, and care for each other more, its

transformative ability to release the imagination and connect us to our intuition in our search for solutions to the challenges that confront us. Art offers a place where the human spirit can find release and our sense of wonder can be refreshed. It awakens compassion and shows us the humanity in the Other. Culture is the rebar framework that gives strength and durability to the structures of our lives.

Art is an act of sharing. Yes, the experience of art is about us as individuals, and how it makes us feel, where it makes us go in our imaginations, what it prods us to do that we otherwise might not have done. But it's also about the connection it gives us to others, even with others we might never meet. Our personal response makes us part of that broader community of other minds, other sensibilities, other souls that the writer, painter, composer, playwright touches; we recognize that we are not alone in what we feel, and that sense of sharing gives us reassurance and comfort and fellow feeling. It smooths the path to compassion.

The Dalai Lama calls this acknowledgement of the humanity in the Other "the education of the heart." What he means is that we should live our lives in a spirit of openness and generosity. It is a principle as old as all our great belief systems. Educate the heart, and we will develop the compassion and concern for others that will help us make the world a better place. He used this as his call to arms when he guest-edited a newspaper I once wrote for. For the single day he was in charge the phrase became the mantra of every section of the paper. First, educate the heart. Then, educate the mind. Change will surely follow.

Cellist Yo-Yo Ma educates the heart through music. He calls music "a convening force." Music, he says, "like all of

culture, helps us to understand our environment, each other, and ourselves. Culture helps us to imagine a better future. Culture helps turn 'them' into 'us.' And these things have never been more important." He singles out the music of Bach, specifically the six cello suites, for anyone "seeking equilibrium and solace at a moment of unprecedented change." Music has always been one of the ways we ease our emotional and psychic pain. But Bach doesn't just offer solace, says Ma; he offers us new perspectives. "The suites' collective vision — at once divergent and coherent, empathetic and objective — reminds us of all that connects us despite an increasingly discordant public conversation," Ma says. Putting his convictions into action, in 2018 Ma travelled to thirty-six countries to play the thirty-six movements of the cello suites, planning the performances on "days of action" that brought people together to think about how to improve society and answer the question, "What can we do together that we cannot do alone?" That idea, of coming together to find solutions to our problems through art, is central to this book's argument.

Milton Glaser, the man who created one of the world's best-known logos, I♥NY, said in an interview not long before he died: "There is something about making things beautiful, and we sometimes call that art, that has something to do with creating a commonality between human beings so that they don't kill each other. And whatever that impulse is, and wherever it comes from, it certainly is contained within every human being … Sometimes, the opportunity to articulate it occurs; sometimes, it remains dormant for a lifetime."

The opportunity to articulate our commonality is here. Drawing on what social psychologists call social identity, the

tendency of individuals to override differences and unite in a common interest or against a common threat, the proposed new Canadian Cultural Contract moves the cultural sector from the fringes of society to a position of active collaboration and initiation, and makes art and culture a transformational resource for all Canadians as a matter of fundamental importance to our personal and social well-being: an affirmation of our instinctive goodness. The artist will be recognized, not as an outlier but as a valued contributor to the fabric of who we are. The entire sector will be embraced on the same level of importance as health, education, defence, and global affairs. The arts will be recognized for contributing thinking that is lateral as well as literal, intuitive as well as rational, humane as well as pragmatic, to the decisions we make about where we take our society in the wake of the pandemic.

What is also likely to happen, when we reposition culture in our lives in this way, is that we will put flesh on the abstract notion of Canada. Culture contributes to our store of social capital and builds social identity. Part of our sense of community comes from our shared understanding of what we have achieved as a group, a collective memory that gives the community coherence and continuity. When a country or a community comes together to respect and celebrate artistic achievement, its cohesiveness is reinforced. Some of the glamour and status that comes with the acclaim and recognition on the world stage of Margaret Atwood's books or Jeff Wall's photography rubs off on the rest of us. It's similar to what we feel when Canadians win medals at the Olympics. We take a pride in the achievements of other members of our group.

The pandemic robbed us of the joy of that sharing, what the French sociologist Émile Durkheim called the "collective effervescence" that unites a group when individuals have the same thought or do the same thing. We feel it at a religious gathering, joined in worship; we feel it when we're in an audience in a theatre, laughing at the same joke or commiserating with a character beset by misfortune. It is an act of joint surrender: what McGilchrist calls "betweenness," which he defines as "being able to share in the character of the Other and feel separateness from it." The term suggests an interrelatedness in which everyone is an individual, yet everyone touches the greater entity in which we exist. We reach a better understanding of our differences and our shared values, our commonality, and get a clearer idea of where we can go and the kind of place we want to live in when we get there.

CHANGE COMES PRELOADED with uncertainty, of course, and uncertainty makes cowards of us all. A new virus variant is discovered and the stock market dives. Wedded to our rationalism and conditioned to be suspicious of what we can't control, we opt for the discomfort of what we know over the peril of what might be.

In Canada, we are at a tense point in the relationship between settlers and Indigenous peoples. Terrible things were done to Indigenous peoples. Great harm was suffered. Legitimate demands are being heard for truth and reconciliation and it is critically important that lost and stolen lives should not be forgotten. But truth and reconciliation, inclusion and

redress, mean more than words and phrases shoehorned into organizational vision statements, valuable and necessary though those words are. It means more than cancelling Canada Day. The attitudes that allow oppression of this kind to occur — bigotry, bias, privilege, exceptionalism — have not gone away. They continue to infest our power systems: law enforcement, the military, the corporate sector. They continue to taint our attitudes not only to Indigenous and minority peoples but to women, to sexuality, and to the marginalized. And the lesson we must take from these dreadful episodes in our national history is an ethical one: the ethical individual should always act from a position of goodness and compassion; an enduring relationship of trust and honest sharing will not be possible until those who wield power share it.

Can we summon sufficient bravery and generosity of spirit to make a change as fundamental as what is proposed here? The pessimists and the cynics would say no. The capitalist consumer model is deeply entrenched and savagely protected by the self-interested and the fearful. Those who run the system are too deep in the rut of How Things Are to be able to peek over the rim and see How Things Might Be.

Even within some segments of Canada's arts community, getting take-up of proposals for such significant shifts in our idea of what art does and what artists can do is likely to be difficult. The insular, self-congratulatory ways of the creative class can be annoyingly offensive, and there will always be a *noli me tangere* (keep your distance) segment of the arts sector that clings steadfastly to the flagpole of art for art's sake, determined to ensure that art doesn't become twisted (or twist itself) into something they think it shouldn't be

(and we're not here to blame them for that: we all have our principles). But I don't buy the argument that art's purity is somehow soiled by letting it get involved with the messy, modern world. The ivory tower has been breached; culture is a treasure for everyone to share.

Some might see the Québec-Canada hurdle as a challenge to clear, given Québec's ever-intensifying demands for autonomy within Canada. The Québec cultural community is rightly proud of its distinctiveness. It is thanks in large part to the province's artists that modern Québec, while nominally within Canada's boundaries but insulated (and to an extent isolated) by its language, is in many respects already a cultural entity unto itself. While timid English Canada was quivering in the wings of the world stage, dependent for its cultural identity first on the paternalistic UK and then the stampeding American cultural elephant, Québec was building its own version of a distinct society. As early as 1948, *Les Automatistes*, a community of young Québécois artists inspired by the French surrealist André Breton and led by the Montréal painter Paul-Émile Borduas, issued the *Refus Global*, a strident call for Québec society to be released from the centuries-long iron grip of reactionary politicians and a repressive church. And in the decades of social and economic transformation of Québec that followed the Quiet Revolution of the early 1960s, it was the artists who inspired and helped premier Jean Lesage and his colleagues to create "national" character out of whole Québécois cloth. In the *joual*-filled plays of Michel Tremblay, the novels of Marie-Claire Blais, the songs of Gilles Vigneault, all of them entirely of their place and free of outside influences, Québec's

chansonniers, playwrights, choreographers, and authors gave ringing proclamation to Québec's difference and distinctiveness in a remarkable coming-together of society and its artist "outsiders." None of that would be diminished by the new Canadian Cultural Contract. Rather, by treating culture as a valued common good, and liberating the country's artists to flourish and find new ways to contribute, the new Canadian Cultural Contract will strengthen the standing of the cultural community in Québec and amplify its opportunities for influence, not only at home but across Canada.

The more pertinent question is, "How can we not do this?" The idea of change on this scale is hardly new. At the start of 2023, the Australian government launched Revive, a five-year AU $300 million plan to renew and revive Australia's arts, entertainment, and cultural sector, centred on a new umbrella body, Creative Australia, which will "restore and modernize" the Australia Council for the Arts (their equivalent to the Canada Council for the Arts). The move followed claims from arts advocacy agencies that the ACA was a "silo model" that had "reached its use-by date" and demands that it be replaced by a body with a "broader and more strategic vision." Creative Australia, said the government, will "provide greater strategic oversight and engagement across the sector," with, as of 2024, a stand-alone First Nations–led board "recognizing and respecting the crucial place of First Nations stories at the centre of Australia's arts and culture" as well as new units devoted to music, writing, and creative sector workers. In April 2023, over and above the Revive package, the Australian government announced a half-billion dollars would also be shared among Australia's galleries and

collecting institutions over the next four years to counter the effects of what the Prime Minister — the Prime Minister! — said was years of "chronic underfunding."

It's also worth keeping an eye on what's happening in Europe. Creative Ireland is an "all-of-government" program of "culture and wellbeing" that aims to ensure that all Irish people have the opportunity to realize their creative potential. It works with government decision makers as well as specialist agencies, NGOs, community organizations, and individuals to "counteract isolation, create connections, generate joy, and inspire and transform people, places, and communities through creative activities." Projects have ranged from artworks that generate renewable energy and a phone-in service where you can listen to folk stories and songs, to a community notebook project in Kildare, a modern-day mummers' troupe in Leitrim, and artist residencies in care homes. Switzerland, Germany, Belgium, the Netherlands, and Austria have all recently adopted "fair practice codes" that move artist recompense away from the traditional free-market principles of supply and demand, under which artists earn income according to how well their products perform in the market economy, toward a recognition of the value of artistic work for society as a whole. This approach leads logically to two significant changes: a repositioning of cultural policy to recognize its centrality to society; and, equally importantly, if "fair pay" is to be meaningful, a corresponding increase in the cultural budget — which is, indeed, already happening in the European countries involved.

These are encouraging beginnings. But to bring about lasting change — to embed arts and culture in our daily lives

in ways that reharmonize and rehumanize our shared existence — we need to dare to be bold, dare to have vision. It will require a profound shift in our priorities. There has never been a better time for that shift, and we have never needed it more. It is time to activate the compassionate imagination.

Intermezzo

*In music, a pause to contemplate what has gone before and
prepare for what is to come.*

BEFORE WE OPEN the curtain and focus our attention on the
main attraction, the Canadian Cultural Contract and its
operational partner, the Canadian Foundation for Culture,
I'd like to paint the scenery and position the lights.

First up, some basic parameters, so we know where we
stand, starting with a working definition of the word "cul-
ture" as I am using it here. It's a veritable little cluster bomb
of a term, so it needs handling with care.

UNESCO's 2001 Universal Declaration on Cultural Diver-
sity called culture "the set of distinctive spiritual, material,
intellectual, and emotional features of society or a social
group, that encompasses, not only art and literature, but life-
styles, ways of living together, value systems, traditions and
beliefs." The Canadian cultural bureaucrat Bernard Ostry
called it "the element in which we live." It is the collective
experience and memory, the shared values, the set of assump-
tions and hopes we agree to embrace.

It is also the way we speak to each other about those aspects of our lives together through expressions of an artistic or creative nature — books, plays, dances, paintings, sculptures, architecture, music, films, videos ... the visible, audible, and tangible (these days, sometimes not even tangible) expression of the human imagination, the human spirit, and the human heart. Above all, said the Canadian educator and politician Walter Pitman, the arts are "how we express the finest elements of our humanity — our understanding, our compassion, our caring, and our love."

This book concerns itself both with culture writ broad and culture in the particular: the transformative impact that engagement with the creative imagination can have on our social, political, and economic health, and its life-enriching, mind-nourishing, soul-ravishing effect on the individual. They are, as we shall discover, inseparably intertwined.

IN TERMS OF the book's structure from this point on, I'll first outline some basic principles of social organization. Change is a broad church; it gathers individuals of many divergent views under its roof. But no movement for change can succeed if it doesn't have a framework of common purpose rooted in pragmatic reality.

Then I'll look at what's in it for the individual involved with art, explore the influence art has on the expression of the human spirit, and show how sharing the products of other people's imaginations can foster the compassion that helps to break down the barriers of ignorance and hatred that prevent us from talking to each other. I'll also look more deeply into

the contributions arts and culture can make to what and how we learn, at school and throughout life: a key area for change if the new Canadian Cultural Contract is to be effective.

Along the way, by way of provocation, I'll sprinkle in some *what ifs*. What if we were to take an integrated, holistic approach to culture in every department of government, and embed artistic experiment in the ways we develop policies and make decisions? What if we were to create an entirely new support network for the arts and culture sector, with more resources and a more inclusive package of priorities and criteria? What if we were to put a little spine into our pious words about reconciliation? What if we were to design new ways to not only encourage but enable Canadians — all Canadians — to make creative activity part of their lives? What if we were to bring the arts back into the school curricula as a central pillar of imaginative learning?

I'll distill all this evidence and speculation into an aspirational, inspirational framework of cultural engagement that rehumanizes the way Canadians live together and releases the joyous, affirmative power of the compassionate imagination for the benefit of us all. Art really can help us make the world a better place. You'll see.

What Are the Principles
We Can Agree On?

Re-examine all you have been told at school or church or in any book, dismiss whatever insults your own soul.
— Walt Whitman, preface to *Leaves of Grass*

FOR A FEW years, at the turn of the millennium, I had the good fortune to serve as president of the Canadian Commission for UNESCO. One of my tasks was to go to Paris once or twice a year (I know, but someone had to do it) to help represent Canada in the cavernous UNESCO negotiating halls. I met a lot of interesting people at UNESCO. One of them told me about a group of global thinkers who had been tasked by the organization with creating a list of moral principles that were common to all cultures. After several years of deliberation and argument, he said, they had been able to agree on two: you should not take another person's life, and you should not harm children. Nothing about race, nothing about gender, nothing about anything else.

The story my Paris friend told is probably apocryphal. But even as a grim joke, it demonstrates how difficult it is for

human societies to find common ground. Today's world lacks intelligent discourse built around a common moral and spiritual framework, because the broadly shared set of values and cultural assumptions and reference points on which the West once thought the entire world operated is cracked beyond repair. The notion of a cohesive, common-code global society built on justice, equality, and peace — the Western canon as Harold Bloom described it — has had to take its place alongside the many different cultural traditions and beliefs from around the globe.

The pandemic threw our lives into turmoil, but the trouble the world now finds itself in began long before the pandemic smote us. Bitter truths that we have tried to ignore have been forced to the forefront of public attention. Huge swaths of humanity feel threatened and exploited and excluded from public life. We treat the planet as if we're house guests who don't have to clean up after ourselves or restock the pantry. Our leaders wear mediocrity and disgrace as badges of honour — and we let them. Grievance, meanwhile, is in plentiful supply; it's always easier to goad people's indignation over perceived assaults on their freedoms (lockdowns and mask mandates) or other people's expressions of their views (athletes taking the knee before games) than it is to get them to think seriously about what to do about the spread of a deadly virus or racial injustice.

And then there's wokeness. In the fall of 2021, the dance critic Elizabeth Zimmer wrote a piece in New York's *The Village Voice* expressing her outrage over a "press policy" she had received from a dance company. It asked writers to "acknowledge race bias as part of their review," along with

their ability/disability status. It instructed them to "treat the art and artists with respect in their language and descriptions, treating their own words as opinion, and not fact; avoiding body-shaming, misgendering, and assumptions about cultural, ethnic, or racial backgrounds." It said that in a performance with many parts, "all works should be acknowledged ... not mentioning an artist and their work is erasure." Elizabeth, who was a dance critic in Vancouver during the 1970s, and has been a friend of mine for decades, was incensed. "Wait, what? Hello? Um, no. Just no," she wrote. "Critics should not be taking orders from the institutions they cover."

She is, of course, right. These are unreasonable demands to make on a critic. They show a profound misunderstanding of the function of criticism, and their righteous tone makes me bristle. Unfortunately, both Elizabeth and the company are victims of the changing times, and it would be wrong and foolish to laugh the concerns off. These clumsy attempts to lay down rules for reviewers' conduct reflect a politically correct wokeness that has become a weapon for social correction (or is it coercion?). It is being wielded by many people who see themselves as unjustly marginalized or oppressed or see themselves as sympathetic to the marginalized or oppressed cause. (This argument is mirrored in the sporadic academic spats over cultural appropriation and who is allowed to say what about whom.) But it is important to recognize that under the clumsiness is a deep urge to set perceived wrongs right.

Recent advances in communications technology, alongside our refreshed awareness of the need for reconciliation with Indigenous peoples, for the rights of women and racial and

ethnic minority groups, and for a rebalancing of the scales of justice, have shaken society in general out of a long slumber; we're still reaching for our first cup of coffee and trying to focus on the potentially schismatic challenges that have fallen on the doormat. We may not agree with what Jordan Peterson or J.K. Rowling have to say about gender, or privilege, or feminism, or cultural appropriation, or speech controls. We may not agree with a New York dance company's view of a critic's job, or its suggested changes. But we should listen. Maybe we have things to learn; maybe there are adjustments to be made. What those adjustments might involve remains an open and potentially inflammatory question, but it's one we might usefully and responsibly ask.

Thinking generously isn't easy. We fear difference instinctively because we think it threatens our survival. Our response is to huddle in our safe compound behind tribal barriers — a response, say the evolutionary scientists, that has been passed down in our genes from the Pleistocene era. But difference is a fact of the life we live. We are all different and, simultaneously, we are all ordinary. None of us deserve special treatment, but we do carry certain mutual obligations to each other: respect for one another's inherent human dignity, whatever our origins; openness to the possibility that others may think differently from us; and charity enough to believe that equable treatment of all is not a threat. That means respecting each other's cultural baggage not as exotic or strange but as the expression of what each of us finds important, and as equally worthy of consideration as art on its own terms.

To lay the ground for the new Canadian Cultural Contract, we might one-up my Paris friend's intellectual worthies

and dare to identify the core ethical and social principles fundamental to living a good life in a just and fair society.

Great philosophers and the foundational leaders of all faiths place the sanctity of human life and duty of care for others at the core of the social contract. Without wanting to oversimplify, and recognizing the different principles of social structures, these beliefs have given us the Confucian concern with the overall social good; the Taoist emphasis on the individual living in harmony with the natural world; the various doctrines of sacrifice, redemption, and resurrection; the diverse arrangements for governing — all of which are essentially the same: we should treat each other with empathy and compassion, generosity and goodwill, honour and integrity, respect and civility.

How do we translate these principles into everyday practice? Are there any rights to which all human creatures should be entitled? For centuries, there was no universal agreement on what those rights were. Then came the European Enlightenment of the eighteenth century, the unruly, sprawling philosophical movement that swept away centuries of superstition and oppression and laid out a new set of principles for the advancement of human happiness: a belief in the central importance of reason; the conviction that scientific experiment and discovery is worth pursuing because of its value to society at large; a belief in democracy, the separation of church and state, and the principle of freedom, both of the individual and of what they have to say; and the importance of education and the law. Both the American and French revolutions reflected the intellectual restlessness and desire for social betterment — *liberté, égalité, fraternité*, the

truths we hold to be self-evident — that the Enlightenment thinkers provoked. Many other countries evolved their own statements of belief and legal principle.

But it wasn't until two catastrophic twentieth-century wars had killed between fifty and eighty million people and devastated whole countries that world leaders established a formal code establishing rights and freedoms for all humanity. The Universal Declaration of Human Rights was adopted in 1948 by the newly established United Nations, as a formal statement of the principles on which its members would operate. Eleanor Roosevelt, the widow of the U.S. president, chaired a drafting committee of eighteen international experts; the Canadian legal scholar and human rights activist John Peters Humphrey was the principal author of the first draft. Mrs. Roosevelt called it the "Magna Carta of all mankind."

The Declaration includes thirty articles, principal among them the basic concepts of dignity, liberty, and equality; the right to life, the prohibition of slavery and torture, and the right to a fair trial; the rights of freedom of movement, residence, property, and nationality; the rights of freedom of thought, opinion, expression, religion, and conscience; and economic, social, and cultural rights, such as health care and a decent standard of living.

Experts and authorities are always offering variations on this list. Philosopher Martha Nussbaum proposed a set of basic human capabilities that should be fulfilled in any good society, based on studies she made of women in developing countries. Among them: being able to imagine, to think, to reason, to experience and produce spiritually enriching materials and events; being able to love, to grieve, to experience

longing and gratitude, to laugh, to play, to enjoy recreational activities; being able to form a conception of the good and to engage in critical reflection, to imagine the situation of another and to have compassion for that situation; to have the capability for justice and friendship; to live with concern for the world of nature.

Many of the rights articulated in the UDHR have since been embedded, in one form or another, in the constitutions and legal systems of many of the nation states of the world, though Mrs. Roosevelt made it clear from the start that it was never a binding instrument, and its boundaries are still routinely overstepped. Still, as "a declaration of basic principles of human rights and freedoms ... to serve as a common standard of achievement for all peoples," the UDHR is a good start.

Leaning into the Unknowable

*Art's beauty lies in the quest, not the completion. Art is using
a sword to stab water. The artist is the one who best describes
the weight of the sword, the troubled water, the glistening blade, the
salty tears, the cruelty of the moment, the tired muscles, the smell of
the soil on the shore and the unending return to begin again.*
— Mélanie Demers, artistic director, Montréal's
MAYDAY dance company

AT ITS SIMPLEST, engaging in a one-on-one exchange with art
is a way to escape from the jingle-jangle of the wired world
and the chitter-chatter of the monkey mind and give your-
self space for imaginative play. Yes, art can make you think.
Sometimes it asks questions that have no answers. Sometimes
it whispers endearments, sometimes it shouts dirty words,
sometimes it's more infuriating than a burst tire on a moun-
tain highway. Other times it's just there to make you laugh or
make you cry or stick its tongue in your ear.

Regular exposure to the creative output of other people's
imaginations reminds you that the world is a strange and
wonderful place to be — with the added benefit that the only

threats you face when you read a book or watch a play is that your mind might be changed, you might have a fresh idea, you might spill coffee from laughing, or you might weep to exhaustion.

The art we like can take a million different forms. As Arnold Spohr, the former artistic director of the Royal Winnipeg Ballet, used to say, as he tossed aside negative reviews of his company, the world is full of personal taste. Taste has nothing to do with art, and whatever the snobs might tell you, none of us should stand in judgment of our neighbours' choices, glimpsed through a window as we pass, or displayed before us when we are invited in.

Beyond the images we hang on our walls lie all the paintings and sculptures and photographs and lithographs that generations of educators have taught us to revere. The principles involved in that reverence are complex, and some of them are suspect. Monetary value, for instance, has become significant because it gives us the false belief that it equals artistic worth. Scarcity, scandal, disputes over ownership, famous anecdotes — the snipped ear, the angelic obscenities on the Sistine Chapel ceiling — they are all part of the superficial paraphernalia of Great Art.

These trifles are all red herrings, hatched of our own self-doubts and hesitations. We let them guide us away from confronting our own unwillingness, understandable and honest though it may be, to call the things that we see as we see them. How can we? Few of us have the time or inclination to learn what we need to know to make an informed decision. For decades, Warren Buffett, who has spent his waking hours making himself one of the richest men in the world, would

visit the home of his friend Katharine Graham, the publisher of *The Washington Post*. Sometimes he availed himself of the bathroom. But he never realized he was peeing in the presence of a Picasso until he was told that one of the great man's works was hanging on the wall all that time. In a world short on scruples, we are, all of us, ripe for the picking. We allow Oprah and a mob of Internet influencers to tell us what books we should read, rather than making our own decisions.

Think about the *Mona Lisa*. Nothing much to see, really: the painting weighs less than twenty pounds and is quite small, thirty inches by twenty. Just a little portrait of a woman and her enigmatic hint of a smile. But what a hold it has on the world's imagination, what an aura of mystery has been woven around it. It has its own mailbox at the Louvre to accommodate the love letters sent by the smitten. Its worth on the open market (not that it would ever get there) has been evaluated at something approaching U.S. $1 billion; someone once suggested selling it to reduce the French national debt. It graced Napoleon's bedroom for a while, was stolen once (with Picasso initially fingered as the thief), has been damaged by vandals several times, and since 2005 has been protected behind bulletproof glass on a bed of humidity-absorbing silica in a dedicated *salle* through which pass six million people a year.

Most of those millions are interested only in this particular work (though they spend an average of less than a minute in its presence). Because despite all those caveats, Great Art casts a spell. From the days of the Grand Tour, to be in the presence of the revered products of other imaginations has become a common high ambition. Great Art was a foundation stone of

the modern tourism industry. People would scrimp and save for years to be able to tell their friends they had visited the Hermitage or the Prado. These days, of course, thanks to the wonders of the digital age, a couple of clicks will bring you closer to the *Mona Lisa* than you'd ever get if you cashed in a chunk of your life savings to fly to Paris.

It's not just the *Mona Lisa*. You can give yourself private access to whole worlds of art online. Call up one of Jean-Paul Riopelle's vast canvases, on the biggest screen you can find. Lose yourself in the tangled depths and mysteries of his seething worlds. That beckoning gesture that insists we go where we might never have been, it's everywhere, if you let yourself see it. It's in Monet's water lilies, it's in the eyes of Rembrandt's self-portraits, it's in David Hockney's swimming pools, it's in Emily Carr's forests. Go ahead. Pull up a chair and sink into Danny Singer's photo-panoramas of small-town Canada and the American Midwest. Did none of those peasants in Bruegel's painting hear the splash when Icarus fell into the ocean just moments ago? Ask them. Take one of the vacant stools beside the guy with his back to you in Hopper's gloomy diner and let that good-looking lad behind the counter pour you a coffee.

Would it make any difference if I told you that the female half of the preoccupied couple facing you in the diner was Hopper's wife? Representational paintings are vehicles in which we can transport ourselves to places we never knew in lands we never visited. Abstractions can carry us away to places our minds have never been. By taking us to these places, by making us look again, art gives us ways to explore what other people are thinking and feeling. It communicates our connectedness. The image lets us experience the world

through the eyes and imagination of the artist. What you make of it is up to you.

I know that constant immersion in the imaginative expressions of other people, their books, their dances, their music, their plays, their paintings, has made me a different person from the one I might have become in a world without art. A better person, I'm tempted to say; better, at least, in the sense of being more prepared to think about alternatives to my own point of view. When we become absorbed in a book or a film or a painting, we are removed from the immediacy of our everyday lives and connected to someone else's way of seeing, perhaps more intense, more colourful, more meaningful, perhaps also disorienting. At the same time, we imbue the work with what we know and feel and remember, the way Proust did with his madeleine. The experience is a complex one; it can show us not only new paths to pleasure and personal fulfillment, but also new ways to feel the world, to feel *for* the world. It can be disturbing or moving; it can make us exultant and cheerful or wistful and melancholic. It can show us the imaginary fences we have built around our lives. It can make us think or want; it can make us angry or indignant or glad to be alive. We come back to our daily lives somehow shifted in our outlook, even if ever so slightly.

The Canadian choreographer Crystal Pite talks about how, as a child, the stories she was told about the cosmos inspired her to "wonder about colossal ideas that were, and always will be, beyond my grasp and to approach great unanswerable questions with imagination and creativity." They gave her, she says, a "longing to lean into the unknowable." What she has evolved, on her way to becoming one of the dance

world's most in-demand artists, is a choreographic language that uses theatricality, the individual body, and the manipulated mass to make those big ideas visible on the stage. The fluid structures of her pieces have a quiet, lulling beauty that gives physical shape to concepts like love and grief and longing; they change the way I understand the world, and I feel fortunate to have been able to watch them.

Angels' Atlas, which Pite made for the National Ballet of Canada in 2020, is one such piece. A pair of dancers make a simple statement in movement — of longing and sorrow, as it might be — in clear, straightforward terms, unadorned. Then the gestures, the lifts and swings, the shapes that the individuals have carved into the air, are absorbed and amplified by a dancing mass. Against a backdrop of shimmering, shifting light, dozens of dancers take that simple fragment of material and convert what had been specific and personal — two individuals, moving together — into a common sensibility, setting before us otherworldly and transcendent evocations of the great mysteries, filled with echoes of what has gone before and thoughts about what might be. It is a process that is both transforming and ennobling. Hints of pietas and passions pass before us like dreams; near the end, a long sequence suggests ecstasy made visible, clusters of moving bodies exploding like starbursts lighting up the universe, returning at last to the human individual, in defiant vulnerability, somewhere in the cosmos.

There's also this, which lifts us to perhaps a loftier plane, but loses no relevance because of that: art takes you by the hand and walks you through the spiritual maze of existence. The world is filled with people looking for justification (even a

hint of explanation would do) for the life we have been given, and for the lives that are taken away. Most of us, somewhere in us, long for a connection with the numinous, the immaterial mysteries of the spirit and the imagination. For an inkling of personal grace. We all hope to make a difference, however slight, however threatened hope may seem.

We shy away, in these cynical times, from words like "spirit" and "soul," so perhaps we wouldn't go as far as Lawren Harris, the painter who led the creation of Canada's Group of Seven, who called art "a high training of the soul, essential to the soul's growth, to its unfoldment." But humanity gets much of its understanding from metaphor, and engagement with creative expression has always been one of the ways we search for meaning in an increasingly chaotic and morally compromised world. Some authorities believe that art itself evolved from our earliest urges toward religion and ritual, a way to make the ineffable tangible.

Harris always wore his spirituality on his canvas. You can see it glowing from his later works — his mountains, his oceans, his yearning trees. Like a lot of the early modernists, he was influenced by the late nineteenth-century Theosophist movement led by the Russian author Yelena Petrovna Blavatsky. The Theosophists believed in what Madame Blavatsky called "the synthesis of science, religion and philosophy" and sought "Divine Wisdom, or the aggregate of the knowledge and wisdom that underlie the Universe."

But you don't need to know any of that to pick up on the spiritual scope of Harris's paintings. Or, for that matter, the spiritual connection with the landscape that is everywhere in the Group of Seven, that sense of an unspoken, unrevealed

presence in nature. Jack Shadbolt talked about his famous butterflies as symbols of "the natural and spiritual will to survive through change and transformation." Emily Carr said she wanted "to paint so simply that the common, ordinary people would understand and see something of God." Some academics don't care much for Carr and her pantheism, but soften the edges of your soul and let her in. You might be surprised at what she has to tell you.

That search for meaning through art is everywhere. The music theatre creations of composer R. Murray Schafer are deep explorations of spirituality and mysticism, blending myth, music, and ritual. *Ra*, for instance, was an eleven-hour overnight journey through the Egyptian underworld ("initiates" were guided through twenty-nine different sites at the Ontario Science Centre) in pursuit of the Sun God, culminating at dawn in Ra's resurrection. Vancouver choreographer Karen Jamieson, an early graduate of the Bauhaus-like arts crucible that was Simon Fraser University's Centre for Communications and the Arts in the late 1960s and early 1970s, has spent her career in search of movement that is, in her words, "primitive and pared down to essential archetypal images, speaking a universal language." The work by which she is best known, *Sisyphus*, is a danced visualization of surging striving, relentless and doomed, a parable about the invincibility of the human spirit in the face of the cruellest odds. It was selected as one of the ten Canadian choreographic masterworks of the twentieth century. Another of those ten masterworks was *Sacra Conversazione*, set to Mozart's *Requiem*, by Toronto Dance Theatre co-founder David Earle, whose creative journey

has taken him, too, on a lifetime exploration of spirituality, ritual, and belief.

Go to any of the great galleries of the world, or any of the great places of worship. Once you start looking, it's hard not to see. They are treasure troves of the transcendent, ready for the imagination's plundering: all that statuary, all those icons, all those magnificent Madonnas and Calvaries, all that mighty music ... a panoply of adoration and warning and storytelling, meant to teach and impress, to show the common worshippers there was a reason they were on their knees.

You can find it in Modernist art, too, though it may be harder to spot. Jackson Pollock was letting his subconscious respond to the world's horrors as he painted. His drip paintings can be tools for meditation if we want to use them as such. Piet Mondrian's lines and rectangles work the same way; he said he wanted to get to the spiritual essence of the world. Wassily Kandinsky was fascinated by the idea of the expression of the spirit in abstract art. I once watched the British composer Cornelius Cardew perform a piece of "music" that consisted entirely of him striking a series of suspended stones for several minutes. He said he was looking for a return to "elemental simplicity" in our lives. The "music" he created (real rock music, I was unable to avoid suggesting in my review) was a way for people to clear their minds. Even the artists who might seem to throw up their hands in despair — Bacon, Schiele, Grosz, Picasso with his *Guernica*, all that twisted, caustic depiction of the ugly underside of the human condition — speak about deep spiritual concerns. Under all the nihilism they show us the deeply compromised soul.

We should never forget that art is also, as University of Chicago philosophy professor Agnes Callard recently put it, a means "for seeing evil." Evil, in her definition, encompasses "the whole range of negative human experience ... hunger, fear, injury, pain, anxiety, injustice, loss, catastrophe, misunderstanding, failure, betrayal, cruelty, boredom, frustration, loneliness, despair, downfall, annihilation." In normal life, she argues, "we tend to be aiming, achieving, improving, appreciating and enjoying." Art releases "the prohibition against attending to the bad." It is the poets, she says, who "take a long hard look at what the rest of us can't bring ourselves to examine; they are our eyes and ears."

THERE'S A MOMENT in Proust's great novel, *In Search of Lost Time*, where the narrator talks about how much he prefers to lie on his bed reading than to be in the street outside his window, because lying in bed lets his imagination roam free. Emily Dickinson put it slightly differently: "There is no Frigate like a Book," she wrote, "to take us Lands away." Books help us make sense of our world and come to terms with the terrors that keep us awake at night by allowing us — expecting us — to use them as points of departure for our own flights of wonder and points of return to the truths that have always guided us. Every book becomes unique to its reader, a specific individual encounter, no matter the number of physical copies sold. And it is that personal connection, the way you bring your own experience to what you read, that is the crux of the matter. When what you read coincides in some way with a memory or a thought of your own, or

reflects a situation, encounter, or debate that you experienced in your own life, your reality and the book's reality become entwined; you have something in common, and you trust it more. Not only that: all the circumstances that surrounded your own experience enrich the book's text and give you a sense of secret privilege; you are able to see what the author has created from a wider, more informed perspective, and you see your own situation in a more nuanced way. That coming-together of you and the writer is what makes fiction work.

Angus Fletcher, who teaches at Ohio State University, argues that narrative can be scientifically shown to help us come to terms with the woes of the world — grief, loneliness, anxiety, ennui — and kindle empathy, courage, and the imaginative spark that enable democracies to thrive and scientists to change the world. In his book *Wonderworks: The 25 Most Powerful Inventions in the History of Literature*, he uses a mix of neuroscience and literary analysis to explore the psychological effects — cognitive, behavioural, therapeutic — of narrative works ranging from nursery rhymes and fairy tales to Chinese poems, the plays of Shakespeare, and the novels of Jane Austen. "Literature is very effective at generating a sense of wonder, which is the most basic and primordial spiritual experience," he said in a 2021 interview with Kevin Berger for *Nautilus*. "We need wonder in our days. That's why most of us, when we read poetry, don't like to think of it as being utilitarian. We like to think of it as bigger than that, as the purpose beyond ... Our brains need literature the way that our bodies need food. Literature provides our brains with basic sustenance."

Many lists of the best one hundred novels of all time exist, but the great torrent of Canadian fiction of the past half century gives us plenty of basic sustenance to be going along with: Margaret Atwood's darkly prescient dystopias; Rohinton Mistry's richly humane stories that take us deep into emerging India's social and political upheavals; Joy Kogawa's *Obasan*, opening our eyes to the Japanese Canadian experience; Eden Robinson's *Monkey Beach*, an Indigenous coming-of-age tale shot through with mysterious spirituality; Mordecai Richler's lovingly preserved-in-amber twentieth-century Montréal; Thomas King, who blends oral storytelling techniques with politicized writing about Indigenous issues; Elizabeth Hay, whose *Late Nights on Air* plunges us into the world of radio broadcasting in Yellowknife ... The scope of what you can learn and experience just from a visit to your local library is without limit.

Reading can also be a dangerous business, of course. Reading sparks ideas, and ideas spark change and challenges. A book, as Kafka put it, is "the axe for the frozen sea inside us," which is why authoritarians and zealots through the ages have always been so quick to burn books they don't approve of: scrolls by the prophet Jeremiah that told the king of Judah things he didn't want to hear; books of philosophy and history that didn't suit the third century BCE Chinese emperor Qin Shi Huang; Jewish holy books, Christian scriptures, Buddhist manuscripts.

The most infamous book-burning episodes in recent history were the responsibility of Hitler and his Nazi henchmen, who in 1933 set out to eradicate literature that in their opinion contradicted "traditional German values." Around

25,000 volumes of "un-German" books were burned in front of the Berlin State Opera, "fire oaths" and incantations were bellowed around bonfires across the country, and the national radio audience heard Joseph Goebbels, Hitler's minister of propaganda, gloat over the mass destruction of "intellectual filth," a term that included, along with political works, writings on history, art, sexuality, bourgeois popular novels, and works by Jewish authors. When the war was over the Allies proved they were no better, ordering the destruction of over 30,000 German titles, ranging from military history to poetry and school books.

In the U.S., anyone who wants to ban or burn books can claim justification in the freedom of speech provision in the first amendment of the American constitution, and many have taken advantage of it. When school board members in North Dakota burned 32 copies of Kurt Vonnegut's *Slaughterhouse-Five* in 1973 on the grounds that it was "evil" and not fit for children, Vonnegut wrote to the board chair to say how "extraordinarily insulting" the news was. He and his publisher, he said, were "angered and sickened and saddened." He never received a reply. In 2013, a Florida pastor proposed burning as many copies of the Quran as the number of victims of the 9/11 terrorist attacks. In 2022, a Tennessee pastor held a book-burning event in his church's parking lot, with parishioners tossing copies of the *Harry Potter* and *Twilight* books into a bonfire intended to clear "demonic influences" from their homes.

In March 2023, the American Library Association reported that attempted book bans and restrictions at school and public libraries set a record in 2022, with more than 1,200

challenges of more than 2,500 different books, nearly double
the number of challenges in the previous year. "I've never seen
anything like this," Deborah Caldwell-Stone, director of the
ALA's Office for Intellectual Freedom, told Associated Press.
"The last two years have been exhausting, frightening, out-
rage inducing." According to PEN America many bans were
put in place in response to challenges from parents, educators,
administrators, board members, or because of new school
board regulations or state laws. Issues addressed by books
that were banned included race and racism, sexual content
of varying kinds (including information about puberty, sex,
or relationships), and LGBTQ+ issues. "We are witnessing
the erasure of topics that only recently represented progress
toward inclusion," said Jonathan Friedman, director of PEN
America's Free Expression and Education program.

That same year, residents of Jamestown, Michigan voted
two-to-one to stop funding the library over its refusal not
to remove or censor books with LGBTQ+ themes, effectively
forcing the library to close, cutting the community off from a
popular source of free Wi-Fi and even from the very meeting
room in which the vote took place. Also in 2022, Utah intro-
duced a law banning "pornographic" and "indecent" books
in school libraries, defining a book or an image as "indecent"
if it includes explicit sexual arousal, stimulation, masturba-
tion, intercourse, sodomy, or fondling. Six months after the
law was introduced, one large Utah school district had 202
challenges from parents on 42 titles. It took district staff 500
hours to review the complaints and cost about U.S. $20,000
in employee compensation. Ten of the books were removed.

Patty Norman, a deputy education superintendent for the state, called it "time well spent."

Don't think it can't happen in modern Canada. In 2019, a francophone school board in Ontario burned about 30 books from school library shelves in what was called a "flame purification" ceremony intended as a "gesture of openness and reconciliation" toward Canada's Indigenous peoples. The books were among 4,716 volumes removed from schools on the grounds that they contained outdated content or perpetuated negative stereotypes about Indigenous people. Among them were comic books like *Astérix et les Indiens*, *Tintin en Amérique*, and a book called *Les Cowboys et les Indiens* that qualified for destruction due to its "atrocious" title. Book banning, meanwhile, gathers force. In 2022, the Upper Canada District School Board banned Agatha Christie's *And Then There Were None* over what it identified as anti-Semitic references.

But attitudes are never static. In 2018, the famous paperback copy of *Lady Chatterley's Lover* that was consulted by the judge in the 1960 British obscenity case came up for sale at a London auction. The British government imposed a temporary export ban so a buyer could be found to match the asking price, "on the grounds that the departure of the book from the UK would be a misfortune because of its close connection to our history and national life." In the U.S., students themselves have taken action, ranging from a Missouri lawsuit filed by students against their school district for removing 8 books from school libraries, to the creation of the Vandegrift High School Banned Book Club in Texas, to a Pennsylvania student

protest movement that eventually forced school administrators to reinstate more than 300 banned books, films, and articles. During a 2006 appeal hearing in Judson, Texas about a ban on Margaret Atwood's *The Handmaid's Tale*, which has had a steady stream of challenges since its publication in 1985, a senior at Judson High School argued: "If we do ban *The Handmaid's Tale* because of sexual content, then why not ban *Huckleberry Finn* for racism? Why not ban *The Crucible* for witchcraft? Why not ban *The Things They Carried* for violence and why not ban the Bible and argue separation of church and state? All the books I just mentioned are part of the eleventh-grade Judson High School English curriculum." Atwood asked a similar question in 2023, when the book was banned from school libraries in Madison County, Virginia. She was "not alone in being unacceptable," she pointed out in an interview with *The Guardian*. "Toni Morrison and Stephen King are banned, too. It's supposedly because there is too much sex in our books. So, when are they going to kick out the Bible, because that's got lots of sex in it? What century are we living in for heaven's sakes?" In 2022 Atwood and her publisher even issued a one-of-a-kind "unburnable" edition of the book, produced using fireproof materials able to withstand temperatures of up to 2,600 degrees Fahrenheit. It was auctioned at Sotheby's in New York, with all proceeds going to PEN America.

Burning books, banning books, worshipping books, it all comes from the same source: our knowledge that the written word has the power to move us, inspire us, infuriate us, change us, bring us joy … and let us share those things with other people. The written word opens doors to parts of the

human universe we haven't explored. It generates empathy and understanding and an appetite for alternatives: that's what gets the zealots and bigots in such a panic.

That's not all literature does. Academic studies tell us that children who read a lot are better readers, better writers, and more complex thinkers; they have a better grasp on the variety of experiences and opinions that exist all around them. Reading leads to reading, books lead to books, because voraciousness — avidity, leaning into the unknowable — is a state of mind, and once it's started, the reading never stops. Which is just as well. We live in a thrilling and terrifying world, in which decision-making is going to depend less and less on short-term political opportunism and more and more on long-term ethical and moral choices. Imagination, ingenuity, and compassion will be at a premium; we need every tool we can get our hands on to make sense of those challenges and those opportunities.

Letting the Soul
Come Out to Play

Everyone needs access to the arts — not as watchers
but as participants. The experience of our creativity is what
connects us with our soul. It gives us meaning, purpose. You don't
have to be a great artist. Write a diary. Play a guitar.
— Brenda Leadlay, former executive director,
BC Alliance for Arts + Culture

WE ALL HAVE our preferences; I have a habit of telling people
that I think dance is the most moving and communicative of
all the art forms. It was Doris Humphrey, an iconic maker of
modern dance, who said movement never lies. What we see
when a dancer moves before us is the naked truth because
the body can't express anything else: it's finite, visibly expres-
sive. The body is who we are and the place where we live.
Without words, the dancing body speaks volumes to us about
the miraculous diversity of the world we live in, the endless
variety of meanings we want to convey, and the intentions we
have toward each other.

Dance isn't a storytelling art. As George Balanchine said, there are no mothers-in-law in ballet. But I like the idea that dance becomes something greater than itself; that it crosses the borders of language and logic, lets you see beyond the interplay of rhythm and pattern and energy on the stage to a greater *thing* — an idea, or an emotion, or an intuition that the dancing has provoked — and gives you, there in the dark in the company of three dozen or three hundred or three thousand strangers, the most piercing affirmation of the intoxicating possibilities of the human condition, the thrill of what it is to be human, what it is to inhabit this watery structure, the bravery and recklessness of this scrap of bone and sinew and skin, muscle and hair and brow, all at the mercy of this huge world. No other art form speaks so directly about the fragile ephemerality of our physical existence, or about the human instinct to transcend those bonds and aim for that perfect moment of self-realization.

Not everyone agrees with all this, by any means. The church didn't connect "the world, the flesh, and the devil" without thinking it through, and the pioneer Québécois dancer-choreographer Ludmilla Chiriaeff once recalled to me a time in the 1950s when her children were refused admittance to a church-run school because their mother showed her legs on the stage. Those old socio-religious hang-ups about dance as something shameful are largely gone now, and many workers in the field of art for social change use movement to address cultural diversity, intercultural understanding, and individual and national identities. However, the essential nature of dance, rooted in the real but situated

in the non-literal, seems to inhibit its widespread acceptance in a society in which the word is paramount.

Not so with music. For many of us, music is our solace. You see with your eyes, you feel with your ears, as the choreographer Édouard Lock once put it. Consolation is one of the great gifts that listening to music can give us. For years, I've watched pianists play. If you concentrate on the hands, just the hands, as they dart up and down the keyboard, you can find yourself slipping into a zone of suggestibility where the hands are separate creatures, manufacturing this cascade of notes and melody that you are submerged in. In that zone, which is something like the hypnagogic zone between sleep and waking, you seem more vulnerable than normal to the emotional effect of the music. At least I do. If I watch a pair of hands playing a Chopin nocturne, or a polonaise, I transcend to somewhere quite else: the restraints of the day relent. Emotion is raw. The heart stirs, there's a bright fullness in my brain and I feel that if I want to weep I can. Chopin expresses, Liszt said, the sorrows we save for our secret communications with God.

What is it about music that can give us such deep emotional responses? Why do we find ourselves singing operatic arias or commercial ditties in the shower? The scientists can give us only limited answers. Is it biological, the release of feel-good hormones when we experience pleasurable sensations or empathize with someone else's pain? Pythagoras, who formulated the harmonic series and the scales that have for centuries framed Western human music-making, believed music had therapeutic qualities, and that mood could be

influenced by a change of key: in one famous tale he stopped a drunk from burning down a house by persuading a flautist to play soothing music. He was even said to have used music to cure illness, foreshadowing today's use of music in both mental and physical therapy (though we have perhaps moved beyond the Greek physician Aesculapius, who, legend says, treated sciatica and other nervous diseases by blasting out notes on a trumpet beside the patient). In 2011, a nuclear imaging study by researchers from McGill University showed that dopamine, the "feel-good" neurotransmitter that helps us think and plan, makes us curious and attentive, and embeds behaviours that we learn will deliver pleasurable rewards, is released in the brains of people who listen to music they enjoy.

For most of us, it's enough that music offers a safe, reliable place to get in touch with our feelings. It can lift us and leave us glad. It can induce delight and despondency, joy and melancholy. And it lets us know none of us are truly alone. Who has not been stirred by anthems, those striding, joyous choruses that seem to say that nothing is impossible, that the human spirit can conquer all, that whatever doubts and barriers you face, for this moment, at least, you can believe that all will come right in the end?

YOU'RE NOT GOING to like everything you see or read or hear, nor should you. Some of it may make you angry, or upset, or just leave you plain baffled. The famous unmade bed: what was that about? Christo and all that wrapping? You might be tempted to turn your back and move on. Some of the most interesting art you encounter may even make you shudder. I

have that response to some of Serrano's stuff: all those bodily fluids. I go away downcast and thoughtful from a roomful of Egon Schiele's brutal scratchings.

Shudder, but try not to turn away. By turning away, you deny yourself access to one of the ultimate functions of art, which is to help us see our world and our place in it. The most interesting work is often the work that challenges our preconceptions, makes us realize that the world contains possibilities beyond our current understanding. Stay flexible, open, receptive, even to ideas that might strike you as strange or stupid or repellent. The discovery of wonder is often random and surprising: a moment you didn't expect. I remember, from my days writing music criticism, going one lunchtime to review a recital by a bassoon soloist. I had much else on my mind, and I arrived tired and irritable. The recital lasted about an hour. Spending that time — being forced to spend that time — listening to the tender and careful unravelling of a handful of delicate and complicated compositions written and arranged for this beguiling oddity of an instrument took me entirely out of my workaday world. I left the concert hall refreshed and renewed, ready to take on whatever the rest of the day might bring.

Look around. Notice how much creativity has gone into the world you live in: the clothes you wear, the design of your cereal box, the colour of your toothbrush. Someone imagined what that window should look like. Someone designed the logo you tap to access your favourite app. Take away the product of the artistic imagination from our daily lives and the world would be a grey place. Change happens one person at a time, and so does creativity. Art hides away in unexpected corners, and the more you look the more you'll find.

It was Lawren Harris who said the arts "epitomize, intensify and clarify the experience of beauty for us as nothing else can." They do, and being drenched in the experience of beauty, whether it's music or movement or paint or stone, works its own sublime changes on us. As Plato and his pals will tell you, goodness and beauty have no regard for us, but if we give *our* attention to *them* there's a chance that we can internalize their influence in ways that will make us better — different — people. Beauty is always there somewhere, raw and bright, ready to drench us in its glow. All you have to do is let it be. We are incidentals with privilege, the privilege of being here, being alive. And all we are expected to give back, in exchange for that privilege, is curiosity and gratitude and the kindness that comes from the recognition of our shared humanity.

HOVERING OVER ALL this, of course, is the question of access. Article 27 of the Universal Declaration of Human Rights states that "everyone has the right freely to participate in the cultural life of the community, to enjoy the arts and to share in scientific advancement and its benefits." Currently, in Canada and elsewhere, this is not the case. For many reasons, cultural participation remains the privilege of a minority. Sometimes it's a matter of not enough time — sometimes, a matter of not enough money.

When Maria Rosario Jackson was appointed chair of the U.S. National Endowment for the Arts in January 2022, she said she would work to give people "artful lives" — which meant, she told *The Washington Post*, not only participation

as audience members, but also "making, doing, teaching, engaging ... Aside from the economic power and economic impact that they have, which is vitally important, there is a power of the arts that allows us to, encourages us to, be curious, to hold nuance, to have the kinds of thoughtful deliberations and a view on humanity that I think is so critically important."

One of the central elements of the new Canadian Cultural Contract proposed in this book is the creation of a fund that would enable Canadians to do exactly that — to feed the compassionate imagination in ways of their own choosing. Say that every man, woman, and child in the land gets $1,000 a year to pay for something, anything, to do with the arts and culture. Passive, active, it's your choice. It's not as revolutionary an idea as you might think. Dedicated government allowances for cultural activities are hardly new. Iceland, Spain, Italy, and France all provide some kind of cultural pass for teenagers, in amounts ranging from the equivalents of $430 to $720 a year, spendable on everything from books and music to concert tickets and movies. But those programs are aimed primarily at contributing to the survival of the pandemic-battered cultural sector. This new program would be solely intended to make it easier for everyone to afford a little art in their lives. Hold onto that idea, even if you have your doubts; we'll get back to it.

Money isn't the only tool we can use to democratize art. Canada's rural-urban split is acute; not all Canadians have equal opportunities to access live performance, even if they have the money to spend. But a next-best solution is waiting to be exploited. The new streaming technologies are only at

the beginning of their influence, but we already know they have the potential to transform our experience of the arts. How do we democratize that transformation to the benefit of Canadian creators and Canadian audiences? The idea of Canadian content quotas meant to guarantee exposure for Canadian creators has been worked over exhaustively, and the Canadian Broadcasting Act specifies that every broadcast undertaking make "maximum use, and in no case less than predominant use, of Canadian creative and other resources in the creation and presentation of programming." But we shouldn't stop there. The new communications technologies can deliver an onscreen theatre experience almost equal in quality and impact to a live event. Has the notion of a national broadcaster become an anomaly, as some politicians tell us, or could it be expanded to become a national online streaming distributor for everything produced by our professional arts organizations?

When we talk about access, we also need to rethink our assumptions about how we assess the quality of the artistic experience. In a society in which we expect everything to have measurable value, we are conditioned to prefer professionalism in the arts we support. When we buy a ticket to listen to an orchestra or to see a play, we expect a return on our dollar in terms of performance quality. The training and experience of the performers — their professionalism — promises the likelihood of quality; their work is monetized, and constellations of awards exist to let them know how much it is appreciated. But by putting professionalism on a pedestal in this way, we set art at a distance from our daily lives.

The unfortunate effect of our eager adulation of the professional is the loss of respect for the amateur. The root of the word is in the Latin for love; it originally signified an individual who indulged in a particular activity (not necessarily artistic) but had no formal training and did not practice it professionally. Its modern usage implies inferiority, dabbling, activities of no monetary value. Yet it is in the non-professional world of the arts that many find their greatest satisfactions. Being an amateur is more about the journey than the arrival: the gratification lies in the process itself, not the end result, whether it be performance or publication or exhibition. You may not be able to sing or paint worth a damn, but you're likely to appreciate singing or painting more if you spend time enjoying the doing of it.

From earliest times, non-professional folk have performed stories for each other, and found in that sharing a sense of fellowship and courage. The church was always a place where a community could find living depictions of the holy tales, in the statuary and the iconostases and the great stained-glass windows. By medieval times the artisan guilds — bakers, carpenters, masons — were travelling round Europe performing stories from the church calendar in the streets. Some of the English "mystery" plays are still performed (the guilds of York present the famous cycle of forty-eight York plays on wagons throughout the city on a four-year cycle) and the tradition of the community religious pageant, in which non-professionals join forces to put on a show, remains strong; I acted in several in my youth. Perhaps the most famous surviving example is the Oberammergau Passion Play, in which the entire population of

a Bavarian village comes together every ten years to re-enact Christ's passion.

Here's another twist on the amateur-professional question. Vancouver's Boca del Lupo theatre company has always pushed the theatrical envelope, stressing diversity and inclusion in its writing and casting, often taking the experience of theatre beyond the conventional proscenium stage. When the pandemic restrictions took effect, effectively erasing the sense of group communion that is at the heart of live theatre, Sherry J. Yoon and Jay Dodge, the company's director and producer, created Plays2Perform@Home. It was the theatre version of restaurant takeout: boxed sets of four short plays, with copies of the script for every character, for performance by small "bubble" groups — families, close friends — in any place they chose, with or without an audience. The project pushed the experience of participation a step further, challenging assumptions about the passive nature of the audience, eliminating the artificial gap between the professional and the amateur, and offering an intriguing new variant on imagining what it's like to walk in someone else's shoes. The idea was so popular that the first set, featuring playwrights from Western Canada, sold out, and in 2021 Boca del Lupo went national, joining six other theatre companies across Canada to produce four more boxes, featuring a total of twenty playwrights.

What also lives and thrives, under the professional radar, is the community play. The idea of a community coming together to tell tales of its history and the people who animated it, and even to shine a spotlight on the troubles that might beset it, began to seriously catch on in England in the 1970s. One of the first community plays in Canada was *The Spirit of*

Shivaree, written by Dale Hamilton of Rockwood, Ontario, and performed by Eramosa residents at Rockwood Woolen Mill in June 1990. The play, which enacted episodes from the township's history, was created in response to plans to turn the rural district into commuter suburbs for Toronto. Several company members subsequently became involved in municipal politics and helped develop an alternative town plan. The community play movement now covers Canada, with many companies devising their own variations, though one element is common to them all: the principle that, as the Toronto-based Jumblies Theatre puts it, they "place partic ipation and radical inclusion" at the core of their projects. "We say *everyone is welcome!* and embrace the joys and challenges, social and aesthetic, of meaning or trying to mean it."

Telling community stories through community engagement is the driving force behind the Heart of the City Festival that has been staged by Vancouver Moving Theatre for close to two decades. Interdisciplinary artists Terry Hunter and Savannah Walling are long-time residents of the city's Downtown Eastside, historically the first centre of the city but today Canada's poorest postal code and long regarded as a hotbed of hard drug use, homelessness, and the sex trade. They founded the festival to provide a place for their neighbours to tell their stories and to create, in their words, "shared experiences that bridge diverse cultural traditions, social groups and artistic disciplines" through stories that "tackle emotionally-challenging territory such as the roots of addiction and recovery, racism, homelessness and the legacy of residential schools." When Walling and Hunter started the project, with a community-created play about the history of the district, gentrification was setting

in and globalization was changing the area's demographics. They encountered a host of assumptions about amateur art making, "high-art taboos against popular entertainment" and fears that collaboration would dilute quality. But they also found enthusiastic buy-in from the area residents, and the annual festivals have become sustained outbursts of shared creative energy, with productions ranging from a community opera about addiction to an eleven-year-old rapper's eyes-wide-open song to the streets that are his home.

In Europe, this emphasis on amateur engagement has led partners from five countries to explore the potential of what they call Urban Arts Education, a discipline that combines arts education and social work as a tool for social inclusion and helps low-skilled and socially vulnerable individuals to integrate into life in large, densely populated urban areas, ultimately supporting community development. In London, for instance, a bus equipped with a recording studio goes into the city's service-deprived housing estates and gives hard-to-reach young people a chance to be creative. In Portugal, participatory photography workshops become tools for social inclusion of migrants and refugees by letting them create images to communicate their needs and share their realities. In Iceland, creative writing workshops give a voice and a communal space to immigrant women victims of domestic abuse. In Slovenia, textile designers integrate isolated and low-skilled immigrant women from the ex-Yugoslav countries through knitting and handicraft. In Vienna, the Firefly Club trains people with cognitive disabilities to become DJs, and acts as their agent for bookings. A 2023 report on the four-year project stressed that the value of these and similar

projects lies in the process of individual empowerment, not the quality of the final product: "The essence of Urban Arts Education is building human connection through art ... crucial for the social development of every country."

Yet another twist on the idea of the democratization of art making was a television series launched in response to the COVID-19 pandemic by the UK artist, broadcaster, and cross-dressing potter Grayson Perry and his psychotherapist wife Philippa. *Grayson's Art Club* featured artworks submitted by viewers, displayed alongside works by the Turner Prize–winning Perry and his celebrity friends. "Art can help get us through this crisis," he said at the start of every program. "It can help us explore our creativity, inspire and console us, and tell us some truths about who we really are." The work didn't have to be "good," he told an interviewer, but it had to be "heartfelt and enjoyable. We're not saying make art like a professional, we're saying get stuck in and lose yourself a while in it." Viewers got stuck in by the tens of thousands, creating what he called "a strange panel-picture of Britain, now ... generous ... tolerant ... vulnerable ... great qualities for making art, and great qualities for being citizens of the future."

IN ONE OF her essays, Mary Oliver wrote: "The most regretful people on earth are those who felt the call to creative work, who felt their own creative power restive and uprising, and gave to it neither power nor time." People who engage with creative activity don't have time for regret. They enjoy the satisfaction of doing something that lets the soul come

out to play. The next time you listen to a piece of music, or watch a video, write down the things it brings to your mind. Anything at all. Maybe it makes you want to dance. Or cry. Or laugh. Or find someone to kiss. The next day, do it again. After a while, you'll have a collection of these lists. And when you read them over, you'll begin to see how widely and how deeply you are influenced and affected by the art that is all around you. Make it a habit. Steinbeck thought habit was a much stronger force in writing than either willpower or inspiration, and look at the wonderful stuff he left us.

The first requirement is the simplest: attentiveness to what the artist has to say. Try to be what Henry James called someone on whom nothing is lost. Then there is the willingness to be open to the connections the artist is offering, and to justify in words your intuitive, gut reactions. That ability to explain *why* and *how* is what separates a deepening appreciation from the of-the-moment opinions we exchange as we're putting our coats on. But beware: the idea that a table of standards exists against which art can always be measured is another red herring. Escape into the future, the exercise of the imagination, is the artist's central nature. Much of what we call art is a kind of early warning system of what's to come. That's what makes it so important, and so scary. How can you fix standards or make a template for that? What you'll find when you ponder these experiences is that you become more attuned to aspects of other people that you hadn't noticed, little human truths that let you understand them in a more sympathetic way: putting into words your own growth and change. As for the words you choose to express all this, give wit room to play; have fun. Appreciation is bias, predilection,

ignorance, enthusiasm. The best you can do is cleave to your own evolving vision of what succeeds for you as art and what doesn't. So long as what is said isn't based on petulance or name-calling or the angry response of a hurt human animal, I defend the right of anyone to say anything about what they've experienced in the theatre or the gallery or between the pages of a book. Even if they disagree with me. *Particularly* if they disagree with me. That's when the intelligent fun begins.

Why Can't We Talk to Each Other?

O, wad some Power the giftie gie us
To see oursels as others see us!
— Robert Burns, "To A Louse, On Seeing One
on a Lady's Bonnet at Church"

BURNS HAD IT right. Knowing what others think of us would be a wonderful gift. Hardly less important is the ability to see others through their own eyes. But we are immensely complicated creatures and recognizing our shared humanity is sometimes a difficult trick. We live in a world where truth no longer means what it once did. Inhuman atrocity is so commonplace it barely makes the news. We hide from the Other behind a barrier of disparagement and disregard for fear of what we imagine they might say or do to harm us. How do we nurture the soul in such a corrupted world? Is there a place where the human spirit can find redemption and refreshment? How do we maintain a sense of wonder? How do we nurture compassion in a world that has become a braying cacophony of competing sound bites, fake news,

and atrophied certainties, where everyone asserts and no one listens?

Modern Canadian society is deep in a bubbling cauldron of social recalibration as we struggle to come to terms with decades of injustice and disenfranchisement and unconscious privilege. The outcome of that process is still uncertain, but it will lie in finding ways to recognize and celebrate our variousness in all its sometimes-troublesome glory, without fear and without prejudice.

Being compassionate means being able to talk to each other in a civilized way about the ideas we have. Being compassionate means learning not to judge without thinking — very little that we see or hear is what it seems. Being compassionate means taking a chance on trust. Being compassionate means taking a moment to recognize that an unexpected accident or an ill-thought decision can upend anyone's day. Life is unpredictable, however much we try to get a handle on it. Yet our automatic response is to dismiss people who don't match up to our own precious principles, to blame them for falling short of our expectations and judgments. It's a way, psychologists say, for us to feel good by feeling superior: we're certain we'd never do anything so stupid.

Judging without thinking gives us an excuse not to get involved. Not getting involved is a habit we fall into because it protects us against all the things we fear about commitment, about intimacy, about making our thoughts and feelings known. Fear that we have nothing worthwhile to say. Fear that if we do say something, the people we talk to will ridicule or disrespect us. Fear that what we say will be held against us

in some way. Fear that whatever the question is, we'll get the answer wrong and be scorned for it.

Fear corrodes our confidence, our belief in ourselves. It stunts our ability to act. It keeps us quiet in the very times when we should be making our feelings known. It makes us mean of spirit and unwilling to make allowances; it stops us from experiencing compassion. Afraid, we become cut off from the infinite possibilities of the world, from adding our own contributions to the sum of human achievement.

Grudges and grievances are powerful drivers of argument. Whole swaths of the world's population clamour for the chance to have a better life. It's only so long before disappointed hope turns to resentment. Some days, to judge by the evening news, it seems we're all victims of something. Angry, stressed people can't think straight, can't *feel* straight. As the sociologist Zeynep Tufekci put it in an article in MIT *Technology Review*, "polarization has eaten a lot of our brains ... We bond with our team by yelling at the fans of the other one." In an ecosystem where the sense of identity conflict is all-consuming, "belonging is stronger than facts." In an era of fake news, we're easy prey for agents of misinformation and disinformation to home in on our vulnerabilities. In such a climate, conspiracy theories thrive, and the more people outside our group dismiss them as nonsense, the more we are convinced the stories are right. As Marshall McLuhan reminded us sixty years ago, a point of view can be a dangerous luxury when substituted for insight and understanding.

Some researchers have argued that fear of the Other is linked to a fear of moral or social pollution by elements that

will affect a society's health. In an interview with Thomas B. Edsall in *The New York Times*, one of those researchers, Lene Aarøe, a professor of political science at Aarhus University in Denmark, explained how, in addition to the physiological immune system, which fights infections once they have entered the body, our species has evolved psychological motivations to help us avoid coming into contact with infections in the first place: the behavioural immune system. These psychological mechanisms, operating at the unconscious level, "work through emotions of disgust and fear of disease and motivate people to respond with avoidance and distance-taking in the face of potential infection risk." That response can translate unconsciously into fear of moral or social contamination by foreign elements, and can reinforce unwillingness to endorse diversity and immigration or any form of engagement with the Other. It has only been intensified by the distancing forced on us by the pandemic.

Developing compassion for each other is our best chance at finding a way out of the mess the world is in. Seeing the world through someone else's eyes, by the simple act of reading a book, watching a movie, or listening to a song, is the first step away from fear and demonization of the Other. Sharing our imaginations through creative activity — letting our own imagination out to play for other people to share — lets us explore other people's realities. We tiptoe into a world that is private and precious to someone else, and, in so doing, we get a hint as to why that world is special. At the same time, we make space in our minds and hearts for people who don't think the way we do. Sharing someone else's vulnerability — recognizing

their humanity — empowers us to show ours, and trust has a chance to flower.

All the tools for building trust — being open and non-judgmental; listening respectfully, even if you don't agree; doing what you say you'll do; admitting your mistakes; speaking from the heart — can be developed through creative activity. Many social-issues art groups routinely get participants to participate in trust-building exercises even before they start their workshops and collaborative performances. The Power Plays that David Diamond's Vancouver-based Theatre for Living has created within communities for decades are often sparked by these theatre games and exercises. The participants are asked to examine moments of struggle in their own lives, and to collaboratively build plays about the issues that are most important to them and their communities.

Obviously, not everyone takes to this process easily. Most of us shrink from personal exposure to the group; surveys have shown that public speaking is for many people a greater fear than death itself. But our willingness to clear a space for another person's ideas, to understand that there are ways of seeing that are different from our own, is a measure of how responsive we can be to alternatives. Will they change our views? Perhaps not. Will we like those people more? Perhaps not. But at least we'll know what they think and how they reach the conclusions they reach. As any musician will tell you, harmony is not exact sameness. Respecting difference is at the root of respectful relationships, be they between individuals or between social groups. Engagement with creative expression lets us experience and understand those differences safely.

It's also about having compassion, beginning with compassion for ourselves. Being comfortable enough to let our guard down means being comfortable with our own conflicting ideas and impulses, being able to accept our ambivalent or contradictory thoughts. Commercial consumer culture doesn't encourage second thoughts or reciprocal sacrifice. We are expected to stake out a position, and people who take their time to weigh the pros and cons and look at a question from all sides are called out as ditherers or procrastinators, unwilling to make a commitment. They are challenged to "stand up and be counted," as if that is a reliable measure of their bravery and strength of conviction. But few of the choices we face personally, or the problems that stir up public debate, have immediate yes-or-no solutions. We need the courage to render ourselves vulnerable enough to have our minds changed. Art, with its constant challenges to the status quo, is the perfect app for that.

EMOTIONAL WELLNESS IS another important aspect of our lives that doesn't get enough serious attention in a world based on competitive advantage and economic growth. We're trained to hide our hurts, which we call bravery in the face of adversity. But this kind of emotional pressure plays havoc with our physical and mental health. Cortisol, the stress hormone, can increase the risk of heart disease, and scientists are discovering that the social and personal stresses of the long-term isolation and uncertainty caused by events like the recent pandemic can shrink our grey matter. A report released by the Canadian government on the first anniversary of the COVID-

19 lockdown showed major depressive disorder, generalized anxiety disorder, or post-traumatic stress disorder (PTSD) in one in five Canadians eighteen and over. We are in what Toronto dancer and choreographer Shannon Litzenberger calls "an epidemic of psychological decline."

But Litzenberger, who conducts workshops on creation, innovation, and leadership for the Banff Centre for the Arts and Creativity and for the Pierre Elliott Trudeau Foundation, argues that the root cause of the problem is the post-Enlightenment worldview that mind and body are separate. "It's neither possible to uncouple mental and physical health, nor is it possible to uncouple the health of a living being from the health of its environment," she wrote on *Medium*. "The disembodied culture we are embedded in — the Western, neoliberal, post-industrial, hyper-capitalist world shaped by values of progress, production, and the externalization of human value — is making us sick." The stress of surviving in this world makes us "myopic, ego-driven, craving of pleasure, praise, and reward. We retreat into our respective ideological corners where we feel validated and understood." We need to slow down and restore our natural capacity for resilience. "When we are well," she writes, "we embody a natural state of open expansiveness where we can simultaneously feel both calm and energized ... in touch with ourselves and also open and receptive to others and to the world around us. In this state we are curious, creative, and able to hold multiple, even contradictory, perspectives. We are collaborative and able to learn and evolve. We can imagine a positive future."

Unfortunately, we are so conditioned to disappointment that it's all too easy to fall into the trap of negative anticipation.

The store will be sold out before I get there. The boss will expect me to want to work on my daughter's birthday. Regret for what is over and done, or fearfulness about what might come to be ... they are not only self-defeating, they are corrosive to the spirit. They block our access to happiness. Matters are so dire that in 2022 a law firm in London, England was reported to be considering the appointment of a Chief Happiness Officer, to counter office stress and employee burnout. At Yale University, the most popular course in the university's history is Psychology and the Good Life, taught by Yale cognitive scientist and psychology professor Laurie Santos. The course explores how the study of psychology can lead us to a happier, more fulfilling life. It was adapted in 2018 into a podcast series, *The Happiness Lab*, that by 2022 had been downloaded over sixty-four million times.

How do we counter these trends in our population's psychological decline? Psychiatrist Iain McGilchrist says he has found that a recipe to heal almost all his patients "is not forcing things to be the way they would like them to be, but to embrace the way that they're likely to be and doing those things that will help that forward." Research has shown, he says, that mindfulness and meditation — being alive in the moment rather than feeling bad about a past you can't change and chasing after a future you can't predict — bring the rational side of the brain more into balance with its empathetic, creative counterpart.

The rise in popularity of mindfulness and similar self-regulating techniques might also be society's response to the need for spiritual succour in an age of irony and doubt: some way to believe without the necessity to commit to a specific

divinity or organized religion. When Allen Ginsberg once asked Leonard Cohen how he could reconcile his Judaism with Zen Buddhism, Cohen said that he wasn't looking for a new religion; he was well satisfied with the religion he had. For him, Zen was a discipline rather than a religion. It made no mention of God; it demanded no scriptural devotion. It was an investigation of the heart of existence. Truth. Goodness. A generosity that cushions us, a force far beyond our understanding. The elemental life force: the desire to make it possible to continue, rather than the opposite. All of which we used to call "God." Quoting Jung's dictum that "The artist is not a person ... who seeks his own ends, but one who allows art to seek its purpose through him," the Centre for Applied Jungian Studies in Johannesburg offers a six-month course that explores "art and creativity as a psycho-spiritual journey."

Drawing on what she learned through her long career as an expressive dancer internationally acclaimed for her emotionally rich, free-spirited choreography, Canadian dance icon Margie Gillis works extensively in the areas of dance therapy (healing through movement) and guided movement meditation. From 2009 to 2013, she joined conflict resolution experts, mediators, counsellors, and other artists in a Swiss investigation of how the expression of emotion through the body could help negotiators understand how to resolve political and interpersonal conflict. She wanted, as she said in a book that emerged from the process, to encourage people "to think not only about the body, but with the body."

There is an obvious overlap here with the therapeutic and spiritual benefits we get when we engage with art and creativity.

Most of us know, from our own anecdotal experience, how reading a book or looking at art can relieve the stress in our lives. It lets us take our minds off our immediate problems: our heart rates settle and our anxiety abates. The therapeutic value of poetry, for instance — as reliever of stress or inducer of heightened experience — has been recognized since the times of Plato. The philosopher John Stuart Mill thought Wordsworth's poetry was "medicine for my state of mind."

Extensive studies demonstrate the indisputable benefits of art therapy in settings as various as hospitals, prisons, schools, and care homes, for treatment of everything from addiction and physical trauma to grief, depression, and developmental disorders. Artistic activity is frequently integrated into the daily lives of the elderly and those suffering cognitive decline, often involving them directly through their own creativity and storytelling. Story-making and role-playing are also seen as safe ways for newcomers to caregiving, or even experienced medical and care staff, to explore the various potential scenarios they might encounter, and to learn human-centred strategies to de-escalate crises and to treat patients who find it difficult to communicate.

Dance has been shown to improve balance, coordination, and cognition, to the extent that Scottish Ballet has been offering dance health classes for victims of multiple sclerosis, dementia, and Parkinson's disease since 2015, including, in 2022, a program in the Orkney Islands, whose residents have one of the highest incidences of multiple sclerosis in the world. In 2022, Osteoporosis Canada launched a bone health dance program in collaboration with the National Ballet School.

We are all aware of music's emotional powers and its usefulness as a socially bonding mechanism: movie makers, marketers, and megalomaniacs have always manipulated music to move the masses. But music also has therapeutic charms. Health professionals know it to be an effective tool for pain management both during and after surgical procedures. We know that taking music lessons early in life builds neuroplasticity and can improve outcomes for people who experience stroke later in life. Researchers are also starting to explore music's value as a cost-effective and readily available therapy for patients with early-stage cognitive impairment in the areas of memory, focus, and understanding. University of Toronto researchers have shown that brain plasticity can be improved in patients with mild cognitive impairment or early Alzheimer's disease when they listen to music that has special meaning for them. (Capilano University, Canadian Mennonite University, and Acadia University are among several Canadian universities offering degrees in music therapy for individuals planning careers working with individuals with challenges such as autism, Parkinson's, and dementia.)

At the University of British Columbia, professor Nancy Hermiston, director of the opera program, is leading a team of researchers exploring whether opera training can rewire the brain. In a first for North America, the three-year Wall Opera Project brought together experts from both the humanities and the sciences — the faculties of arts, medicine, education, science, and applied science — to measure the way the brain of an opera singer works. "We know that students who train in opera demonstrate remarkable plasticity of the brain," said

Lara Boyd, one of eight principal investigators. They hope the findings from their indexing of singers' brains through MRI and EEG scans will provide data on memory, learning, and executive function with potential applications in education, rehabilitation, and preventive health.

Recent research also suggests there's a link between listening to music and interpersonal empathy. A study by psychologist Benjamin Tabak and musicologist Zachary Wallmark, both involved in neuroscience research, suggests that "music-making is much more than simply a fun way to pass the time — it could be intrinsically connected to how we process our social world." In an ongoing project sponsored by the Grammy Foundation, they are examining whether emotional understanding of both people and music is facilitated by the same mechanisms in the brain — and, if so, whether those overlaps would enable the use of music to treat "those with disorders that involve difficulties in understanding and responding to others' feelings."

Music is also a powerful tool for releasing the compassionate imagination. Its ability to convey emotion in an abstract way enables us to express what we might otherwise not be able to. Hussein Janmohamed, a University of Toronto composer, singer, and choir conductor uses music to "build dialogue across cultures and express individual identity in a pluralistic society." Singing in choirs, he says, helped him transform the negative influences of racism he experienced as a child into positive feelings of belonging. He creates interactive choral events that support socio-spiritual development for schools, businesses, and community groups, and presents

performances that explore the dialogue between the sounds of Muslim devotion and the music of modern Canada.

David Lemon, a former insurance underwriter and Vancouver record store owner, set up the Health Arts Society in 2006 to present professional performances in residential care settings when he noticed that friends and family members in end-of-life care missed the cultural environment they had previously enjoyed. It was, he said, simply a matter of "normalizing" the lives of people in care, providing "music performance at a high level for the pleasure of audiences too frail to leave their institutional homes."

Health Arts Society, through its Concerts in Care programs, is today the country's largest provider of live professional arts programming for elders, though it switched many of its programs to Zoom during the pandemic — enabling musicians to continue to work, and isolated audiences to stay connected to their musical lifeline. The concerts delivered unexpected benefits. Following a recital by pianist Robert Silverman at a Vancouver care facility, a resident in a wheelchair approached Lemon and Silverman, mentioned that he was a composer, and showed them a collection of song scores. When Silverman looked at them, he discovered "a true gem," which Lemon arranged to have scored for an ensemble and presented at a public concert at the Chan Centre for the Performing Arts. The work was given a standing ovation. It was "a memorable event in all our lives," recalled Lemon. The composer died three months later.

Health professionals have long been aware of the beneficial effects of art and design in hospital environments. The

British non-profit Hospital Rooms commissions internation-
ally famous contemporary artists — including Anish Kapoor
and Julian Opie — to create art specifically for display in psy-
chiatric hospitals, often involving patients in the process. The
range of modern art on the walls and in the public concourses
of institutions like the Vancouver General Hospital, Saska-
toon City Hospital, and Toronto's Centre for Addiction and
Mental Health make them feel more like public galleries than
clinical settings. St. Boniface Hospital in Winnipeg operates
the Buhler Gallery, what it calls "an oasis of contemplation,
healing, and rejuvenation" that has attracted more than one
hundred thousand visitors since its 2004 opening. In 2009,
cardiologist and artist Ian Penn and his wife Sandy Penn
Whitehouse, a pediatrician and adolescent medicine doctor,
pushed the Vancouver General Hospital public art concept a
step further, establishing an annual $5,000 award that chal-
lenges young artists to create site-specific works which will
aid healing at health care facilities. The impact is twofold: the
environment for patients, families, and staff is enriched, and
the artists are encouraged to think about how their work fits
in the broader social context of health and healing.

Other programs approach the art-health intersection from
the opposite direction. At the UBC Faculty of Medicine, stu-
dents engage with the contemporary art at the university's
Belkin gallery to strengthen skills in observation, which are
obviously connected to diagnosing; skills in description and
communication, essential to the doctor-patient relationship;
and, through their experience of artworks that often have no
story or evident explanation, their ability to speculate and
handle ambiguity, a challenge for any diagnosing doctor.

At the University of Alberta, the faculty of medicine and dentistry uses the arts and cultural studies to broaden the insights of student health professionals into the human and socio-cultural dimensions of health care and "help foster understanding, care and compassion, self-reflection, action and advocacy." Students can choose electives in subjects such as philosophy and ethics, history, spirituality, anthropology, sociology, and cultural studies.

At North Vancouver's Presentation House Theatre, director Kim Selody, a veteran producer of theatre for young audiences, created a program called Golden Firefly to bring seniors together to craft narratives from their experience and act them out. He saw it as an alternative to the traditional occupational-therapy approach used at many seniors' homes, and found that participants became "addicted to the adrenalin rush of using their imaginations. They also developed a critical sense, became more engaged." There have been striking outcomes, some around sexual orientation — "people who had lived their lives in secret came out and created extremely powerful metaphor" — and when the seniors shared their work with a parallel children's group, one of the elders showed such a knack for entertaining and communicating with the kids that he became an ambassador for their program. "He had always imagined himself doing something like that," says Selody. "This ignited him and changed his life."

Jan Derbyshire is a Canadian stand-up comic and multidisciplinary artist whose theatre events promote ideas of diversity and belonging, with an emphasis on mental illness. Her show *Funny in the Head* dealt with her experiences with bipolar disorder. In *Certified,* she enlisted her audience to

take on the role of her mental health review board and assess her sanity. Workman Arts, which claims to be the oldest multidisciplinary arts and mental health organization in Canada, was founded in Toronto in 1987 as a group of eight performers who wanted to improve public understanding of mental health and addiction. Today close to five hundred members produce original plays and exhibitions by artists "with lived experience" of these issues. The Art Studios in Vancouver is a long-term provider of art-based programs for people with mental health issues. Established in the late 1990s by Vancouver Coastal Health, it provides art classes to help develop confidence and social skills, with the focus on the process of creation and what it reveals, rather than on a finished product.

Burnt-out health professionals themselves turned to art therapy during the pandemic. Ontario's Fleming College offers courses on its Haliburton campus in everything from ceramics, fibre arts, and digital image design to glass-blowing, jewellery making, and "artistic blacksmithing," some of them specifically tailored to encourage self-expression by professionals in psychology, education, and health care. In 2021, Vancouver's Indian Summer Arts Society established a three-year "artist as healer" program in which South Asian artists of any discipline received a bursary to work with health care professionals or wellness mentors to create an event, workshop, or interactive project that could become part of the health care system. "There was a time when all artists were healers," said Indian Summer's co-founder, Sirish Rao, in an interview with the Vancouver magazine *Stir*. "So I feel like we're coming back to that original intent, which is to really give the artists the space as healers in society."

The Montréal Museum of Fine Arts has gone further. Extending the museum's function far beyond the traditional stand-in-awe display of great works, former chief curator Nathalie Bondil introduced a program enabling doctors in Québec to prescribe a free trip to the museum as a mental health treatment. *Not feeling up to par? Visit the art gallery and call me in the morning.* The museum also operates the largest art education and therapy centre in North America, specializing in dementia and teen eating disorders, and maintains an open-to-all studio fully equipped for individual art making. The program has been so successful, it has been adapted for use by health authorities in Europe.

In the UK, the National Health Service has conducted several studies of social prescribing in which young people waiting for mental health care are given the opportunity to take part in dance, music, sport, and exercise. Early results have suggested participation improved personal and mental well-being, reduced loneliness, and reduced participants' sense of stigma around mental health challenges. In 2020, Arts Council England and the National Academy for Social Prescribing co-sponsored a fund to support community activities — including arts and culture — that promote well-being. Also in the UK, the National Health Service is funding Comedy on Referral, a course in stand-up comedy that uses games, group, and one-to-one work to help people recovering from mental illness, postnatal depression, PTSD, and anxiety disorders to analyze, write, and perform stand-up comedy sets based on their personal stories.

Iceland provides another interesting example of how involvement with the arts can have broad social and individual

benefits. At the turn of the century, Icelandic teens were noto-rious across Europe for their drinking. Yet, fewer than two decades later, the percentage of problem drinkers in the fifteen-to-sixteen-year-old population had dropped from almost fifty percent to five percent. Smoking among teens showed similar reductions. The reason? The kids had been shown how to get high naturally — by getting involved with the arts.

The turnaround began with an idea that grew from an American psychology professor's research into brain chemistry. When he was an intern in psychiatry at Bellevue Hospital in New York in the 1970s, Harvey Milkman noted that young people developed drinking and drug habits because they were addicted to the changes in brain chemistry created by the drugs. Might it be possible to get teenagers to replace poten-tially damaging drugs with natural high alternatives derived from engagement with art? In 1992, he and some colleagues launched a program that aimed to counteract drugs and crime through classes in music, dance, and visual art rein-forced by life-skills training and sport. In Iceland, where no amount of earnest educational programs had put even a dent in the epidemic of teen addiction, Milkman's ideas struck a chord. Under a new national plan called Youth in Iceland, the federal government set aside new money for sport, music, art, and dance, including a Leisure Card that gave families 35,000 krona (about $340) a year per child to spend on rec-reational activities. The project was so successful in reducing teen substance abuse that it has become a standard program in schools and communities, and the model has been picked up in more than thirty countries.

Would something similar in Canada help deal with school bullying, gang problems, even learning difficulties? We might get fresh insights from a program at the Vancouver Art Gallery. In 2022 the Vancouver-based April 1 Foundation gave the VAG $1 million to waive admission fees for anyone aged eighteen and under for the next five years. The gift will improve accessibility for thousands of youths of all ages and backgrounds, said VAG director Anthony Kiendl. At the same time, a program called Kids Take Over displays art from the gallery's collection alongside texts and drawings by local students, and turns the gallery's rotunda and alcoves into interactive spaces — fostering creative thinking and problem solving at precisely the time when the young mind is at its most flexible and has not yet been infected by the germ of adult cynicism.

What's the common thread of support and funding that links all these examples of the compassionate imagination at work in the world of health care? There isn't one. But in 2019, the World Health Organization published a global survey of two decades of studies and analyses such as these, showing how the arts impact both mental and physical health under two broad themes — prevention and promotion, and management and treatment — and recommending a number of actions. They support the use of arts interventions where convincing evidence exists, such as the use of recorded music for patients prior to surgery; arts for patients with dementia; and community arts programs for mental health. More broadly and probably more effectively, the WHO recommends ensuring that culturally diverse forms of art are available and

accessible to a range of different groups, and they encourage arts and cultural organizations to make health and well-being an integral and strategic part of their work. They also advocate for collaboration between the culture, social care, and health sectors through lines of referral from health and social care to arts programs; prescribing schemes; and the inclusion of arts and humanities education in the training of health care professionals. All these recommendations should be integrated into the policy framework of the new Canadian Cultural Contract.

Knitting Our World Together

By distilling complex and often contradictory truths
from the diverse experiences of our fellow humans, theatre
can be as vital to our democracy as it was to that of the ancient
Greeks. Unlike the echo chambers and keyboard warriors of social
media, its emotional immediacy offers us visceral experiences of
other points of view, encouraging empathy in times of
widespread extremism and intolerance.
— Antoni Cimolino, artistic director, Stratford Festival,
quoted in *The Philanthropist Journal*

ARTISTS HAVE ACTED as agents of instruction or social change since the time of the Greeks, if not long before. Aristotle said plays like Sophocles's *Oedipus* trilogy were intended to create a sense of pity and terror for their flawed, human characters, so that audiences would feel a catharsis of their own emotions — "There but for the grace of God go I" — and take moral lessons from the tragic tales. The mystery and miracle plays of medieval times taught virtue from the back of a cart. The rude buffoons of the *commedia dell'arte* pointed taunting fingers at the silly and the self-satisfied. And by the time

Shakespeare wrote his last plays he was probing moral ambi-
guity to depths that contemporary psychology might envy.

Like advertisers, artists have also long known that the
well-chosen word, story, and image help the public process
information more effectively and absorb it more deeply. We
are more easily persuaded. Milton taught grave moral lessons
in dramatic epic poetry; Voltaire, Swift, Molière, and Cervantes
used the sharp edge of satire to puncture the overinflated, and
the novels of Balzac, Dickens, and Zola whipped up public
indignation through their detailed and sympathetic portraits
of the lives of the nineteenth-century poor. A direct line runs
from Goya's famous call to the public conscience, *The Third
of May, 1808* (a marker of Spain's resistance to French occu-
pation) to Picasso's *Guernica,* which bears witness to the
bombing of the Basque town during the Spanish Civil War.

Art of this kind isn't overtly polemical, or shouldn't be,
because it doesn't need to be. It shows; it doesn't tell. That's
what gives it power. But in the twentieth century, we saw the
emergence of a form of art that was deliberately made for
the purposes of social improvement: agitprop. The word was
coined in Russia (a contraction of the title of the government
ministry responsible for its production, the Department for
Agitation and Propaganda) to describe art created to spread
the good word about Communism. Agitprop trains toured
the countryside with actors staging message plays in the
villages; politically constructive theatre and art shows were
staged on agitprop riverboats.

Soon, artists like Bertolt Brecht, Kurt Weill, and the
German artist George Grosz, with his grotesque visions of
Berlin in the 1920s, were turning agitprop on its head, using

theatre and the visual arts to expose the iniquities and inequities of the socio-economic state. Writers like George Orwell, Margaret Atwood, Nadine Gordimer, and James Baldwin, and playwrights as diverse as Ibsen, Shaw, John Osborne, Athol Fugard, August Wilson, Lorraine Hansberry, Wendy Wasserstein, Ntozake Shange, and Larry Kramer and his powerful LGBTQ+ rights plays in the U.S., represent just a sampling of those who have used art to urge us to rethink the way we organize our societies and reimagine our collective future.

The use of theatre as a vehicle for the re-examination of our moral and social priorities has always been a mainstay of Canadian drama, and the great social dilemmas of our time — race, gender, justice, poverty — provide fertile ground for our writers' imaginations. Paul Thompson and his Toronto company, Theatre Passe Muraille, developed an influential form of collaborative social-issues theatre on Canadian themes through works like *Doukhobors*, *The Farm Show*, and *1837: The Farmers' Revolt*, created with Rick Salutin, another writer deeply concerned with social injustice. The Montréal playwright and novelist Michel Tremblay, who put *joual*, Québécois working-class slang, on stage for the first time, in plays like *Les Belles-Soeurs* and *Bonjour, là, bonjour*, is widely regarded as a contributor to the transformation of Québec society following the Quiet Revolution of the early 1960s, though he refuses to be identified as a spokesman for the province. "I am not Québec, I am not Montréal, I am not even a district of Montréal," he told me once. "I am one street, perhaps." Tomson Highway's plays, particularly the award-winning *The Rez Sisters* and *Dry Lips Oughta Move to Kapuskasing*, have done much to put a human face on

Indigenous challenges. Ravi Jain and his mother shone a personal light on the generational and cultural divide in immigrant South Asian families in their international two-hander hit, *A Brimful of Asha*. Brad Fraser has become one of Canada's most consistently produced issue-theatre playwrights, bringing a tough, frank humanity to topics like disability (*Kill Me Now*) and the search for connection and relevance in contemporary Canada (*Unidentified Human Remains and the True Nature of Love*).

The tightrope line between preaching and persuasion is a risky one to negotiate. But Vancouver playwright and actor Marcus Youssef, artistic director of Neworld Theatre, believes that if theatre is to engage its audience at the most fundamental level of awareness and connection, it must involve some form of risk, perhaps by experimenting with new forms of theatre, perhaps by confronting us with uncomfortable social or political quandaries, even by collaborating with artists whose intellectual disabilities situate them far from theatre's mainstream. "Theatre offers us communal pleasure in the unfiltered, corporeal presence of our own fallibility, absurdity, and joyful, tragic, unknowable humanity," he says. Two Neworld productions, *Peter Panties* and *King Arthur's Night*, were created by Youssef in collaboration with his friend Niall McNeil, who has Down syndrome. McNeil is a writer, says Youssef, although he writes at a grade one level. They devised a conversational method for writing together in which Youssef could define structure and edit material without changing McNeil's words. *King Arthur's Night* toured internationally, and both shows drew widespread praise from critics and audiences for their honesty, freshness, and

the insight they provided. Which is another way, of course, to describe compassion.

IN RECENT DECADES, we have also seen the emergence of a global brigade of artist-activists who use collective creative activity to give not only a voice but also a language to those who have been mute, helping individuals and communities become catalysts for change in their own right. In the words of Vancouver dancer-choreographer-activist Judith Marcuse, who has spent much of her career working with dance and theatre for social change, collective community art making "is a form of social innovation, generating dialogue, insight and action through the creation of metaphor ... Different, often non-verbal, out-of-the-box ways of seeing help partici-pants to expand their own perspectives and understand those of others."

A celebrated pioneer of theatre for social change was the Brazilian director Augusto Boal. His Theatre of the Oppressed involved entire communities in theatrical discussions of issues of culture and citizenship, and he insisted there should be no barrier between actor and audience; the spectator took an active part in how the presentation unfolded, so the social impact was as much in the preparation as in the performance. Sometimes, indeed, there was no formal performance at all.

Vancouver's David Diamond discovered Boal's work at a workshop in Paris in 1984. Diamond had spent five years developing Headlines Theatre, a troupe that turned pressing social and political issues into theatrical arguments for social change. Adapting Boal's techniques, he established Theatre

for Living as a process of community debate and discovery in which every spectator was given the opportunity to participate in what was happening on the stage. Between 1984 and 2018, Diamond facilitated over six hundred interactive performance exchanges around the world, working with Indigenous groups, refugees, women's groups, environmentalists, street youth, health practitioners, and the homeless. The performances addressed racism, violence in the home, school, and workplace, the legacy of Canada's residential schools, language reclamation, harassment, suicide, gangs, and, for the health practitioners, how to deal with patient death. In these Power Plays, non-acting members of the community improvise scenes that dramatize their concerns, then members of the audience intervene by acting out alternate outcomes. Everyone takes part; everyone can have a voice; everyone can see that change is possible. "We create fictions that tell the truth," Diamond says.

In 2010, Lisa Doolittle, a theatre arts professor at the University of Lethbridge, used Boal techniques and other engagement processes in a cross-disciplinary course about food, part of the university's contribution to a national research program on art for social change. Out of the course came a performance, *Moveable Feast*, staged with audiences seated like guests at a huge banquet table. One scene dramatized the food distribution politics that threatened the survival of the common banana, in a samba dance for Carmen Miranda in which unscrupulous politicians and businessmen stripped off her costume of plastic bananas and left her naked. The show was seen by about one thousand people and raised donations for food banks, but, said Doolittle, "the biggest changes

occurred in the students ... We believe they think and act differently, more thoughtfully, with more awareness of social context and social justice ... Direct participation in creating and performing the art was key to moving from complacency into action."

Art's ability to turn abstractions into metaphor makes artists particularly adept at making scientific data understandable to the lay mind. For the COP26 climate conference in Glasgow in 2021, an artist from Britain's Royal College of Art worked with scientists from the British Antarctic Survey and engineers to turn abstract ideas about climate change into physical experiences. To demonstrate the fragility of polar ice, they invited visitors to listen to the sound of ancient air bubbles popping from melting ice cores drilled from the Antarctic Peninsula. They displayed an ampoule of air from the year 1765 in a cylindrical glass sculpture. Through art, they made a pressing problem vivid and personal.

The National Museum of History in Washington also turned to artists to deliver its message about climate change, inviting seven photographers and conceptual artists — among them Canadian photographer Edward Burtynsky, whose iconic images of industrial landscapes explore human impact on the planet — to contribute to the museum's first-ever art exhibition, *Unsettled Nature: Artists Reflect on the Age of Humans*. As David Suzuki belatedly realized, reason and facts alone no longer suffice to move people and society to action. "We have to touch people's hearts, to move people emotionally," he wrote in a 2022 article about his decision to collaborate with his partner Tara Cullis and theatre artist Miriam Fernandes to create a theatre piece about climate

change. "That's why the arts ... have an important role to play in the environmental movement."

That need to take action to protect the environment engages many artists in Canada. The Only Animal, a theatre collective, has created over thirty shows around environmental issues. Its mission statement is succinct — "local focus, global responsibility" — and its members live what they preach: nothing is bought new, no one flies anywhere. One of its initiatives is a collaboration of environmentalists, scientists, artists, and Indigenous elders that aims, says founder and artistic director Kendra Falconi, "to inspire and to mobilize a society paralyzed by climate anxiety and grief."

In Jordan Tannahill's play *Is My Microphone On?*, a chorus of twelve-to-seventeen-year-olds at Canadian Stage in Toronto confronted adult audience members with questions about the environmental choices they had made — and not made — and what this meant to the world they would leave behind. Part of the text was adapted from speeches by climate activist Greta Thunberg. Similar thinking animated Diego Galafassi, a Brazil-born, Stockholm-based visual artist and sustainability scientist, in *Breathe*, a twenty-minute "mixed-reality experience" he created in collaboration with Montréal's PHI Centre, a multidisciplinary organization blending art, film, music, design, and technology. Participants wearing augmented reality glasses and breath monitors were immersed in a narrative that combined body movement, gesture, and breath to demonstrate our dependence on the environment.

These days, there's even a prize for art of conscience: it's called Visible, and it was conceived by the Italian artist and

art activist Michelangelo Pistoletto in collaboration with the Fondazione Zegna. The prize, worth €25,000, is described as "firmly against the idea of art for art's sake," and is dedicated to artists and collectives who aim to bring about responsible social change through their artistic practices. Not that we should necessarily expect art — even art that is firmly against the idea of art for art's sake — to provide answers. It is "a space where we can ask these very difficult questions and explore things in a more open-ended way and not be committed to solutions," said Galafassi. "Good art," as Canadian documentary filmmaker Nettie Wild said in a 2021 interview, "doesn't wag its finger at you."

Wild has spent her career making documentaries (she calls them "real life high-stakes dramas") that focus on marginalized groups and discrimination. One of her most successful films, *A Place Called Chiapas* (1998), followed the chaos and rebellion that occurred when the Zapatista Army of National Liberation took over a poverty-stricken area of Mexico following the signing of the North American Free Trade Agreement. *Fix: The Story of an Addicted City* (2002) focused on the fight over the use of safe injection sites to combat Vancouver's catastrophic drug problem. Wild and her production partner, Betsy Carson, have also explored other ways to get their messages out: an interactive DVD, a multi-platform web production designed to give residents of a small Vancouver neighbourhood ways to connect creatively, a public art installation featuring the Adams River sockeye salmon migration.

Does any of this have any lasting effect? Many people, even now, in an era of increasingly devastating wildfires and floods, of shrinking ice caps and all-too-frequent "hundred-year"

storms, think climate change is fake news. Even believers shrink from the doomsday tone of the message. If all hope is lost, what's the point of building lifeboats? We have so far seen little evidence that government wants to involve the cultural sector in fulfilling its commitment to the "swift, all-society, all-sector transformative action" demanded by the UN's Intergovernmental Panel on Climate Change. Yet the cultural sector is in the vanguard of raising awareness of the perils we face. All the evidence suggests that by showing us pictures and telling us stories art can accelerate our progress toward action. Person by person, mind by mind, it can help us think a different way. *Guernica* didn't stop the world from going to war again, but millions of us have turned to it for reassurance in our hope that one day enough of us will be persuaded of the futility of conflict that peace will finally come.

MYTH IS ANOTHER way we make sense of the world. Every human society from the beginning of remembered time has its origin story. It's how we ask the big, unanswerable questions — who we are, how we came to be, why we are here, fragments of being in an overwhelming universe — and form ideas of what the answers might be. Our shared myths weave art and belief and ideas and identity into the warp and weft of our cultural fabric. We know these stories are not literally true, but they become totemic talismans of group identity. Joseph Campbell famously viewed mythology as a way to understand our place and mark it as our own, and saw its manifestations in art as humankind's poetic attempt

to demonstrate transcendence, the eternal spiritual force that lies within the material world.

Among the dominant societies in the modern era of the divided Western brain, the power of myth has been to a large extent subsumed into film. Rationality hasn't much to say about dragons and princesses, so we mix them up with magic and mystery and produce *Star Wars* and *Harry Potter*. The big movie franchises provide the landscapes on which untold millions of us explore creation myths, follow the hero's journey, and learn the enduring universal truths of human interaction through, as always, stories we can relate to. Film today is an important creator of cultural literacy.

"A creation story, a narrative of origins, gives you the strength to get up when you are knocked down, the motivation to endure the most desperate circumstances," writes the Italian physicist Guido Tonelli in his book *Genesis: The Story of How Everything Began*. "Clinging to the blanket that gives us protection and an identity, we find the strength to resist and to carry on. To be able to place ourselves and the others in our clan in a long chain of events that began in a distant past gives us the opportunity to imagine a future. Whoever has this knowledge can place in a wider framework the terrible vicissitudes of the present, giving sense to suffering, helping us to overcome even the most terrible tragedies."

In this regard, the Indigenous peoples of North America have much to teach. A complicated and important set of mythologies and creation stories provide cultural unity and identity in a torrent of uncertainty and threat. The myths are kept alive through art: singing and dancing, carving and painting, music and stories. This is where a profoundly misunderstood and

mistreated people mark their place as their own. It is scrupulously guarded and only cautiously shared.

The driving principle behind the Clayoquot Sound UNESCO biosphere reserve, on the remote west coast of Vancouver Island, is drawn from the philosophy of the local Nuu-chah-nulth First Nations: "Everything is one." Stressing the importance of recognizing the interconnections within and among ecosystems, Clayoquot has a broad-based culture committee that brings together Indigenous and non-Indigenous individuals to show the value of cultural activity in building individual and community well-being and conserving a sustainable environment in a way that respects its origins and fosters its future. Projects have ranged from a high school film program, living language courses, a cedar-weaving workshop, and a program called Sharing the Grandparents' Teachings.

Victoria Wyatt, professor emeritus in the department of Art History & Visual Studies at the University of Victoria, has pointed out interesting similarities between Indigenous worldviews that unify the intellectual, the emotional, the spiritual, and the physical in non-linear systems of knowing and being, and the processes at work in modern Western sciences such as neurobiology, quantum physics, and climate science.

"We will not solve the global challenges we face using the same conceptual framework that allowed them to develop," she says. "That paradigm separates and isolates components of complex systems, as if artificially simplifying reality is the key to understanding." In vivid contrast, she says, Indigenous ways of knowing "embrace the concept that everything connects. Understanding the systems in the world depends on comprehending the invisible relationships between the parts.

Recent shifts in Western sciences similarly focus on the actual nature of dynamic non-linear systems. Quantum physics, systems biology, epigenetics, neuroscience, and climate science all emerge from the conviction that complexity is not an obstacle to understanding, but essential to it. Dynamic systems comprise diversity, complexity, relationships, and process. The global, real-world challenges we face involve the same. Climate change, environmental degradation, pandemics, resource scarcity, and social justice violations all connect, and all require a conceptual framework that celebrates complexity." Both Indigenous ways of knowing and newer fields in Western sciences embody the ability and the commitment to address those challenges, she says.

Wyatt makes the additional point that Indigenous concepts of time can also affect the way we handle debate. "Getting Western audiences to consider time as anything but linear is challenging," she says, "but when time is considered linear, it gets compartmentalized between past, present, and future, with the past constantly receding in distance and in relevance, and the future similarly disconnected from the present. In Indigenous constructs, when past, present, and future all converge in each point in time, ancestors are present in the present, and we are all ourselves ancestors, time becomes an interconnected non-linear system with all parts critical to each moment. That affects policy-making and approaches to global problem-solving in highly significant ways."

The recent highlighting of Indigenous issues through the deliberations of the Truth and Reconciliation Commission of Canada (TRC) prompts the cultural sector to find fresh perspectives as Canada grapples with the issues of Indigenous

identity and reconciliation. It is now common practice to introduce live performances with words of gratitude that recognize that the events are taking place on Indigenous territory. (The publishers of this book make similar acknowledgements.)

The TRC specifically recommended that museums and heritage centres review the manner in which they acknowledge Indigenous history and perspectives. In the fall of 2022, the Canadian Museums Association issued a report on "how settlers can assist in dismantling the parts of museums that continue to perpetuate colonial harm." The report included a detailed outline of how to foster reconciliation by integrating Indigenous input into museum operations and sharing decision-making authority. It laid out new standards for museums when interacting with Indigenous peoples and materials, and a ten-point set of recommendations, including new legislation regarding Indigenous belonging and dedicated funding for the repatriation process.

By that time, the cultural realities of modern Canada were already being reflected in institutional programming and staffing. When, in 2018, the Montréal Museum of Fine Arts mounted a French museum's show featuring the influence of African art in Picasso's work, it added works by Black artists from the U.S. and Canada. At the Art Gallery of Ontario, the "Mighty Whities" who dominated major exhibitions have been augmented by women and Indigenous artists, among them Inuit artists Kenojuak Ashevak and Tim Pitsiulak. When plans for the exterior cladding of the new Vancouver Art Gallery drew criticism, the design was changed to drape the building in a copper cladding suggesting traditional Coast Salish weaving. And in the fall of 2021, to mark the initiation of

Canada's National Day for Truth and Reconciliation, the VAG appointed Willard "Buddy" Joseph as its Elder in Residence. Joseph, a master of traditional Coast Salish wool weaving, will "provide counsel, support, and guidance to staff while promoting understanding and respect for Indigenous perspectives, culture, and values." The significance of his preparation for the post — he conducted a traditional brushing ceremony to cleanse the gallery's historic building, a former courthouse — did not go unnoticed.

In 2021, Calgary's Arts Commons project, which provides a home for six professional performing arts companies and over two hundred community groups, launched a multi-year scheme to expand and modernize the downtown cultural district. "Not only are we paving the way for what a performing arts centre should be … we are also laying the groundwork for the cultural landscape of tomorrow," said President and CEO Alex Sarian in his 2021–2022 annual report. Part of the overall process of change included the development of a Reconciliation Strategy, in consultation with representatives of the Indigenous community. "Arts Commons is a 'social business' with the social objective to ensure that we ignite positive change in society by providing equitable access to the transformative power of the arts," said the report. "The framework by which the Strategy is developed, therefore, considers this important position and approaches the work based on the Indigenous principles of Making Relatives, Ethical Space, and Sanctified Kindness, a reciprocal approach that honours both Western and Indigenous ways of doing and ways of being."

Not all such changes have gone smoothly. In 2022, as part of a branding process, the National Gallery of Canada

proclaimed a new "institutional purpose — to nurture interconnection across time and place ... to have difficult conversations, to see the world from other points of view, and to inspire empathy and humility." The gallery's new slogan was *Ankosé*, an Anishinaabemowin word meaning "everything is connected." The word emerged from planning conversations with Algonquin elders during the COVID-19 pandemic, and it gave symbolic form to the gallery's renewed determination to "decolonize" the institution and "recognize the limitless connections that exist beyond the frame."

Part of the process involved the creation of a Department of Indigenous Ways and Decolonization, to lead a program of what former director Sasha Suda called decolonization and reconciliation throughout its collections and programs. But within the year, four senior staff members at the gallery, including its Indigenous arts curator, Greg A. Hill, and its chief curator and deputy director, Kitty Scott, were fired. Suda's interim replacement, Angela Cassie, called the dismissals a restructuring, "made to better align the Gallery's leadership team with the organization's new strategic plan." These firings followed at least ten others at the gallery's management level in recent years. Hill, a twenty-two-year employee who was named Audain Chair and Senior Curator of Indigenous Art in 2007 as part of a $2 million endowment from Vancouver philanthropist Michael Audain, said in an Instagram post that there had been little dialogue about the department's function. "What are 'Indigenous ways' at the National Gallery of Canada? What can they be? How do we move forward and how do we decolonize? These are questions I still have and there has not been a dialogue on that."

In its strategic plan for 2021–26, the Canada Council for the Arts took a similarly revisionist view of its history. It said it recognized the role it has played in "the history of oppression, exclusion, and anti-Indigenous racism in colonial institutions" and the "persistent lack of equity, diversity, and inclusion in the arts, particularly in the workforce and programming of far too many publicly funded organizations." In the spirit of truth telling, reconciliation, and decolonization, the document said, the council would work to eliminate the inequities and injustices that the pandemic had exposed in its treatment of Indigenous, Black, Asian, and other minority communities.

In 2022, the council reported it had allocated $37.5 million to support Indigenous culture, just over a third of its way to a goal of $100 million by 2026. Its new operational system includes a granting program called Creating, Knowing and Sharing, which the council says will use a self-determined, Indigenous-centred approach, guided by Indigenous values and worldviews, administered and assessed by individuals of First Nations, Inuit, and Métis heritage. What it calls the "{Re}conciliation Initiative" also promotes "artistic collaborations between Indigenous and non-Indigenous artists, investing in the power of art and imagination to inspire dialogue, understanding, and change." And it promised that by 2026 "the arts sector ... will have found tangible ways of fostering the emergence of new voices, making space for youth, and promoting and supporting the leadership of people from underserved and marginalized groups. Artists, collectives, and arts organizations will play an inspiring, innovative, and exemplary role in our collective development."

At the Council's annual public meeting in January 2023, Simon Brault said that the strategic plan's commitment to a more equitable arts sector "stands alongside its vision for a decolonized future for the arts." In terms of the council, he said, decolonization means "we must:

- Accept to reframe our understanding of what constitutes art.
- Question the notion of professionalism and artistic disciplines, which are deeply rooted in a specific time in history, mostly Eurocentric and often from a very colonialist perspective.
- Challenge the notion of 'artistic excellence,' a concept that upholds hierarchies of good taste and values that confirm and perpetuate the status of the dominant culture.
- Move beyond limited notions of artistic expertise that are often the product of an education system built to reproduce power relations and safeguard the privilege of the dominant colonial discourse on art and culture."

At the same meeting, Jesse Wente, the council's first Indigenous chairman, said the council's equity work "must continue to place the autonomy of historically marginalized and disenfranchised communities at its core," fostering "an arts sector that includes, represents, and speaks to the diversity of this country" and "acknowledges the cultural sovereignty of Indigenous peoples and respects the concepts of First Nations, Inuit, and Métis self-determination."

"We are all agents of either stasis or change," said a statement of corporate policies on the council's website. "For every act of political, social, or cultural agency that challenges the status quo, there will always be opposing forces fuelled by colonial entrenchment/privilege, oppositional paranoia, or, simply, inertia."

Some might interpret this language as a sign of the socio-cultural weaponization of Canada's artists at the service of a broader government agenda. I prefer to see it as a sign of our emerging (if belated) understanding as a society that reconciliation and redress need more than words and good intent. It is important — vitally important — for an agency like the Canada Council for the Arts to pursue the aims of equity and reconciliation for all our historically marginalized and disenfranchised communities; it is a principle at the heart of this book's ideal of a new Canadian Cultural Contract. If that plays into the politics of the government of the day, so be it.

What matters is how that change is structured and how it plays out. Good intent does not always lead to good outcomes. As we "reframe our understanding of what constitutes art" (a necessary process, as this book argues, given the evolutionary forces at play), it will be important not to throw out the champagne with the cork. The plays of Shakespeare speak profoundly across the centuries about issues that bedevil humanity still, despite the fact that they were written in archaic language 450 years ago and deal with events and characters from ancient times. (When Creative New Zealand, that country's equivalent to the Canada Council for

the Arts, withdrew its support in 2022 for a popular school Shakespeare program on the grounds that it was irrelevant to "the contemporary art context" and was "located within a canon of imperialism," the move was robustly characterized by a former deputy prime minister as political and social engineering by "overpaid sickly liberal bureaucratic wokester morons," a judgment one can roundly applaud.) Beethoven's orchestral music is enduringly good and demands years of individual practice and exploration to master. And while Shakespeare and Beethoven are "rooted at a specific time in history," that does not diminish their universal value, any more than the fact that many innovations that contribute to our quality of life today, from vaccination to printing to structural engineering, are in some way devalued by their origins in Europe in earlier times. Cool and wise heads are needed to ensure that justice and equity prevail, but prevail they must.

Outside the institutions, the process of building cross-cultural understanding is more organic. Anishinaabe filmmaker Lisa Jackson approaches the challenge by creating multidisciplinary experiences that, in her words, can help "knit the world together." We are so busy chopping experience into categories and compartments that we lose sight of what Jackson calls "the wholeness of the world" and our relationship with it: our dependence on it, and its dependence on us. In her virtual reality installation in Toronto, *Biidaaban: First Light,* which she created with the National Film Board, viewers were shown a futuristic vision of downtown Toronto, in which the natural world had taken the land back. In her six-thousand-square-foot, immersive film

installation *Transmissions*, shown in 2019 at Simon Fraser University, visitors wandered through coastal forests, past empty glass towers, surrounded by soundscapes of threatened Indigenous languages intended to underscore the importance of language as a transmitter of wisdom and understanding. Both pieces served as bridges connecting cultures, offering the opportunity for compassion in a relationship that has been fraught with suspicion and remains freighted with guilt.

One of the most consistently interesting experimenters in cross-cultural interchange is Brian Jungen, a BC artist of part-Indigenous ancestry whose explorations of the intersection of what he called "native and white cultures" challenge mainstream assumptions about Indigenous art and have been featured in major shows in Canada and internationally, including London's Tate Modern and the Shanghai and Toronto biennials. He drew attention early in his career with his *Prototypes for New Understanding (1998–2005)*, a series of what appeared to be Northwest Indigenous ceremonial masks assembled from deconstructed Air Jordan sneakers. A *New York Times* critic said the work "might be seen as a sardonic view of the cultural takeover and commercialization of Indigenous art so widespread in Canada and the United States, and also as a comment on the need for fetishes — in this case, the exalted Nike — that is every bit as strong in modern societies as in so-called primitive ones." Jungen has also used other trappings of sport — jerseys, bats, and catcher's mitts, from which he fashioned *The Prince*, a rendering of the wooden "Cigar Store Indian" once familiar outside tobacconists' shops — and has built huge whale skeletons from discarded plastic chairs.

Since 2010, Winnipeg-based Métis and Finnish artist Jaime Black has travelled North America with her REDress Project, in which she hangs red dresses from trees in public spaces, in galleries and on university campuses. Each dress represents a missing or murdered Indigenous woman. It's a simple but provocative creative statement intended to draw attention to the persistent violence against Indigenous women and girls in Canada and the U.S., the absence of recourse for the women's families, and the lack of action by government.

In Vancouver, Anishinaabe comedian Ryan McMahon hosts a ten-part video course called Home on Native Land, introducing non-Indigenous people to issues of Indigenous law, colonial history, and environmental justice. Offered through RAVEN, a Vancouver-based non-profit that raises funds to help Indigenous communities with legal defence, the free, self-guided course highlights contributions from specialist speakers, leavened with humour and anecdotes. According to RAVEN executive director Susan Smitten, in an interview in The Tyee, the idea for the course emerged from a livestream event discussing the work RAVEN does. "People were phoning in with questions like, 'What do I say to my uncle if he shows up at Thanksgiving and he's a racist?'" said Smitten. This course provides an abundance of material with which to enlighten him, presented in a format that's easy to digest and share.

In 2019, Toronto's Tarragon Theatre mounted Kiviuq Returns, an interdisciplinary production from Iqaluit, told entirely in Inuktitut and without subtitles, using traditional and contemporary music, Inuit drum dance, throat music, and elder storytelling. In the same year the Vancouver Opera

collaborated with Pacific Opera Victoria to create a performance for young audiences, *The Flight of the Hummingbird*, based on a South American Indigenous myth and featuring decor by Haida artist Michael Nicoll Yahgulanaas, inspired by his Haida-manga graphic novel on the theme. Also in 2019, Indigenous playwright and filmmaker Marie Clements took the story of BC's missing and murdered Indigenous women and joined composer Brian Current to create an opera, *Missing*, with libretto in English and Gitksan, for Pacific Opera Victoria and Vancouver's chamber opera company, City Opera, which regularly commissions "stories in music that are relevant to our time and people." Its first was *Fallujah*, an anti-war exploration of the agonies of one person's experience of PTSD with music by Canadian composer Tobin Stokes. In 2016, *Fallujah* was staged by Long Beach Opera and the New York City Opera. The Vancouver company also commissioned Stokes to write the music for Margaret Atwood's first opera, *Pauline*, the story of Canadian poet Pauline Johnson, the daughter of an English immigrant and a hereditary Mohawk chief.

Attention is being paid. But across the Canadian cultural sector, far more needs to be done.

A Full Head of STEAM

I heard a great story recently, of a little girl who was in
a drawing lesson. She was six and she was at the back, drawing.
The teacher went over to her and asked, "What are you drawing?"
and the girl said, "I'm drawing a picture of God." The teacher
said, "But no one knows what God looks like." "No,"
said the little girl, "but they will in a minute."
— Sir Ken Robinson, international advisor on education in the arts

IN THESE BRAND-OBSESSED times, there's nothing like a
catchy acronym to imply importance, and anyone who has
been around children in the past couple of decades knows
about STEM. It's an interdisciplinary approach to learning
that brings science, technology, engineering, and mathemat-
ics into an integrated single curriculum to train the future
workforce: STEM, the conduit through which the intellectual
life force reaches the techno-economic flower.

What's missing from this picture? The arts and humanities.

The belief that the arts and the sciences exist in their own
separate universes, with one far more important than the
other, has bedevilled education for decades. Stephen Toope,

who left his post as president of UBC to become vice-chancellor of the University of Cambridge, calls the idea that the arts are less important than the sciences "a zombie: scary, dangerous and apparently impossible to kill."

The reason the zombie still stalks the land is because education today is considered essentially instrumentalist: a means to equip the young to thrive in the marketplace, to help build the economy, to provide the worker-fodder for the economic machine. For all the relentless lobbying by the professional cultural community, educational policy has consistently undervalued art and culture as contributors to our economic, social, and individual well-being.

It wasn't always that way. I spent my teenage years at Wellingborough Grammar School, in the Midlands of England. The grammar school's job was (in the words of our headmaster, H.A. Wrenn, who wrote a book about it) "not to prepare its pupils for any particular trade or vocation, but rather to teach its pupils to think, to distinguish the true from the false." From a very early age we were streamed into either the arts or the sciences; I chose literature and languages, and I've always considered myself a fortunate beneficiary of a liberal education in the humanities.

Our English teacher, Geoff Cooksey, ran his classes with his feet up on his desk, as if we were a group of friends who had dropped in for a chat. He hated lazy thinking, and he didn't put up with any kind of pretension. As he pointed out the first time we met, the quality of what you read has a direct impact on your ability to make the kind of informed judgments that will lead to your best choices. He wanted us to be able to discriminate between the honest and the mer-

etricious, so along with getting us to sort out for ourselves what worked and didn't work in a wide span of great and not-so-great poetry, prose, and drama, he made us dissect newspaper articles and advertising copy to find the intentions of the language they used. He also showed us how effective poetry can be at compressing the loose, messy randomness of the everyday into metaphor that invites us — persuades us, forces us — to look more carefully, less comfortably, at the unregarded aspects of our lives. The seductive ways in which Hopkins, Hardy, Cowper, Brooke, Arnold, Eliot, all that great, trundling troupe of golden-tongued handwringers, wielded the language of melancholy darkened my daydreams and, for a time, had a disproportionate influence on both my cast of mind and my writing style. Cooksey helped us chart our way through: he guided us into careful thinking and he helped us grow up. And, in my case, he gave me invaluable tools for the life I was to lead.

None of what I learned, however, had anything to do with science or engineering, nor did it prepare me for any particular vocation in an economy with ambitions to compete internationally in an age of technological advancement. I was by no means alone in these deficiencies, and those perceived shortcomings in the liberal education began to draw increasing attention. I had moved on to university when C.P. Snow, a novelist with a distinguished background in physics and chemistry, delivered his first "two cultures" talk. In it, he took the British educational system to task for not preparing all students for the challenges of the modern scientific world. An understanding of how to use science and technology was, in his view, the best way for humanity to prosper; scientists,

he said, had "the future in their bones." Literary intellectuals were "natural Luddites." As things stood, he said, individuals educated in the humanities had about as much insight into science as their neolithic ancestors.

Snow's talk and the book that followed, *The Two Cultures and the Scientific Revolution*, unleashed a long and furious debate. Over the course of the second half of the twentieth century, the arts became widely deemed less important to the creation of an educated workforce, displaced by what were deemed "necessary" courses. Literacy was based on the ability to comprehend manuals and guides, not appreciate poetry and novels. In 2008, the *Times Literary Supplement* included Snow's book on its list of the hundred books that most influenced Western thinking in the fifty years following the Second World War.

The prioritizing of the STEM curriculum shows the continuing strength of the arguments Snow voiced. Between 2000 and 2020, enrolment in English departments in the U.S. dropped by twenty-five percent; enrolment in STEM classes doubled. In May 2021, the UK Department for Education announced it was to cut funding for arts subjects at universities by almost fifty percent. Music, dance, drama and performing arts, art and design, media studies, and archaeology were not among the government's "strategic priorities." The cuts would "target taxpayers' money towards the subjects which support the skills this country needs to build back better, such as those that support ... high cost STEM subjects." Universities would be penalized if fewer than sixty percent of students were in professional jobs or studying for a further degree within fifteen months of graduating. Within months,

universities throughout the UK were making cuts to arts and humanities courses.

The instrumental value of a STEM education is not in question. But it is more and more apparent that we are shortchanging not only ourselves but the generations of the future by relegating the arts and humanities to a position of secondary importance in our schools and turning the university into what literary critic Terry Eagleton calls "a mere service station for the capitalist economy." Arts education advocates risk falling into the trap of instrumentalizing the arts by talking about them in industrial or manufacturing terms: their contribution to the economy, to social cohesion, to national identity.

Our insistence on valuing education for its economic functionality flies in the face of the broader notion of education (from the Latin root, *educere*: to lead or draw out) as the development of the whole person. We have lost our grip on the ancient conviction that science on its own is incomplete, and that its full benefits can only be found when its explorations are informed by morality, wisdom, and spirituality. Setting aside something as morally challenging as the atomic bomb and the development of nuclear weaponry, advances in medicine over the past century alone have thrown up a host of issues — thalidomide deformities, reproductive technology, genetic experimentation — that entangle us in ethical conundrums.

It's not and never should have been a case of either-or. The arts and the sciences have a common root in human curiosity, and a common cause in helping individuals understand the world and find ways to confront its challenges. Science,

engineering, and digital technologies help us find solutions to practical problems and create a more physically secure and livable world. The arts and humanities — books, plays, paintings, music, dance, philosophy — give us ways to think about our place in the continuum of being (Who am I? Why am I here? What does it mean to be a good person? What are my responsibilities to my neighbours?) and, by showing us that others before us have wrestled with the same imponderables, help us appreciate other people's realities. They may ask different questions and lead us to different answers. But they both satisfy our impulse to ask *what if?*, an urge that is integral to the learning process, not only at school but throughout life.

At the Flatiron School, a New York coding boot camp, students come from many professional backgrounds, including the arts and humanities. And that's an advantage, according to co-founder Adam Enbar. In a *Forbes* interview with Benjamin Wolff, Enbar said, "When you're sitting down on day one and you've got to write a program ... the competitive advantage you have as a liberal arts major or if you worked as a musician, is that you can get over that creative hurdle much faster ... It's not just about knowing how to use technology — that's ... a skill set. But your ability to use that skill set to do something creative, to ask the right question, to develop the right insights, is what actually creates value." In the same article, Wolff quotes Catie Cuan, a Stanford PhD candidate in mechanical engineering who danced with the Metropolitan Opera in New York City while working at a web design agency. Cuan believes that a training in the arts brings valuable and important insights.

As a choreographer, she focuses on the humanity of her dancers. "There's an incredible amount of vulnerability ... You have to examine all the angles in which someone could be harmed or hurt by the work that you make." But that kind of self-awareness, she said, is not nearly as cultivated or valued in engineering. "So many things in technology have been deployed at the exploitation or expense of people ... I wonder, what would it be like if we had, in engineering, a detailed humanist practice like we do in dance?"

The idea of the modern day union of artists and scientists in common cause was central to Shirley Thomson's thinking when she was director of the Canada Council for the Arts from 1998 to 2002. Thomson, in her severely pinned Martha Graham–esque hair arrangements, was one of the most acute and rigorous thinkers I met in Ottawa. Her intimate understanding and regard for the arts world, combined with her command of logic and rhetoric, made her inspiring to hear. She believed one of the council's greatest challenges was to make art equal in importance to education and science in the minds of the people who influenced public thought: politicians and journalists. She once brought the new-media guru Michael Century to a council board meeting to give emphasis to her assertions. Century founded the media division at the Banff Centre for the Arts and Creativity, one of the first programs to focus on the relationship between art and new technologies. He argued that it was no longer possible to think about the arts in solitary splendour. Artists and scientists were "running in packs" again, the way they did in the Renaissance. His message: don't toss aside the traditional arts, but at the same time don't treat the new media as some

kind of exotic, specialist interest. Be ready for the interchange. Between them, art and science would create new hybrids of expression and new creative values.

The current generation of students will have to respond to some of the most profound dilemmas humankind has faced; if we are serious about educating to innovate (to use a term that governments love), we must equip them to think hard in ways that go beyond the rigidly rational — to bridge the gap between the material and the non-material, between scientific knowledge of the immediate and the intuited world of what might be. Without the imagination, we are anchored in the present, mired in the predictable. Without the imagination, we deprive ourselves of hope. Art licenses imaginative play. Time spent in creative activity is time to let ourselves be distracted, feel the dopamine flow, and give the unconscious a chance to come up with ideas the conscious mind might have missed. (None of this would have been news to one of the most influential thinkers in evolutionary science, naturalist Charles Darwin, who took *Paradise Lost* with him on his famous voyages, when he had room for only a single book.)

It is time to cut the head off the zombie for good.

HARVARD PSYCHOLOGIST HOWARD Gardner changed the debate nearly four decades ago with his argument that children learn in a multitude of ways and that we all have multiple intelligences beyond the verbal and mathematical. Learning *in* the arts (that is, gaining skills in various artforms: learning how to play the flute, say, or make mosaics) and learning *about* the arts are quite different from learning

through the arts, though they each bring important benefits to the educational process. An imaginative education that works through the arts, that has arts activities infused into the curriculum, helps develop both the human imagination and the fully rounded and functioning individual in the modern world. Developing critical judgment, for instance, along with the ability to articulate it, enhances our ability to assess and discriminate in the wider world.

Stanford arts and education visionary Elliot Eisner has listed a wide range of benefits of arts in education, among them the way it leads to better decision-making: children learn that problems can have more than one solution and questions can have more than one answer; that there are many ways to see and interpret the world and that we must be open to unexpected possibilities; that knowing and understanding are not limited to words and numbers; and that the arts help us express what cannot be said and give us access to a variety of experience we can have from no other source.

But one of the greatest blocks to the integration of creative activity and artistic expression into the learning process has been the difficulty of measuring these benefits by the standardized scientific or mathematical testing commonly used in schools. We are imprisoned by our society's obsessive need to measure and quantify: if you can't measure it, it doesn't count. You teach to the test. A 2019 study blamed the increasing neglect of arts education in the U.S. on the expansion of standardized testing, which has pressured schools to focus resources on tested subjects.

In 2004 and 2005, I led a cross-country consultation on arts education in Canada, in preparation for Canada's participation

in a 2006 UNESCO world conference on the topic in Lisbon. Every meeting began with the question, "Why is arts education important?" The most frequent responses concerned people's life-changing encounters with the arts during their school years. Some talked about the inspiration they received from a significant teacher or a great art program. Others described the effects of an opera, a play, a radio program, family activities, or part-time jobs in the arts. Many spoke of early private arts classes that helped them make career choices or established lifelong habits like visiting museums or singing together. Some talked about how their art experiences taught them the joy of working collaboratively with others and how they carried these experiences into their daily lives. The link between spirituality and creativity, and the human gravitation to the spiritual connection, was widely discussed.

One of the documents that emerged from those consultations, *Canadian Reflections on Arts and Learning: The Challenge of Systemic Change*, became Canada's principal contribution to the Lisbon conference and, for many years, a significant reference tool for advocacy groups in Canada. Much of it remains valid today. One of the principal challenges the document identified was the need for hard evidence that could be used by people who want to create change in the world's schools.

Empirical evidence does exist. Advocates in many countries are working to find practical ways to show how an imaginative, arts-infused education enhances learning, improves literacy, and seeds the growth of more empathetic, expressive, confident, self-reliant, and critically thoughtful human beings able to succeed and thrive in the new imagination

society. A major contribution to that debate was *The Wow Factor: Global research compendium on the impact of the arts in education*, a 2004 UNESCO-sponsored world survey of standards in arts education and methods of evaluation in more than sixty countries, by Anne Bamford, professor of education at the Wimbledon College of Arts in London. And a growing body of studies show how exposure to the arts — and education that incorporates creative activity into the learning process — helps develop motivation, collaboration, and social, psychological, and ethical development. Even the persistence acquired from having learned to play an instrument can benefit a scientist in search of answers to the mysteries of the universe.

As early as 1993, a study that reported a short-term improvement in spatial reasoning while listening to Mozart led to a spate of media claims that listening to Mozart makes you smarter — the Mozart Effect. Later studies demonstrated that listening to Mozart improved students' ability to solve math problems. Other studies have shown that playing music is one of the best all-in-one workouts for the brain. It increases the volume of activity between the brain's two hemispheres, letting information cross the brain faster; it improves executive tasks like planning and strategizing; it engages almost every area of the brain at once; and it makes memory function more efficiently. (In 1998, the governor of Georgia became so convinced by these claims that he set up a fund to give the parents of all 110,000 babies born in the state that year a CD of classical music called *Build Your Baby's Brain Through the Power of Music*.)

Early results from a three-year study of classes in elementary schools in Tucson, Arizona, showed children who

participated in Opening Minds Through the Arts (OMA), a program integrating arts education with the core curriculum, scored up to twenty-five percent better in reading, writing, and math tests than children in classes without those programs. A 2012 Lesley University study of teachers from nineteen American states found that integrating the arts into the educational curriculum leads to increased academic achievement and student retention, and helps teachers be more effective and innovative. For students, the study showed, arts integration can lead to deeper learning; increase student creativity, innovation, and imagination; and can help students develop empathy, awareness of multiple perspectives, and cultural sensitivity to others. For teachers, it can rejuvenate those on the verge of burnout and renew their commitment to teaching through providing hands-on engagement in the creative process and enabling them to offer dynamic and innovative instruction.

According to a 2019 study of forty-two schools in the Houston area by Brian Kisida of the University of Missouri and Daniel Bowen of Texas A&M University, "a substantial increase in arts educational experiences ha[d] remarkable impacts on students' academic, social, and emotional outcomes." In elementary schools they found increases in arts learning positively and significantly affected students' school engagement, college aspirations, and their inclinations to draw upon works of art as a means for empathizing with others. Students were more likely to agree that school work was enjoyable, and that arts activities made them think about things in new ways and kept them interested in school.

WHAT'S EQUALLY IMPORTANT is how the arts are presented in the curriculum. More and more international educators imagine a new style of teaching in which the arts and creative activity are given more space and relevance in the timetable.

At the University of Cambridge, the School of Arts and Humanities has launched the Global Humanities Network, with partners around the globe who are tackling what Stephen Toope calls "big-picture questions — the future of the human world and the human spirit." This work includes exploring innovative approaches to teaching and research. In the words of former UBC president Martha Piper, if we wish to create a "civil" society, "we must put more emphasis on what we may learn from the human sciences about the world we live in and our responsibilities as members of that larger community." And that means more than simply bolting on a few extra courses or extracurricular "service" obligations. It means developing "an integrated approach that relates academic study to the needs of society: that encourages in our students a stronger sense of social purpose and instills an awareness of one's responsibilities as a citizen."

Canada has been at the forefront of this global campaign for curriculum change. UNESCO's first Chair in Arts and Learning was established in 2007 at the Faculty of Education at Queen's University in Ontario. Its inaugural occupant was education professor Larry O'Farrell, a pivotal figure in the development of the arts in education movement in Canada and principal author of the Seoul Agenda, a blueprint of goals for international development in the field.

O'Farrell spearheaded the creation of the Canadian Network for Arts and Learning, which brings together artists,

arts organizations, educators, policy makers, funders, and researchers. The CNAL vision statement sees arts education as "an intrinsic component of human culture that deserves formal recognition in schools; fundamental to the development of the fully realized individual; and a means of resolving the social and cultural challenges facing the world today by building empathy and intercultural understanding" and the organization aims to bring about "a systemic transformation that will realize the full potential of the arts to achieve crucial social, economic and cultural objectives for children, youth and lifelong learners of all ages." It has produced a handbook, *Creative Insights*, by researchers Ann Patteson and Steven Campbell, intended as an open reference source for assessment techniques based not on testing and marking but on creativity, personal growth, and social development.

The Imaginative Education Research Group (IERG) at Simon Fraser University has worked since 2001 to bring about "a transition from an industrial age school system to a post-industrial system: from a system that attempts to squeeze people and thoughts into standardized boxes, often to the detriment of originality and adaptability, to a system that enables the unusual and effective to flourish wherever possible." The late Kieran Egan, the Canadian education professor whose theories form the basis for the work of IERG, believed that imagination is too often seen as something peripheral to the core of education, "something taken care of by allowing students time to 'express themselves' in 'the arts,' while the proper work of educating goes on in the sciences and math." He argued that "the sidelined and neglected 'frill' is actually the most effective tool we have for efficient and

effective learning" and proposed instead that imagination be placed at the centre of education, as crucial to any subject, to mathematics and science no less than to history and literature.

Egan also stressed the need for educators to engage students' emotions as well as their imaginations. "The mention of emotions might be a bit unexpected," he said in his influential book *Teaching as Story Telling*, "but it is crucial because the imagination is tied in complex ways with our emotional lives. Students don't need a throbbing passion for learning algebra or a swooning joy in learning about punctuation, but successful education does require some emotional involvement of the student with the subject matter. The best tool for doing this is the imagination."

Particularly through stories. Children are readily and powerfully engaged by stories. "The world they are to make sense of has a vivid and dramatic history," wrote Egan, "and I think we can relatively easily reconceive our primary curriculum in terms of telling children the story of science and technology, the story of mathematics, the story of history, the story of art, and the stories of all our ways of sense-making." This would recast teachers as "our culture's storytellers. The stories that constitute our culture are ... terrific and dramatic stories ... Instead of thinking of a lesson or unit as embodying a set of objectives to be attained, we might enable teachers to think of it as a good story to be told."

Out of Egan's theories has sprung a program called Learning in Depth (LiD), described by Lee S. Shulman, president emeritus of the Carnegie Foundation for the Advancement of Teaching, as a "fascinating, provocative, utterly visionary and courageously speculative imagining of an educational future

that is simultaneously elite and egalitarian, deeply intellectual yet utterly connected to passion and identity."

LiD is simple and effective. Each child is given a specific topic to learn about through their entire school career, in addition to the usual curriculum. The topic could be anything: spiders, apples, trees, the range is unlimited. The commitment of time is about an hour per week. By the time students graduate, they have become experts on whatever their topic happens to be, and usually know far more about it than their teachers. Hundreds of schools around the world have built LiD into their curricula, and teachers report a new depth and quality to student learning. SFU professor Gillian Judson, who helped guide the LiD program for many years, says take-up often happens when individual teachers start the program in a single class and other teachers become intrigued and decide to give it a try. After LiD was introduced at a school in Burnaby, BC, the program became part of school culture. Everyone knew it was LiD time when the Pharrell Williams song "Happy" began to play over the intercom.

SEVERAL UNIVERSITIES IN Canada and elsewhere already offer combined degrees in arts and sciences. But because education in Canada is strictly a provincial responsibility, the availability and quality of arts engagement in schools vary widely. A 2022 study by the Coalition for Music Education in Canada drew a picture of wild inequalities among school jurisdictions in terms of access to music education, even among adjacent schools. In some schools, children get three music classes a week. In others, they get one. Some schools have a range of

instruments available to students. Others have none. Some jurisdictions use specialists to teach music. Others add the music curriculum to the general classroom teacher's load. "For the most part," says O'Farrell, who has worked with teachers for more than four decades, "the elementary school cultural curriculum, no matter how well written, relies on the generalist teacher to deliver it, although not all of these teachers are prepared to introduce even one art form, much less several forms." In private schools, by contrast, the arts are often an integral part of the school year, both in classroom work and extracurricular activities that can range from outings to the theatre and concert hall (particularly for schools with access to major urban centres) to international cultural tours (for the privileged students who can afford the cost).

In general, O'Farrell believes, "despite the best intentions of our teachers, education systems have tended to move away from an institutional commitment to the goals and methods of Progressive Education, the philosophical basis that kept the arts in schools from the late nineteenth century until the past few decades." (Broadly, Progressive Education gives more value to creative experience than rote learning in the development of a child's talents.)

The key to renewing the importance of the arts in the educational process, he told me in an email exchange in 2023, lies in teacher education, particularly at the elementary level, and the assignment of specialist teachers, giving more attention to arts learning in generalist teacher education programs, and an increase in (or in some cases, a return to) the use of specialist arts teachers in elementary schools ("with sufficient time allotment to make their presence felt").

Outliers exist. Calgary Arts Academy, a charter school founded in 2003, uses immersion in music, visual art, dance, drama, and literary art to deliver the Alberta curriculum from kindergarten to grade twelve. It claims to be the only school of its kind in North America. Instruction comes from teachers and artists, and parents take an active part in creating and supporting their children's learning plans, which are designed, in line with the school's statement of purpose, "to transform children into young people who are curious, kind, empathetic and engaged, preparing them like no other school to contribute and lead in their communities." The Faywood Arts-Based Curriculum School in Toronto makes the arts central to learning skills and concepts in other subjects, in order to develop what the school calls "truly literate persons." But school boards in Canada seem in no hurry to move the arts to the heart of the educational curriculum, and it has largely been left to arts enterprises outside the school system to take up the slack. Toronto's Royal Conservatory of Music, which launched its Learning Through the Arts program (LTTA) in 1994, is a leader in this field. More than fifty studies of this program have found that using the arts to teach non-arts subjects improves students' ability to work collaboratively and be open to different points of view; promotes intercultural understanding; boosts test results in subjects like mathematics and language; reduces dropout rates; and enlivens and deepens learning.

LTTA also contributes arts-based activities to a variety of social service programs. Its ARTS-REHAB project used creative arts programs to help patients in rehabilitation get back into their communities sooner; studies of its Living Through the

Arts programs for seniors have shown that mastering something like storytelling, creative writing, or creative movement can influence health and well-being, reducing depression and the perception of pain.

For fifty years, Toronto's Inner City Angels immersed inner-city children in programs of creative learning alongside professional artists. Founded in 1969 by social activist and entrepreneur Marianne Heller, with the collaboration of inner school principal Doug Balmer, the project began life in an old streetcar parked in Balmer's school playground. Actors and artists hired by Heller helped guide students in a variety of creative programs and, gradually, as more "angels" were found to contribute to costs, the program expanded to other schools. "Artists and artisans, scientists and mathematicians seek to find truth and beauty by asking deep questions," reads a statement on the organization's website. "If we are to believe that we are all connected and that we can build a collective social intelligence and that this intelligence, inculcated at a young age, is our humanity, then this is where we'd like to start." Hundreds of professional artists have taken part in programs integrating hands-on creative activity into the science, culture, social justice, and well-being strands of the educational curriculum for millions of children. By the time the project closed in 2022, following the death of its director Jane Howard Baker — remembered by dance veterans and ICA facilitators Karen and Allen Kaeja as "a true visionary ... compassionate, passionate and tireless in her pursuit of reaching the hearts and souls of students" — the program was drawing significant support from corporations and government agencies.

Driven women like Heller and Baker have been the prime motive force of similar projects across Canada. Vancouver's Arts Umbrella opened in 1979 with an enrolment of forty-five students. Co-founder Carol Henriquez described it as "a dream to instill in all children the love of the arts, inspiring them to become healthy, confident, productive, creative citizens. A dream to build a centre that would awaken the artistic potential of young people in a way that hadn't been done before ... a dream to make a difference." By 2021, its enrolment had reached twenty-four thousand at four locations throughout BC's Lower Mainland. Some of the young people who have passed through its doors have gone on to professional careers, particularly in dance, but creating professional artists is not the principal aim. Its vision remains unchanged: "A better world where all young lives are inspired to pursue a lifelong journey towards self-expression, compassion, and humanity."

That vision also sums up the work of Toronto-based Thrive Youth Development Canada (TYDC). The organization was founded in 1996 by Marilyn Field, a Toronto teacher and pianist who believed involvement in the arts could help disadvantaged children counteract poverty, bullying, social isolation, and violence by developing life skills and self-confidence. The programs (in Ontario, Nova Scotia, and British Columbia) cover music, drama, literature, dance, fashion, architecture, and the visual arts, and are delivered by teams of teachers and artists inside schools and in the community.

TYDC also operates a Youth Leadership Institute aimed at youth who are interested in making art for social change. The projects are chosen by the participants and take the form of movies, websites, comics, or anything that catches the teen

fancy. In 2020, the RBC Foundation committed $240,000 to a three-year expansion of the program in British Columbia and Ontario to create, in the words of current head Jennifer Wilson, "a sandbox for youth to embrace their own power as community leaders and build their own path forward in a way that reflects their values and passions."

After a massive wildfire destroyed the village of Lytton, BC in 2021, a Vancouver-based investment firm teamed up with TYDC to create two hundred "creativity kits" of art activities and supplies. These kits were given to the village's children, providing them with a creative outlet for their emotions and anxieties to help them deal with the trauma of the community's destruction.

A significant element of TYDC's out-of-school arts learning programs intersects with the process of Canada's reconciliation with Indigenous peoples. At Vancouver's Britannia Elementary School, where the student population is sixty percent Indigenous, students from grades six and seven worked with TYDC artist-educator Charlene Johnny, a Quw'utsun artist, to create a collaborative mural depicting their lives as urban Indigenous kids. In a blog about the process, one of the students, Shiloh, wrote: "Art is a language for everyone ... This mural was made with the idea of breaking the barriers of race and religion by showing how other cultures are just forms of art. Also, art isn't just creating something outstanding, it's respecting everyone else's designs and taste."

The famous Venezuelan music education program El Sistema, launched in 1975 by musician and social activist José Antonio Abreu to give poor children free education in classical music, has also been a significant inspiration in

Canada. Abreu saw music as a way to teach at-risk children teamwork, discipline, and the value of aiming for excellence, building confidence, collaboration, and self-esteem through group sessions in playing, improvising, and composing. "Just sitting a boy in a rehearsal to play, when he could be on the corner smoking marijuana," he once said, "is already a very important achievement." When Abreu won the $100,000 Glenn Gould Prize in 2008, Brian Levine, director of the Glenn Gould Foundation, cited El Sistema as conclusive proof that "music education is the gateway to lifelong learning and a better future."

The first El Sistema program in Canada was established by the Vancouver-based Saint James Music Academy in 2007, but similar offerings can now be found in cities from coast to coast. Astrid Hepner, a saxophonist and former music industry executive, is the driving force behind An Instrument for Every Child, an initiative based on El Sistema and launched in 2010. Led by the Hamilton Music Collective in partnership with the Hamilton Philharmonic Orchestra, the project aims to enable every child in Hamilton's elementary schools to get a musical education and learn to play an instrument. Since 2015, Queen's University's education faculty has hosted Sistema Kingston, an intensive music program for disadvantaged children.

Ironically, pandemic restrictions on in-person attendance at schools and universities forced educators and students to find digital ways to learn and to share, sometimes involving the cultural sector. In Halifax, Zuppa Theatre led a senior high school drama class through the creation of an online

"walkumentary" of their district. The Royal Conservatory of Music had already begun to experiment with remote learning before the pandemic struck; COVID-19 forced the school to pivot the entire examination program online to avert what was expected to be substantial student dropout rates. Not everyone was immediately enthusiastic. Examiners needed careful preparation. Students needed reassurance that Zoom really was the way to Carnegie Hall. But it worked. Results in the first year were overwhelmingly positive, with enthusiastic buy-in from both teachers and students, who said being able to play their own instruments in their exams helped calm pre-exam nerves. Virtual classes won't necessarily dictate the future of teaching. Nothing quite replicates in-person learning and interpersonal exchange. But digital technologies saved the day when the day needed to be saved. And as new communications technologies — interactive exchange, augmented reality, robotics — become more flexible and sophisticated, the online classroom might increasingly become a viable alternative.

It's all entirely admirable. Many of the kids these programs touch are enriched in ways that will resonate throughout their lives. Some go on to professional careers in the arts. Some go on to enjoy the arts as members of audiences, as readers, or by attending art galleries. And the initiatives often spark valuable collaborative partnerships among schools, arts and community organizations, and businesses.

But we are still left with the fundamental problem. How do we balance the education system for *all* our children? At a time when the emerging global information economy

is making unprecedented demands on the essential human resources of imagination and creativity, it's time to embed the arts deep into the basic educational curriculum. Time to add another letter — A for arts — to the acronym and turn STEM into STEAM.

SO WHERE DO WE GO FROM HERE?

What's Wrong with
the Status Quo?

A nation is an association of reasonable beings united in a peaceful
sharing of the things they cherish; therefore, to determine the
quality of a nation, you must consider what those things are.
— St. Augustine, *The City of God*, xix–xxiv, quoted in
the Massey Report, 1951

THE FIRST SERIOUS attempt at drawing a blueprint for the
nurturing and growth of modern Canadian culture, and still
by far the most significant, appeared in 1951: the report of
the Royal Commission on National Development in the Arts,
Letters and Sciences. The commission had been convened
two years earlier, in the shadow of the Second World War,
by Prime Minister Louis St. Laurent, and it was chaired by
University of Toronto chancellor Vincent Massey.

The report was frank about the scale of the challenges.
"If modern nations were marshalled in the order of the
importance which they assign to those things with which this
inquiry is concerned," it said, "Canada would be found far
from the vanguard; she would even be near the end of the

procession." The report doubted whether many Canadians could list the names of six Canadian composers. The country was "singularly deficient" in concert halls. Except in the few largest centres, professional theatre was "moribund." What's more, Canada faced "influences from across the border as pervasive as they are friendly" and it warned against "the very present danger of permanent dependence" on American culture. These were not idle concerns: the prime sources of funding for the arts in Canada at that time were the Carnegie and Rockefeller foundations, both American.

Organized and sustained support was necessary: "Good will alone can do little for a starving plant. If the cultural life of Canada is anemic, it must be nourished, and this will cost money. This is a task for shared effort in all fields of government, federal, provincial, and local."

Massey was reluctant to use the world "culture" — he called it "a naughty word" that "suggests everything that is highbrow, self-conscious and esoterica" and the term was crossed out often in early drafts of the report — but he believed firmly that it was "in the national interest to give encouragement to institutions which express national feeling, promote common understanding and add to the variety and richness of Canadian life."

This integration of the arts and humanities into a larger concept of nationalism was an important part of Massey's thinking. In his book *On Being Canadian*, which he published in 1948, four years before he became the country's first Canada-born governor general, he wrote: "No state today can escape some responsibility in the field to which belong

the things of the mind ... Our peoples need to understand the way of life which they are defending in the war of ideas of today so that they can defend it the better. The state indeed has very serious obligations in this field." He warned particularly against the influence of the United States on Canadian culture. "If the obstacle to true Canadianism was 'Downing Street' in the nineteenth century," he wrote, "its enemy today is 'Main Street' with all that the phrase implies."

The Massey Report enabled great talents to flower and mighty things to be achieved, among them the creation of the Canada Council for the Arts and the establishment of Library and Archives Canada. But for all its success in fostering orderly progress and professionalism in the arts, assiduous commentators have found blinkered attitudes in the report's pages. In her 1976 book, *Who's Afraid of Canadian Culture?*, cultural critic Susan Crean called the Massey Report a "cultural smokescreen" and "the effort of an elite class of patrons to preserve its own cultural forms by transforming them into Official Culture." In her 1990 book, *Making Culture: English-Canadian Institutions and the Arts Before the Massey Commission*, historian Maria Tippett accused "a Trojan Horse of the elite" of sweeping away the history of community arts centres and folk traditions in favour of their own notions of official culture. In a 2018 essay in *Canadian Art*, media artist Zainub Verjee (who won the 2020 Governor General's Award in Visual and Media Arts) called the Massey Report "an out-of-date document premised on elitist, Eurocentric, 19th-century notions of culture" but one that nevertheless "still leads to policies which define, officially, what

that Canadian 'culture' and 'content' is — to the exclusion of much actual Canadian art making and actual Canadian artist experience."

Others have applied a kind of reductive logic to question whether a distinctive Canadian (or any national) culture can exist at all, on the grounds that (a) political boundaries don't of themselves enclose a homogenous culture, and even if they do (b) the content of a localized culture can't be assumed to be the expression of a fixed national character. To which one might be tempted to reply, (a) absolutely, and (b) no, of course not, yet those distinctions have nevertheless been made throughout history — or why would we have such battles over cultural appropriation? — and will go on, as long as humans organize themselves into discrete groups and express their identities in discretely idiosyncratic ways, whether those ways be mariachi bands or *bharatanatyam*.

Three decades after the Massey Report, the Canadian government took another shot at its relationship with the arts. In response to the recommendations of a royal commission on financial management and accountability, a Federal Cultural Policy Review Committee was created in 1980 to propose better ways to administer arts funding. Co-chaired by composer Louis Applebaum and publisher Jacques Hébert, the committee repeated Massey's demands for a serious rethink of our attitude toward culture, insisting that "the artistic professions must be placed on the same footing as any other honorable and vital vocation" — in part because a fresh public awareness of artists' societal contributions would make it easier for government to support them — and calling for significant improvements in funding for artists, because

"the largest subsidy to the cultural life of Canada comes not from governments, corporations or other patrons but from the artists themselves, through their unpaid or underpaid labour."

One of the most controversial of its recommendations was that the CBC should get out of television production and buy its programming from independent companies. The report also reiterated the importance of the arm's-length relationship between the government and its cultural agencies (an issue that has always been contentious). It did little, however, to counter the accusations of elitism that had been thrown at the Massey Report or to address the complex cultural realities of an increasingly polyglot Canada.

In 1992, the Standing Committee on Communications and Culture produced *The Ties That Bind*, a report on consultations held with the arts and broadcasting community and government agencies the previous year. "At a time when the impact of culture on the spirit of our nation has never been more important," said the report, "Canadian culture is facing seriously declining support from most directions." To counter this, the report made sixteen recommendations for change, starting with the formulation of Canadian cultural and communications policies.

More money was a high priority. "Our Committee believes that culture and communications are truly growth industries," explained the report. "Given the cultural malaise which appears at the root of many of our country's constitutional conflicts, we believe that serious consideration must soon be given to a quantum move forward in the level of federal budget investments in culture and communications." More money was by no means all the report called for. It

also recommended that citizens be given access to Canadian culture and endorsed integrated policy planning among all federal departments.

Unique Among Nations, the government response to *The Ties That Bind*, appeared the following year. It said all the correct, encouraging words about the importance of arts and culture, and declared full agreement with the report's call for a new policy structure. The government stopped short of making plans to actually create a new policy structure, instead listing the piecemeal bits of legislation it was working on in areas such as copyright, broadcasting, and the status of the artist. As for the funding increases proposed by *The Ties That Bind* — five percent a year for five years — "there is not, at present, funding available" and "the Government's efforts must be consistent with the current climate of fiscal restraint."

The refusal to commit more cash wasn't what upset the arts community the most. Indeed, the Canadian Conference of the Arts, the lobby group that led the campaign for policy change, agreed that a call for major increases in funding was unrealistic: "The commitment of ... stable and responsible levels of funding would be a welcome enough signal in the current economic climate," commented CCA national director Keith Kelly. But he added: "Perhaps the most distressing element of the document is that it reflects no enthusiasm or appetite for the task of cultural policy development ... If the response was designed to send a message to the cultural sector, it has done so with great clarity. Those of us who earn their livelihood in this sector have received the full measure of government attention that we can hope."

By the end of the twentieth century, the idea of "cultural industries" as a pillar of Canadian artistic life was well entrenched — even though, as former Canada Council director Timothy Porteous always insisted, they are services, not industries. But the threat from the south to Canada's cultural identity had only magnified as globalization's tentacles reached deeper into the cultural marketplace. The U.S. was gaining a larger and larger share of our audience and threatening the survival of the homemade cultural product.

By 1999, Sheila Copps, at that time minister of Canadian heritage, Canada's chief cultural fiefdom, launched a campaign to enlist international support for a binding agreement to respect the "cultural diversity" of individual nations and not "constrain local cultures" and the policies that supported them. The aim was to ensure that Canadians would have access to the best the world could offer, while preserving space for Canadian culture. As Copps put it, "sharing a border with such a powerful world economy, we need shelf space for our own stories." Protectionist? Well, of course.

From the start, Copps's campaign was characterized by the media as a fight against Hollywood and the American music machine. However, it is also worth recalling the words of former Canada Council chair, Mavor Moore, in an article he wrote for the *Canadian Review of American Studies* in 1997, when the movement for cultural sovereignty was just beginning to gain momentum: "Far from being anti-American, fostering one's own creative plants is as American as apple pie — bearing splendid witness to the validity of the U.S. principle of self-determination."

UNESCO, with its lofty ambitions to foster world peace through shared advances in education, science, and culture, was selected as the most likely place in which to wage the battle for a binding international convention on the topic. Victory took six years. Not surprisingly, the U.S. wanted no part of any international deal that would threaten its global cultural domination, and its stonewalling influence on what became an international juggernaut of support for the proposal was relentless. In the end, however, none of the American attempts to thwart or modify the convention worked. In a session of high drama, with seating in UNESCO's great Paris assembly hall at a premium, the Convention on the Protection and Promotion of the Diversity of Cultural Expressions was adopted on October 20, 2005. The vote was 148 countries in favour, 2 against: the United States and Israel. You could probably claim the establishment of this convention as one of Canada's greater successes on the international stage in the new century. It earned us no friends south of the border.

CANADIAN HERITAGE HAS one of the largest portfolios in the federal government; it includes creativity, arts, and culture, sport, diversity, inclusion and official languages, museums, Library and Archives Canada, as well as national battlefields and state symbols. About twenty Crown corporations, agencies, and tribunals report to the minister, among them the Canada Council for the Arts, the CBC, and the National Gallery of Canada. In 2021, the Canadian Heritage budget was about $56 billion, just over 5 percent of the overall federal budget.

One of the Canada Council's most jealously guarded privileges is its arm's-length relationship to official power, a principle rooted in the recommendations of the Massey Report. The Second World War had been a battle for many freedoms, and the idea of "state culture" was anathema. "Government should support the cultural development of the nation but not control it," said Louis St. Laurent when he recommended the council's creation. It was established as an independent Crown corporation, reporting on its operations through what was then the Department of Communications. Canada has many Crown corporations, usually providing services the private sector wouldn't be willing or able to undertake. They are ultimately responsible to Parliament, generally through a minister, and Parliament sets their budgets, but they operate outside direct political control and are theoretically free to chart their own course: the arm's-length principle.

As it turns out, "arm's-length" is an elastic term. I once saw a chart created by Heritage staff depicting the positions that different agencies occupied along the ministry's outstretched limb. Out by the fingers were the Canadian Radio-television and Telecommunications Commission, which controls all aspects of broadcasting and communications, and the Public Service Commission, which oversees government staffing. The Canada Council sat at the middle of the forearm, along with the CBC, the National Arts Centre, and Telefilm Canada: the core of the production team, as it were. Closer to the shoulder, at say the elbow, were all the national museums and galleries. Even closer were the National Film Board, Status of Women Canada (now known as Women and Gender Equality Canada), the National Battlefields Commission, and

Library and Archives Canada. These different positions on the minister's arm had to do with the agencies' official level of autonomy. But it's not difficult to see the positioning as a way of justifying interference by bureaucrats and politicians: the closer to government, the less freedom for autonomous activity.

In the six years I was on the Canada Council board, one of the few principles that united board members was the unassailability of the arm's-length position. That is hardly surprising. Functioning at arm's-length from the money dispensers, free from political pressures, the council can support work that might be difficult, controversial, and even critical of government. It's also a win for the politicians, since they are insulated from blame for decisions that might be controversial and can legitimately claim it wasn't their funding decision when people complain that public money has been given to an art exhibit featuring dead rabbits, a decaying meat dress, or a book of poems by bill bissett that included the title "in nova scotia th peopul call shit houses housus uv parliament."

It would be unnatural, however, for politicians not to try to sneak in a little untoward influence from time to time, whether it is in the guise of extra cash for specific undertakings, ensuring that boards include individuals sympathetic to the political cause, or whispering a well-judged word in the right ear.

And for all its vaunted independence, the Canada Council has sometimes been quietly co-opted as a tool of the government in power — to help promote national unity in the late 1990s to counter the movement for sovereignty in Québec, for instance. In 1984, council director Timothy Porteous

incurred ministerial displeasure by speaking out against a parliamentary bill that would increase government oversight of Crown corporations, including the Canada Council. It might, he said, "seriously diminish the freedom from political and bureaucratic interference which has allowed the Council to be an effective and credible organization supporting the arts." He was supported by the chairs of the boards of the Canada Council and the National Arts Centre, both of whom threatened to resign, and ultimately the council and several other arts agencies were exempted from inclusion in the bill. Porteous remained outspoken about what he saw as increasing government control of arts funding, and the following year, believing that the government was about to fire him, he quit.

Of course, arm's-length is also an elitist position, which makes it an easy target for the populists. Insisting that an unelected agency be allowed to give away public money without having to consult a higher authority implies that you believe that some people are in a better position to know how to distribute those resources than others. They are, of course; but in populist times that can be an unpopular thing to say.

Free marketeers might even argue that government intervention of any kind, at whatever length of arm, is unwarranted. Why should the cultural sector get special attention? Live and die by the market: isn't that the point of neoliberal capitalism? But those who trumpet the notion that the free market is the only viable system in which both the individual and society can thrive seem to ignore frequently the inconvenient evidence that were it not for sustained government bailouts, neoliberal capitalism itself would have collapsed long ago.

According to figures quoted by economists Robert Pollin and Gerald Epstein in the *Boston Review*, the pandemic-inspired CARES Act amounted to about 14 percent of the United States' GDP in 2020, yet those massive "stimulus measures" were exceeded by nearly $4 trillion, almost 20 percent of American GDP, that was spent to save Wall Street in 2008 after it had lobbied against regulations so it could do the very things that almost destroyed the world economy. According to Pollin and Epstein, similar bailout operations have been mobilized regularly and with increasing force in other high-income countries since the early 1980s. We should also not forget the subsidies various levels of government in Canada provide the oil and gas industry and professional sports. The problem with cultural spending is not the *fact* of government support. The problem is the *how*. And the *how much*.

Under the current system of cultural support in Canada, grants to cover operations and creativity for professional artists and arts groups are largely (but by no means entirely) distributed based on competitive merit. The Canada Council is the main source of federal arts funds, although Heritage administers a host of programs of its own, supporting presentation, training, cultural spaces, and publishing. The professional arts can also call on similar grant programs from a piecemeal set of provincial and municipal funding.

Quite apart from the fact that there is never enough money to go around — or, more accurately, that not enough money is allocated to culture as a priority — the system is lamentably out of touch with current Canadian realities. It might be a what-if too far to suggest we give overall control of the arts sector to the arts sector itself, in a form of collaborative

independence that might be modelled on the recognition of the traditional legal and governmental practices of Canada's Indigenous peoples. Snatching a bleeding haunch of meat from a ravenous hyena would be child's play compared to the task of prying the grasping hands of power from control of the cultural cash box. But it is beyond time to rethink and reframe the way we support Canadian culture. As previous chapters have shown:

- Government's insistence on proof of measurable social usefulness as justification for support ignores the less measurable ways engagement with culture and creative activity contributes to a healthy society.
- Its scattershot approach to funding, with various levels of government and multiple agencies making the decisions and handing out the cash, means the benefits of shared planning are sacrificed.
- Despite funders' recent prioritizing of Indigenous and minority arts, the continuing emphasis on professionalism and accountability locks out vast communities of creative activity and many forms of non-commercial creative expression.
- The process of making policy and granting decisions is highly susceptible to racial, social, and even arts-disciplinary inequality.
- Artist compensation lags far behind that of most other workers in Canada.

Beyond these essentially pragmatic issues around the equitable redistribution of resources lie equally important

demands for social rebalance and redress. In recent years, the federal government has expanded its consultation process with Indigenous groups. Some Canadian provinces are finding ways to access Indigenous knowledge in health care. Hiring practices are changing in government offices across the land to ensure a fairer representation and a louder voice for the previously unheard and under-represented. And it should hardly need to be said that any new mechanism that aims to put culture and society on an equal, collaborative footing should incorporate not just the fair and proportionate representation and authority of Indigenous voices at the decision-making table but, equally, a new respect for the forms of Indigenous wisdom that Canadian society has until very recently chosen to ignore. Collaborative decision-making based on seeing issues from different points of view; respect for the wisdom and advice of elders; a collective consciousness that is intricately interwoven with the natural world; an ingrained understanding of the need for balance in all things: as we saw in the previous chapter, non-Indigenous Canadians have much to learn from listening to Indigenous artists.

Daniel Heath Justice, Canada Research Chair in Indigenous Literature at UBC and author of *Why Indigenous Literatures Matter*, stressed in a recent podcast that we "need to hold up those stories and those storytellers whose voices maybe haven't been given a centred space and encourage them ... We have a lot of allies who want to help us tell our stories when what they really need to do is help open the door so that we can tell our own stories ... We need to buy those books from Black writers and from Indigenous writers and from trans writers and a whole range of writers. If we really believe in

a range of representation, we need to bring our support to that and not just ask for more inclusion in Harry Potter or whatever."

A more balanced, more compassionate Canada is something arts audiences evidently want. One of the conclusions drawn from a broad Culture Track audience survey in 2021 was that it is important for arts organizations to take a holistic approach to diversity, equity, and inclusion, building it into every facet of every organization, from decision-making and workforce representation to programming and community engagement. In other words, diversity isn't simply a box to be checked, a number to be met. It has ramifications in many corners of our complex world.

The new Canadian Cultural Contract proposed here walks the reconciliation talk, not as a tired gesture of affirmative action, not in any mealy mouthed spirit of so-called tolerance (what an arrogant word that is: *I will put up with you*, it says, *but I know I'm better*) but by embracing the cultural perspective and needs of the Indigenous community and historically neglected minorities and embedding them deeply and permanently in the discussion. The activation of the compassionate imagination to deal with these issues will need boldness, wisdom, and generosity; boldness to tackle entrenched attitudes and practices from new directions; wisdom to recognize that, when we venture into a new unknown, risk is ever-present and setbacks will threaten at every bend; and the generosity that understands that, whatever the choices we make, they must be to the positive benefit of the full, individual diversity of society.

ANOTHER SIGNIFICANT CONCERN as the new Canadian Cultural Contract takes practical form will be how the cultural sector integrates and manages new technologies and social media. The Internet of Things is upon us, and we live and work in a densely connected wireless version of Marshall McLuhan's global village, a matrix of electronic exchange that allows us to communicate at lightning speed across many platforms with no consideration of real or imagined borders. The medium, now normalized and fully integrated into our everyday lives, is no longer the message; the medium is a tool we use to find the answers, and the access that the Internet gives us to what the Canadian tech analysts Don Tapscott and Anthony D. Williams call networked intelligence, a source of wisdom and technological innovation that has enormous implications for anyone working in the arts.

Media artists pioneered ways to document and display artworks on the Internet, leading to the current cornucopia of free online access to many of the great collections of the world. Mass collaboration through social media has made crowdfunding a familiar means of raising money rapidly. Crowdthinking, a concept of collaborative problem solving (not to be confused with groupthink, with its emphasis on conformity), is enabling writers to interact on the Internet to create multi-author narratives and collaborative fiction. The impact of the new technologies even extends to something as basic as searching for information about things we've come across in books. Until now, that has meant having to do a physical or electronic search. But scientists in the UK have created prototypes of what they call "a-books" — augmented reality books that embed a search ability in the volume itself,

enabling readers to swipe a finger over a printed line and have related information pop up on nearby devices like phones and laptops.

While it brings us immense social benefits, the Internet is also the single biggest source of misinformation and conflict in our modern world. One of its most insidious effects is the way it has destroyed our ability to concentrate. Neuroscientists are coming to understand that social media manipulates our responses to information and experience by generating digital delivery systems that interact with the same brain mechanisms that control how we manage uncertainty. Managing uncertainty involves being able to understand and represent the world accurately, a process that social media consistently disrupts by overloading us with promise and surprise — *mail is waiting, updates are ready, here's what happened half a world away a minute ago* — and by exposing our neural systems to potential reward, whether it's through the generation of "likes" for that video featuring the escapades of our cat or the casino-like unpredictability of Facebook's "swipe to refresh" feature, "behavioral crack cocaine," as it has been called. It doesn't just want us to pay attention; it commands our next click.

This addictive quality of social media is so comparatively new that it hasn't yet drawn the scrutiny given to alcohol or drugs or tobacco — the idea of digital self-control, for instance, has not been promoted with the same zeal as, say, healthy eating or regular exercise — although early indications suggest it should be of similar importance. The steady coarsening of public discourse, the shallowness that paralyzes public debate, the pernicious crudeness of public taste: much

of this is directly attributable to the mind-warping effects of social media.

Inevitably, the Internet has affected the critic's role. In the past decade, more than half of all arts journalism positions have been eliminated in North American newsrooms. The job I did for much of my life, arts criticism, has been rendered — is thought to have been rendered — redundant by the gift that the Internet has bestowed, the ability for everyone to circulate their views, instantly, to the world, in 280 characters, reductionist thinking in a virtual nutshell. On BookTok, the readers' corner of the global social media app, a fifteen-second clip of a book "review" by a school-age "influencer" can vault books to the top of the best bestseller lists.

How do we react to this? Do we wring our hands and lament that technology has fostered an anti-elite, anti-intellectual society where people feel that professional criticism is not necessary? (The cynic might point out that anti-intellectualism is nothing new.) Or do we find ways to adapt, new ways of responding? While it's easy and tempting to dismiss social media innovations like TikTok and BookTok as glaring examples of social media's power to lower the common denominator, we cannot ignore them. As writer Leigh Stein put it in a post on *Literary Hub*, BookTok is "the most powerful word-of-mouth engine the book publishing industry has ever seen."

James Gnam, who directs Vancouver's interdisciplinary ensemble plastic orchid factory, has noted that the Internet generation, one that has never known a time when the Internet didn't exist, communicates by what he calls "digital collaging:" specific cultural references (music, language, image, popular

culture) that they weave together into a rich new form of expression.

The same thing is happening in performance. Classification into genres (music, dance, theatre, mime, film, video) is not only out of date but has diminishing relevance. Everything is accessible, and everything is endlessly cross-referential. Nothing is static, no previous assumptions can be trusted. And as the new technologies continue to expand our creative range, the scale of what is on offer from our artists will grow exponentially.

The great and exciting challenge of writing cultural commentary today lies in finding ways to get a grip on that seething complexity, and in finding new ways to write about it that will interest and provoke audiences looking for help prioritizing and contextualizing what they discover in this new creative universe. Maybe, indeed, we will develop new forms of communication that go beyond writing and embrace the "digital collaging" that Gnam identifies. However the form evolves, we will continue to need people who will stimulate critical thinking and enhance public understanding and appreciation of creative inquiry, even skepticism, in our interpretation of the world around us. This is not so much the era of the death of criticism as the period of its rebirth.

THE NEWEST TECHNOLOGICAL advance — artificial intelligence — presents us with fresh quandaries. Like it or not, we are being forced to re-examine our moral, economic, and social priorities as human creatures in a networked world. What might have seemed extravagant claims for AI at the start

of the century now seem modest. We're approaching Web 4.0, the "symbiotic web," where technology and humanity intertwine. In early 2022, Timothy Shoup of the Copenhagen Institute for Futures Studies estimated that 99 to 99.9 percent of web content will be AI-generated by 2025 to 2030, rendering the Internet as we know it unrecognizable and opening the door to entirely new expressive and creative realms.

In this brave new world of creativity facilitated by technology, we must be careful what we wish for and circumspect in the ways we use what we find. We know that, for the moment at least, everything that AI generates is in response to human input. But the creative potential of apps like OpenAI's ChatGPT, with its ability to generate disconcertingly authentic-seeming content for professional and private users — everything from college essays to advertising copy — or the image-making app that gave us the Pope in a white Balenciaga puffer coat, which fooled me and many others, is already challenging our understanding of the creative act. In what ways, for instance, can we say that a painting created by a computer is a work of art?

Harvard psychologist Steven Pinker thinks fears that chatbots will displace human thought and writing are misplaced. "It's impressive how ChatGPT can generate plausible prose, relevant and well-structured, without any understanding of the world," he said in an interview with the *Harvard Gazette* in February 2023. "We're dealing with an alien intelligence that's capable of astonishing feats, but not in the manner of the human mind." What is more likely, he said, is that "as with the use of computers to supplement human intelligence in the past ... we'll be augmenting our own limitations."

Not all are so sanguine. In *The New York Times* in February 2023, political analyst Ezra Klein raised the spectre of AI's developing capabilities as an agent of manipulation and disinformation. "What about when these systems are deployed on behalf of the scams that have always populated the Internet?" he asked. "How about on behalf of political campaigns? Foreign governments? ... Somehow, society is going to have to figure out what it's comfortable having AI doing, and what AI should not be permitted to try, before it is too late to make those decisions."

In March 2023, Elon Musk, Apple co-founder Steve Wozniak, and hundreds of others released a letter urging a six-month moratorium on development of yet more powerful versions of AI. (His plea was eerily reminiscent of Robert Oppenheimer's comment when he saw the first tests of his atomic bomb: "Now I am become death, the destroyer of worlds.") But time has a habit of rendering moratoria moot. We know that social media companies are reluctant to police themselves or their users, arguing that regulation would throttle free speech and inhibit innovation while curtailing their revenues and the extraordinary, but unrealistic, value of their companies. We also know the electronic universe, like pharmaceuticals or aerospace, is also an area of broad social benefit. Where do we find the balance?

The effect of the new digital technologies on broadcasting in Canada has also provoked vigorous debate about how best to protect Canadian interests in the online world. In 2023, Canada's Online Streaming Act, the first update to the Broadcasting Act in over three decades, laid out new Canadian

content regulations for streaming giants like Netflix and Spotify. The intent of the bill echoed the spirit of Sheila Copps's moves to protect national identity twenty years before: to give Canadian creators more opportunity to have their work broadcast, to make it easier for Canadian audiences to access Canadian and Indigenous stories, and to require those who benefit from Canadian arts and culture to invest in it.

The change drew guarded enthusiasm, with some commentators questioning exactly how Canadian content would be defined, and others fearing that small-scale contributors would be forced out of the picture. In an impassioned speech in the Senate, the novelist David Adams Richards declared: "This law will be one of scapegoating all those who do not fit into what our bureaucrats think Canada should be."

The misgivings were not misplaced. The changes to the Broadcasting Act are a useful first step, but much remains to be done. The challenge of how we fit the increasingly sophisticated technologies of the communications multiverse into the structures that protect and nurture Canadian culture, without infringing on personal freedoms, inhibiting scientific advances, or silencing alternative voices, will be one of the greatest challenges faced by those who shape and lead our country's cultural future. It will make our international convolutions over the cultural diversity issue at the turn of the century seem a minor squabble. The principles and policies that eventuate will shape the identity not only of the Canadian Foundation for Culture but of Canada itself.

The Canadian Foundation
for Culture

*The times we are living in require reflection, and
attentiveness to the work of others, so we can hear our own voices
better and see more clearly what our role may be. The arts, and
artists, are more important than ever now.*
— Mirna Zagar, executive director, The Dance Centre

IN THE OPENING chapter of this book, I briefly sketched a
vision of a wholesale realignment of the way society inter-
acts with art and culture: a new Canadian Cultural Contract
between the government of Canada and the people it serves.
At the root of that vision is the belief that by agreeing to
make art and culture a fundamental part of the Canadian
experience, we will find new realms of solace, inspiration,
provocation, and pleasure in our lives; we will re-infuse our
social discourse with the decency, openness, modesty, good-
will, and concern that mark the Canadian character; and we
will embrace the imaginations and inspirations of our artists
in our search for better responses to the great challenges and
opportunities of our time.

This is not as extreme an idea as it might sound. Canada's low standing in the Global Innovation Index (in 2022, the GII report from the World Intellectual Property Organization placed us at fifteenth) and our dismal self-ranking in terms of innovation (in 2021, the Conference Board of Canada innovation report gave us a letter grade of C) has drawn a similar call for policy change from the social sciences. "Social scientists study people, cultures, systems and behaviours," wrote Angèle Beausoleil, a University of Toronto professor of business design and innovation, in a February 2023 article in *The Conversation*. "While research and development is critical for invention, it's human insight — also known as end-user research — that leads to innovation." She proposed a reframing of government policies to zero in on human-centred market research and encouraged research and development labs to include at least one social scientist for every engineer or researcher.

Those policies will also have to factor in the increasing demands for the decolonization of arts support and for new, more inclusive definitions of what constitutes Canadian art and culture. In the following pages I offer a draft blueprint for how the new Canadian Cultural Contract might work. It is the product of both my hands-on experiences in Canada's cultural trenches and my decades-long observations as a critic and commentator. It neither pre-empts the dialogue nor commandeers its conclusions. It is a point of departure, a topic for debate.

Central to the entire enterprise will be the creation of the Canadian Foundation for Culture, a new agency that will operate at arm's-length from government, skipping over

ministerial restraints and reporting directly to Cabinet. Its remit will be Canadian culture in its entirety. Under its aegis will be all the arts disciplines that the Canada Council currently deals with, and most of what's cultural at Canadian Heritage — festivals, arts presenting, touring, community cultural development, Indigenous and minority cultural support, film and television production and sound recording, the publishing industries, and communications technologies.

The Canadian Foundation for Culture will have five operating principles at its core: the recognition of arts and culture in all its manifestations as a necessary humanizing foundation of civil society; culture's status as a cross-cutting priority throughout government; the democratic involvement of Canada's rich natural source of creative imagining, the cultural sector, in the creation of public policy; the inclusion of Indigenous and diverse creative expression and ways of knowing as an integral element of the cultural fabric; and a commitment to ensure open access to arts, culture, and creative activity for every Canadian.

Permeating the foundation's operations will be an integrated, holistic approach to culture in every area of government. In the days when the largest conurbation in Canada was known as Metro Toronto, a sign hung on the wall of the city's largest newsroom. Its message was simple: "What does it mean to Metro?" On the same principle, it will become standard practice for policy makers in every field — health, education, justice, Indigenous relations, global affairs — to ask, as they make their deliberations: "What does it mean to Canadian culture? How does it relate to what other branches of government are doing? How can artists help?"

From those principles are drawn four broad strategies:

1. Embed artistic experiment and Indigenous ways of knowing into the methods our governments use to develop policies and make decisions.
2. Broaden the scope and availability of art-making of all kinds, and reinforce its support.
3. Create new ways to enable and encourage Canadians to make the arts and creative activity part of their lives.
4. Expand the role of the arts in the educational curriculum, from kindergarten through high school and beyond.

This realignment of priorities and cross-fertilization of ideas and understanding will:

- Infuse the human and moral dimension more deeply into bureaucratic decision-making.
- Lead to more inclusive views of the benefits of public investment in cultural activity, involving not only the instrumental benefits, but also the less tangible elements that go to make up community power and social wealth.
- Spread responsibility for developing and funding culture far beyond the current narrow fiefdoms.
- Flood Canadian society with the spirit of the compassionate imagination.

I hear the cries of outrage already. But the mansion of Canadian culture has many rooms. However we might try to keep them separate, the cultural industries and the not-for-profit creative sector are like the arms of poet John Donne's

compass: without each other they don't work. The ideas generated by private creativity and the risks taken by the not-for-profit arts sector are what make commercial culture possible. Reciprocally, the commercial sector supports the innovation economy and keeps many creative artists fed and housed. Everything connects. Their coexistence under the umbrella of the Canadian Foundation for Culture rationalizes that connection and lets us take a fresh look at how it might be rethought for modern times and a changing world.

A broad range of opinions, offered in structured discussion, will always lead to better-informed decisions, and the visions, policies, structures, mechanisms, and funding processes of the Canadian Foundation for Culture will be overseen by a leadership panel as inclusive and diverse as Canada itself, drawing on the creative and performing arts, humanities and social sciences, business, industry and labour, and non-governmental organizations that support the arts as well as representatives of Canada's Indigenous and diverse communities (strong arguments can be made both for and against the establishment of a stand-alone Indigenous and Diversity Cultural Secretariat, perhaps along the lines of the Canada Council's Creating, Knowing and Sharing program).

What will be the role of the Canada Council for the Arts in all this? One of the pandemic's most profound lessons was that the old ways of running our arts organizations and cultural bureaucracies were no longer enough. As Canada Council director and CEO Simon Brault said at the council's annual public meeting in 2023: "In Canada and all over the world, the era of arts funders as gatekeepers of society's artistic and cultural life is coming to an end — and this is not

a bad thing." I'm not persuaded that arts funders ever were truly gatekeepers of our cultural life. But even if they were, what Brault advocated at the same meeting — the wholesale reframing of our core understanding of what art is and does through the "decolonizing" of the council — would indeed bring about the end of their influence. Which, as he says, may not be a bad thing at all. We are certainly at a stage where we need to do things differently. But what this book proposes is not more bureaucracy and bigger government. It's about retooling the machinery we already have in preparation for the demands that will be made on it in the years to come. It's about making the government we have smarter, more flexible, more open — open to possibility and change, certainly, but also open to a wider society than the one that is currently served.

Truly pan-Canadian outreach and collaboration will be baked into everything this agency does. That doesn't mean identikit art making or cookie-cutter policies and programs. Common interests can bring together a wide variety of human individuals, but the cultural sector is in no way homogenous in its needs, or even unified in philosophy or ambition. Change will require a significant redistribution of power and resources, a bold new approach to sharing and collaboration, and recognition that the current administrative and funding silos can't deliver what our changing understanding of the interlocking world requires. We all make and experience art in our own way; we all find our own ways to grow through those experiences. And there's much to be said for the value of the small scale and the local, particularly in Canada, where we are so often hostages to our geography. Under its national

umbrella, the Canadian Foundation for Culture will emphasize small-group collaboration and recognize regional differences and interests.

As the foundation's financial arm, the Canada Cultural Fund will function as the country's cultural bank, reflecting the new importance we attach to the cultural sector as the compassionate, imaginative guide to our common future. It will be sustained by an augmented, centralized treasury, operating at arm's-length from government, to foster all aspects of the creative expression of the multiple cultures of modern Canada. Here is where professional arts organizations, museums and galleries, and individual artists of all stripes and inclinations will find a common operational resource.

How will we pay for it? Part of the revenues will come from the consolidation of funds that exist across a wide variety of cultural agencies and departments. Part will come from repurposing and reallocating other resources at government's command according to new priorities that recognize culture as a central contributor to the common good on the same level of importance as health and education — and both those areas will also need to see budgetary increases to recognize the overlaps between the arts, health, and education.

Fundamental tax reform will also be in the cards. Perhaps a fraction of the GST could be allocated as a dedicated contribution to cultural funding. Part of what's needed will also be covered by debt. The fiscal conservatives will protest that we can't afford it; we must avoid debt and keep taxes low. But as Alex Himelfarb pointed out in 2022, the cost of public borrowing to restore the caring economy is still historically low enough that it would be frankly irresponsible not to borrow

what's needed. (We all know that interest rates fluctuate, but the Bank of Canada official rate averaged 5.79 percent from 1990 to 2022, reaching 16 percent in February 1991, and 0.25 percent in April 2009.)

"Of course, we have to figure out how we will pay for what we want (starting with taxing the rich has rarely made more sense) and how we might best manage the fiscal risks," Himelfarb blogged at the end of 2021. "But we have to reject the fiscal primacy that somehow puts money risks ahead of risks to human health and wellbeing." In an early 2023 email exchange, he added: "The issue of debt is tricky as interest rates rise, but rather than treating public debt as poison we'd be better to debate what's good debt — investments that make us stronger and more resilient — and bad debt, for example tax cuts for those who need help least."

Recent studies by the International Monetary Fund suggest that, contrary to common opinion, there seems to be no limit to how much debt advanced economies in good standing like Canada can issue. The economic benefits of policies designed to shrink the size of government have been badly oversold, one study showed, while the social and economic costs — namely, the corrosive effects of increased inequality — had been significantly underestimated. "Now is a time for collective choices," wrote Himelfarb, "a time to decide what matters most to us, what kind of world we want to strive for and leave behind, and what are the greatest risks to what we value ... Whenever we are told that there is no alternative, rest assured that not only do alternatives exist but we would probably prefer them if they were on offer. If we are to truly renew democracy, we need a new common sense shaped not by so-called economic

laws, a new common sense that restores our political imagination, our sense of possibility that we can live in harmony with one another and the planet."

The private sector must be welcomed as part of the change. Business support for cultural activity has been called, with some justification, capitalism with a conscience. Of course, pure altruism is tempered by pragmatism. Shareholders must see a return on their investments. Ledgers must balance. But business understands the importance of research and development, and culture is the R&D of a nation's soul. The field of business interaction with the arts is rich with mutual benefits we have barely begun to explore, although it is imperative that both sides bear a share of the cost of those explorations; otherwise they run the danger of becoming exploitations — to the detriment of the cultural participant. Given the immense potential benefit of involvement with the creative community, business should also be encouraged to foster long-term cultural development. In the education sector, perhaps a giant of Canadian business might establish a STEAM-based program to match the Schulich Leader Scholarships in the sciences, established by entrepreneur Seymour Schulich in 2011 (currently one hundred scholarships a year, half worth $120,000 for students pursuing an engineering degree, and half worth $100,000 for students in science and mathematics).

This might also be the time to ramp up the kind of public appreciation that encourages us to recognize artists as contributing members of society. We already have an impressive panoply of national prizes: the Governor General's awards in visual and media arts, performing arts and literature, the Molson Prizes, the Audain Prize, the Scotiabank Giller Prize,

and so on. We have national, provincial, and municipal poets laureate. But what if we created a National Artistic Treasures program, honouring art objects and artists, to underscore this country's vitality and creative resilience? The debate about who or what to include would itself contribute to the expression of our compassionate imagination.

ONE CROSS-CUTTING DILEMMA that must be fixed from the outset is artist recompense. The argument for the support of individual artists has always seemed plain to me: they are the ones who make possible everything else that happens in the cultural field. Not everyone has always agreed. At one point during my term on the board of the Canada Council, it was seriously suggested that the council get out of the business of funding individuals altogether. Budgetary shortfalls were partly to blame, but the suggestion also reflected a preference for backing likely favourites. Organizations were safer. Giving money to individual artists was like trying to pick racing winners by stabbing a list of horses with a hatpin. Sometimes all you got was an embarrassing public fuss over houses of parliament in Nova Scotia.

Most Canadian artists are artists by their own choice. No one is making them do it. But that doesn't diminish the challenge they face in their attempts to make a living in a modern, capitalist society. If what is created doesn't sell, the artist makes no return. The rapid evolution of the digital universe and the easy availability of creative digital tools have only made things worse. Countless numbers of artists who have trained and sacrificed and suffered still can't turn the

lights on without a side-hustle waiting tables, working in construction, or teaching. Performer unions have managed to establish good and enforceable wage scales for performers and production personnel working with professional producers in television, film, music, theatre, and dance, but no such protection exists for freelance writers and visual artists.

But that's precisely the point. Money for individual artists is risk money; risk is precisely what it's meant to underwrite. Money gives artists the freedom to fail. The possibility of failure is ever-present when artists push their limits, but so is the possibility of transcendence. A grant from the Canada Council is at best a stipend that will cover food and rent for a few months, maybe as much as a year, and there's fierce competition for what few of those are available. (A handful of awards and prizes, some quite lucrative, enrich the mix, but these are few.) But artist after artist, from Margaret Atwood to Michael Ondaatje to Ben Heppner to Judy Kang and Lara St. John, has affirmed the value of a well-timed Canada Council grant. In some cases, it can be life changing. When the twenty-five-year-old Leonard Cohen received a $3,000 grant in 1958 to study "the old ways of ancient capitals," he used it to travel to London, where he wrote the first draft of *The Favourite Game*, and finished another book, *The Spice-Box of Earth*.

As Shannon Litzenberger wrote in *The Philanthropist Journal* in 2022, artists "rely on every and any small benefit afforded to us by the system. We work ourselves regularly into states of burnout. We never say no because we can't. We focus on artistic activities that have the best chance of being funded and promoted … The return on our emotional,

spiritual, and creative investment is shockingly unacceptable. To transcend these dynamics where we artists are too often exploited in our own industry, we will need to experiment with new ways of working that are better aligned with the world we want to live in."

Governments have sometimes attempted, usually in times of economic downturn, to put artists to work on the public dollar. Examples include the American government's New Deal arts programs in the years of the Great Depression and the beginning of the Second World War and the Canadian Opportunities for Youth and Local Initiatives programs during the economic downturn of the 1980s.

In the summer of 2020, scores of arts organizations and hundreds of artists across Canada called on the federal government to implement a permanent basic income guarantee without eroding the existing support for arts and culture programs. (The idea is not new. Several American cities, as well as Norway and Finland, have experimented with some form of basic income guarantee scheme for artists and arts workers.) In the spring of 2021, leaders of Canada's five largest municipal arts councils called for the same basic income for artists, citing the economic devastation wrought on the arts sector by the pandemic. But opposition has always been strong, and not merely to the high costs of such a program. Since conditions of employment are not a factor, objectors argue, individuals receiving these payments would have less incentive to find work or contribute to society in return. When it comes to money, we're not a trusting species.

Revisions to Canadian copyright law, to bring it into line with the rest of the developed world, would also be a significant

contribution to artist solvency. One proposal (advocated since 2010 by the lobby group Canadian Artists' Representation / Le front des artistes canadiens) suggests visual artists should receive a share of the profits from resale of their works on the secondary market, like the residuals that actors' unions collect for television and movie performers. A program of this kind, known as the Artist's Resale Right, was launched in France in 2020 and has since been taken up by many jurisdictions, including the UK, Australia, and the European Union. Canada remains among the holdouts, although in 2021 the federal government indicated that reform of the Canadian Copyright Act to allow resale rights for artists was one of its priorities.

The mention of copyright should remind us that it is imperative that we re-examine the book business in Canada. Within my lifetime, Canadian writing has come of age at home and abroad, in no small part due to the work of our publishing community, which has consistently nurtured our writers, given them a voice, and presented them to domestic and foreign markets. The generous system of grants and subsidies to Canadian publishers has ensured Canadian stories are told. But the survival of Canadian publishing is under serious threat. In recent decades we have lost many of our publishers, leaving the industry in the hands of deep-pocketed, foreign-owned conglomerates which dominate our bookstores and classrooms. How can Canada develop a national literature when publishing decisions are vested in what are, in essence, branch plants of vast international combines controlled outside the country?

Directly linked to this is the problem of sales. Between 1995 and 2022, Canadian publishing lost eighty percent of

its market share in English-speaking Canada. And the market itself shrank. From 1995 to 2020, Canada lost two thousand bookstores and the national association of booksellers. Most perplexing is that many school systems and public libraries in English Canada order their books from the U.S., even when the books are originally published in Canada. That's not allowed in Québec, where all public institutions are obliged to buy their books from accredited booksellers. To get accreditation, those booksellers must guarantee shelf and display space to Canadian writers. The result: bookstores thrive, and Québécois writers get exposure and sales that their English Canadian counterparts can only envy.

The new Canadian Cultural Contract would strengthen the publisher-distributor-reader chain, with tax breaks, incentives, and subsidies to ensure that every segment of the process stays within Canada's borders and Canadian readers are able to buy the works of Canadian writers at competitive prices at Canadian bookstores. Incentives could mirror Québec's shelf-space regulation or follow the example of Paris, which rents city properties to booksellers at low rates and keeps city taxes low. It is an issue that needs urgent attention at the level of both policy and on-the-ground action.

ANOTHER LOOMING ISSUE for the central arts funder: who will choose who gets what? At the Canada Council for the Arts, the responsibilities are broad: to sustain mature organizations and artists who are on their way, to foster new and emerging organizations and artists, to protect tradition but

be open to the controversial and the questionable, to embrace culturally diverse and Indigenous art communities.

The splitting of what spoils are available has always been highly contentious. (In the 2021–22 budget year, 9,107 artists applied for funds and 4,611 were successful, a success rate of 50.63 percent, or slightly over half. They received an average of just under $30,000 each. In addition, 18,139 individuals shared a total of just under $15 million, an average of $829 per person, through the Public Lending Right program.) For many years, the decisions were made within specific arts disciplines by peer review, a system that was regarded even outside the country as the best and fairest available in an admittedly unfair world, and far preferable to arts-granting processes in which decisions are made by bureaucrats.

When I was on the Canada Council, a small jury of experts in the field convened, usually in Ottawa, to evaluate most grant applications. This system was not without its challenges. Finding people from across Canada with sufficient exposure and understanding to make informed assessments can be difficult (particularly since no individual was allowed to be a juror more than once every two years). For the grants officer trying to balance regional representation, gender, diversity, and stylistic specialization (an expert on ballet might not know much about Congolese dancing), it could be a bonus to find a single juror who covered multiple concerns.

Adjudicating quality is, in essence, a personal matter and from time to time the peer panel system has been disparaged as a closed circuit of cliques rewarding cliques. Putting "an ordinary member of the public" on juries has also periodically

been proposed. The idea has the smell of democracy about it: the general public is, after all, the intended audience for the work under adjudication, as well as the tax-paying provider of the funds being distributed. What's more, the voice of the potential consumer, the argument goes, would help balance out the artsy theorists more interested in experiment and new directions than box-office success.

My view on that is that asking "an ordinary member of the public" for specialist advice of this kind is, if not illogical, then unwise. We don't ask ordinary members of the public to make decisions on medical research or what kind of tanks we should buy; we leave that to people with the appropriate experience and expertise. Much of what the Canada Council gives away is risk money, in the sense that there is no guarantee that the investment will deliver creative dividends, so it's important that applications be assessed by individuals able to recognize the edgy, the fresh, the unexpected, and to recognize, too, relative importance (always a fluctuating quality) in the field. That sounds, to be sure, like an elitist position. It *is* an elitist position, if we take elitism to mean requiring a threshold of expertise and experience on the part of the jurors — but it is an important position to take.

At other times, it has been suggested that cultural grants should be distributed on a per capita basis, with each province or region getting a proportionate share. This, too, would be fine if the blessings of the nine muses were distributed across Canada in the same proportionate way, because you would be able to just divvy up the available money and save administrative costs. But creativity pays no attention to postal codes.

Much of this became moot in 2017, described by Simon Brault as "a year of unprecedented transition." Under its new funding program, the Canada Council eliminated the separation of its grants programs by discipline and condensed the existing 147 grant programs into 6 non-disciplinary programs on cross-cutting themes such as creation, presentation, and touring. One of those 6 programs, Creating, Knowing and Sharing, was devoted entirely to Indigenous art and artists and set aside conventional ideas of professionalism in its eligibility criteria.

Juries are still convened, but jury members, still regarded as "peers," are supplied with "context briefs" giving background on "emerging, minoritized and less-understood arts communities and practices" and do much of their basic scoring ahead of their meetings, which are exclusively held online. The eventual recommendations made by the artist jurors are prioritized by staff and it is on those final assessments that grants are awarded.

Some have lamented that the process has become mechanical and the all-important human connection that existed when juries gathered face-to-face has been diminished. But radical changes are occurring in the making and presentation of art, and in Canada's demographic makeup, and these changes demand responses that go far beyond the new guiding principles articulated in the Canada Council's strategic plan. If we are serious about bringing the benefits of creative engagement to all Canadians, it is time to interrogate, to use the shuddersome term so favoured by the academics, the entire question of how we support areas of creative activity beyond traditional funding boundaries.

It is also time to make better use of one of the most valuable natural resources at our disposal. Bringing in the artists to help make decisions — across government, and not simply as peer assessors of their colleagues' grant applications — is a central pillar of the new Canadian Cultural Contract.

Government has a long-established process for reaching pragmatic decisions based on justifiable conclusions. You might call this the rational, left-hemisphere approach. But the rational way, accountable as it might be, isn't always the best way. Artists can engender that vital element of imaginative and sympathetic play that allows tangential approaches to sticky issues like morality and principle without the apologetic embarrassment that so often shrouds open discussion of those matters. Artists prod us out of our comfort zone and allow the imagination to carry us away. As physicist Brian Greene says in his book exploring our search for meaning in the universe, *Until the End of Time*, all art has the capacity to yield "a variety of truth we would be unlikely to anticipate from conscious deliberation or factual analysis. A variety of truth that does indeed stand beyond wisdom. Beyond pure reason. Beyond the reach of logic. Beyond the necessity for proof ... We gain access to worlds otherwise uncharted."

The provocateur who animates and destabilizes a group through comedy and mockery is an enduring figure in theatre and folklore. Traditionally, these figures show us the error of our ways, teach us the principles of living together, and pass on traditional knowledge. They have generous latitude to upset the social applecart, say the unsayable, and animate the imagination, which is where innovation comes from. Collaborative

creativity — story exchange, cross-disciplinary performance, making things together, sharing our imaginations — broadens knowledge, increases understanding, admits conflicting views and values, and fosters compassion and respect; all essential elements of fruitful policy debates.

Creative individuals from every field of cultural activity and all Canada's shared cultures should be invited into the policy-making pit, not as consultants or advisors, but as participants, bringing the compassionate imagination to bear on our decision-making and fostering a process of collaborative imagining that will help our bureaucracies get a better, more humane understanding of the issues confronting them. What might happen if Theatre for Living were to create one of its Power Plays with the powers that be at, say, the Treasury Department? What if everyone in government were given time to dip into Anishinaabe comedian Ryan McMahon's free video course on Indigenous law, colonial history, and environmental justice? Consciousness raising doesn't have to be done in an atmosphere of solemnity, even if the issues are as serious as these.

Studies of the impact of this kind of engagement with creative activity have repeatedly shown how valuable this work can be. Freeing our imaginations in this way allows us to see ambiguity more clearly. Creative play of this kind amplifies the debate by admitting the possibility of failure, by allowing mistakes to become learning experiences, and by suggesting fresh and positive outcomes. It also fosters understanding and compassion.

THE NEW CANADIAN Cultural Contract will spread wealth to the broader community. Right now, access to the arts isn't a level playing field. Many Canadians living outside the country's larger centres have only limited access to live performance. However, substantial evidence exists that audiences are ready to take advantage of enhanced access if it is provided. Part of the new Canada Cultural Contract should include an individual credit, accessible via a central registry, giving every Canadian the chance to feed the compassionate imagination, in ways of their own choosing: let's say $1,000 a year, to spend on anything to do with the arts and culture, simply for personal delight and exploration.

Of course, every Canadian already enjoys an invisible arts subsidy, in the form of the government grants and other supports given to the arts sector. Without subsidies, Canadian authored and published books would cost about double what we pay for them. Many Canadians would be unable to afford concert or theatre tickets if the full cost of production was factored into the price. The Canadian Cultural Credit will extend this benefit by giving Canadians both access and choice: not simply to buy books or art or tickets to performances, but also to become involved with creative activity in the community.

Any increase in access to cultural activity should include free admission to all to our traditional cultural shrines. Free access has allowed libraries to play a significant role in bringing people from every segment of society together to share a common resource. Their contribution to literacy alone makes public investment in libraries worthwhile. But their value and usefulness don't stop there. Libraries have become social

centres, with classrooms offering courses, public event spaces, coffee shops, even gardens. They are safe places where people without their own access to the electronic universe can do research, find out about jobs, explore their family trees, search out help with physical or mental problems, or just spend a morning curled up with a book. Research shows libraries play an important role in reducing crime if they are "open and staffed with folks who have the resources and tools to work with people in different circumstances and situations," as Vancouver Public Library board chair Kevin Lowe told Vancouver's city council in March 2023, when he requested three social worker positions for the VPL system. As a matter of practicality in an increasingly unpredictable urban street environment, libraries also provide safe public washrooms.

The same emphasis on social relevance should also guide our galleries and museums into modern times. Today's museums are already far more experiential places than the institutions our grandparents knew. Among the hands-on programs at the Montréal Museum of Fine Arts, for instance, is a digital creative workshop that lets participants use digital tools to create original artworks of social commentary inspired by items in the museum collection. The Royal Ontario Museum in Toronto, like many others, offers dozens of creative games and projects for kids, ranging from rock collecting on Mars to making a sarcophagus for an Egyptian mummy. And it should all be free — although you'd be welcome to drop something into the donation box if you felt so inclined.

It's also time for the Canadian creative community to elbow its way into the new digital universe. Online, it's

already possible to interact with great art without leaving home. Many of the world's great galleries and museums make their collections freely available in digital format.

It's starting to happen in Canada as well. Forced by pandemic restrictions to rethink its entire modus operandi, the National Arts Centre, which has never been able to live up to its name as a physical space, in 2020 chose to take theatre directly to its audiences. Fourteen small, mostly experimental companies from Igloolik to Victoria were commissioned to create Grand Acts of Theatre: new, large-scale works, many with Indigenous links, to be performed outdoors, bringing the experience of theatre to new audiences in unexpected places.

The series was so successful the NAC mounted a follow-up program, Grand Acts of Hope, in 2021. Everything was also made available online — indeed, the Internet became a place of salvation and rediscovery for many of the arts enterprises that traditionally relied on the physical presence of an audience. Orchestras, dance companies, theatres, museums, galleries — the more agile of them rapidly found new ways to make their work, or some modified version of it, available, just as many retailers in the commercial sector were forced to do. Some, like the Stratford Festival, set up on-demand streaming services of filmed versions of their productions. Others organized live Zoom performances and readings.

Private gain will need to be juggled against public benefit, but it would surely not be difficult to create a national streaming platform to provide a central source of online access, some of it in real time — not only to our orchestras but to the entire imaginative ferment of the country's creative community. I'm not suggesting we abandon the theatre, the concert hall, and

the gallery: the live experience of artistic transcendence in the company of others will never be replicated online. But the old-style model has been showing its age. The symphony orchestra, for instance, has found its original mission to make society a better place, through making skilled performance of fine music available at reasonable prices, threatened by the dwindling of its once-reliable subscription audience, which has been lured away from long-term commitment by the dazzling plethora of one-night-stand choices and an increasingly convenient technology that makes sophisticated, live-quality performance available for a fraction of the cost of in-person performance. Already the CBC, under attack from some political quarters for perceived irrelevance and bias, is indicating it's likely to go fully digital within a decade, or as soon as broadband is universally available, both to remain relevant in a streaming-centred world and to capture younger and more diverse audiences.

A national streaming platform might go some way to easing the suspicions of those who look askance at the new federal Online Streaming Act. It would ensure that the effects and benefits of the Canadian Cultural Credit are felt across society. The cultural sector would get more resources to do what it does best. Artists wouldn't have to struggle so hard to put food on the table. The new technologies would flex their creative muscles. The arts community would show its savvy and suppleness in responding to the demand for more diversity of appeal, more room for minority artists, a louder voice for the marginalized, and the dismantling of social barriers. And we would all find it easier to appreciate what all the fuss is about.

THE CANADIAN FOUNDATION FOR CULTURE

OF COURSE, NONE of that matters if we haven't been given the tools with which to appreciate these gifts. That's where STEAM fits in. The Canadian Foundation for Culture will promote a holistic approach to learning that dismantles the disciplinary silos, puts an end to the relentless academic turf wars and recognizes that, in our multi-stranded, multi-textured world, everything is connected, and nothing exists in a vacuum. The foundation will function as a national, transdisciplinary research hub without trespassing on provincial educational jurisdictions, centralizing research into how the teaching of art and science overlap and how they can be integrated in the classroom.

The foundation will build on current thinking to evolve a process of evaluation that can be used by educators and school authorities as a measuring tool, in the process exploring new definitions of excellence that are focused less on the product and more on the process.

The foundation will also be a source of practical help collaborating with education authorities on a national artist in the classroom program, in which artists, and art for social change groups, work alongside teachers as equals to activate student imaginations in new ways. Through this process, art will become a learning tool rather than a learning target, a means to release the power of wonder and imaginative adventure before the cynicism of adulthood has a chance to close the mind down.

This process is not without its dangers. Imagination isn't a commodity to be kept in a cupboard until the next class comes into the room. Mix the questioning, restless nature of art and artists with the questioning, restless minds of the

young and risk is all about. But turning STEM into STEAM can certainly lead to some provocative outcomes. At a UK school, pupils developed a show called *Einstein — The Musical*. The intention was to provide visual renderings of Einstein's interests: for example, a lone dancer, singing of her solitary life while waltzing across the stage in a straight line, represented a particle in a vacuum. A second musical, *That Certain Uncertainty*, was a farce set in a seaside hotel. It was billed as "a musical comedy of love, loss and quantum physics" and featured two sets of guests that had to be kept apart by the hotelier.

Curriculum content should also get a serious review. A serious argument can be made that Canada's unassertiveness on the world stage can be traced in part to the textbooks we use to teach our young. One novel that appears year after year on study lists is *To Kill a Mockingbird*, which is set in Alabama in the 1930s. Another is *The Catcher in the Rye*, which is about a depressed New Yorker, also in the 1930s. Books like these yield valuable life lessons, but they are lessons learned at a distance. The implicit message built into their inclusion in Canadian students' reading lists is that the Canadian experience takes second place to experience abroad ... reinforcing, even if subliminally, our instinctive sense of inferiority to the U.S.

Canadian students do need to be familiar and comfortable with the world beyond our borders, but they also need to be secure in their awareness of their own history and social development. When their history classes are dealing with the effects of the Second World War, their English reading might include Joy Kogawa's *Obasan* or Gwethalyn Graham's *Earth*

and High Heaven (which not only took the 1944 Governor General's fiction award but was also the first Canadian novel to top the *New York Times* bestseller list). The CanLit shelves are bursting with teachable books that deal with universal issues in recognizably Canadian settings: not just the MacLennan-Laurence-Richler-Wilson-Shields-Gallant pantheon, but the whole rich plethora of the twenty-first century, of whom Lawrence Hill, Thomas King, Eden Robinson, and Douglas Coupland are just a sampling.

Jurisdictional issues will have to be negotiated. Education in Canada is the responsibility of the provinces, and that responsibility is guarded jealously. Deft persuasion will be needed to bring the various independent authorities on board, but collaborative bodies already exist. The Council of Ministers of Education, Canada (CMEC), for example, is an intergovernmental forum for discussing policy issues and collaborating in areas of mutual interest. Providing a form of accreditation for artists working in schools is a service CMEC might be willing to take on. To raise public awareness and appreciation of art in the learning process, CMEC could, from its position of authority, institute a national awards program for schools that make exceptional efforts to integrate the arts into the general curriculum.

One of the major impediments to a more arts-friendly curriculum in our schools, as Larry O'Farrell has indicated, is the reluctance or inability of educators to engage with processes or subjects that are challenging, unfamiliar, or serve as mere afterthoughts in teacher-education curricula. I remember being told by a former superintendent of schools in Vancouver, an individual much in favour of a transformation of this kind,

that he could give orders to make change tomorrow, but that's where the change would stop: teachers resist because they haven't been given the tools. Teacher-training programs at universities and colleges across Canada, whose graduates take their learning out across the land, need a fundamental levelling up of the curriculum.

If there is to be a hope of lasting success for such a radical rethinking of the way we educate, the pressure for change must come from the grassroots, where social and political change always begins. That involves a fresh understanding, on the part of parents and educators alike, of both the practical and the aspirational aspects of creative engagement within the educational process. It means recognizing the need to deal with the social and personal issues that interfere with learning and stand in the way of a young person's ability to be creative — issues as simple and profound as bullying, getting a proper breakfast, or learning difficulties. And it means recognizing and embracing the clear truth that unfettered involvement with the arts carries the child beyond the narrow, conventional definitions of performance and artistic practice to the far more important function of fulfilling his or her potential as a compassionate, creative, and collaborative individual who can contribute to building a better world.

Coda

In music, a conclusion in which themes can be
summarized and loose ends tied.

Empathy is not something that happens to us when we
read Dickens. It's work. What art does is provide material
with which to think: new registers, new spaces.
After that, friend, it's up to you.
— Olivia Laing, *Funny Weather: Art in an Emergency*

SKEPTICS MAY SCOFF and call this kind of societal rethink pie-in-the-sky dreaming. Life is enough of a challenge. The System has become too monolithic, the challenges too amorphous and hard to get a grip on. Who has the time to get involved? And even if we do get involved, how much actual change can our personal involvement bring? We live in a time when many have thrown up their hands in despair at the way that greed and inequality and brazen lying have made a mockery of the social contract. Cynicism about our political leadership is widespread.

This book draws the arc of the possible, not some fanciful ideal; it focuses on the pragmatic, well aware of the unpredictability and folly that lie at the heart of human nature. Our glorious cussedness. The proposal I have set out here is founded on our growing understanding of the role of culture in our shared lives, its ability to generate within us what Alex Himelfarb calls shared well-being in the creation of a more just and sustainable future, and what Shannon Litzenberger characterizes as that "natural state of open expansiveness where we can simultaneously feel both calm and energized ... in touch with ourselves and also open and receptive to others and to the world around us."

It takes a grassroots, one-to-one, trickle-up approach to the idea of using our innate creativity to recognize the human being in the Other and offer more inclusive and collaborative ways of sharing our lives, the reverse of the top-down, government-knows-best thinking that for decades has dominated our approach to living together.

My proposal is not bound by conditions so tight there's no room to breathe. It offers no single solution, no magic wand that will overnight transform the world into a better place. It's about looking at our cultural identity — what it constitutes and the way we express it — through a twenty-first-century lens and applying the intuitive creative mind to what we see, stepping outside conventional boundaries of expectation and seeing our world from a different perspective. It's about making ourselves ready for where the rising tide of human concern and understanding will take us.

For the cultural sector to have any shot at substantial policy transformation of this kind, it will need to enlist the

understanding and goodwill of politicians, bureaucrats, educators, and, most specifically, the Canadian citizenry. The debates will be messy and loud. Ideas will clash. Voices will rise. I am fully aware that this framework would be susceptible to misuse. Any government program of social benefit has its exploiters, its percentage of failures and frauds. But just because it's fraught and difficult doesn't mean we shouldn't do it.

Augusto Lopez-Claros, former chief economist at the World Economic Forum and now executive director of the Global Governance Forum, said recently: "One important lesson from COVID-19 may be that, in a fully integrated world, solidarity and altruism are not just luxuries for the spiritually minded but, in fact, are indispensable conditions for survival."

Solidarity and altruism get bad press in many places these days. The belief that government is deeply beholden to special interests is embedded in the public discourse. But I learned enough during the years I spent on the fringes of government to know that politics is pragmatism: the art of consensus. Consensus means compromise and compromise needs courage — the courage to be open, and the courage to trust. Despite the excesses of hate and spite and mendacity that fill the nightly news, the human instinct for decency is strong.

With the worst horrors of COVID-19 reduced to a background presence in our lives, many have settled back into the comfort of familiar patterns of living, free of all those mitigating actions that became such an irritant: social distancing, masks, hand sanitizing. But in our very natural sense of relief at returning to the way things were, we should not abandon the impulses to empathy and concern the pandemic brought

to the fore: the pot-banging in support of health care workers, the little kindnesses for housebound neighbours, the grin-and-bear-it resignation to the fact that wearing a mask was as much in the interests of the people you met as it was for your own health. These small acts remind us that kindness, generosity, and justice must be at the heart of how we redesign the way we live together. We also shouldn't forget how the enforced solitude of COVID-19 gave many of us a chance to take stock of our priorities: we read more, we did things we'd been putting off, we reconsidered what really mattered. Why would we want to slip back into old habits? The time is ripe to make the changes this book suggests.

Bringing the blessings of art and culture to their natural centrality in our lives will require new levels of generosity, of willingness to believe in each other. Perhaps the sector might steal from modern business and adopt the idea of internal-culture catalysts, those innovators who strategize wholesale value shifts in organizations. And perhaps — we live in a time when identity has rarely been such an important signifier — those catalysts could come up with a new brand for culture that takes it out of the golden castle we have allowed to be built around it and restores it to the public domain and encourages grassroots buy-in. Something that, in the spirit of solidarity, makes culture not only a vital force in our communities — the marketplace, the streets, the parks, our homes — but an important issue at election time.

Social pressure has changed the way humans live together more often than we might think. Without raised individual voices and passionate arguments, we would be living today in a far less inclusive world. It was public sentiment that ended

the slave trade. It was relentless campaigning that won suf-
frage for women. It was the education of the heart, through
illustrated storytelling, that changed the world's mind about
the use of land mines, not assertion, however authoritative or
well intentioned.

When good intent goes hand in hand with sweat and toil,
there is no limit to what humanity — you, me, all of us — can
do together. It is on the inherent goodness and compassionate
imagination of the human creature that we can build together
that "better country" that is the aspirational aim of the motto
of the Order of Canada.

When we imagine compassionately, when we infuse our
imaginations with compassion and empathy, when we share
our thoughts and dreams, we create new avenues for change.
Yes, life says, *yes, there will be surprises and maybe some of
them will hurt, but* ... and it's that point of pause, that *but*,
that draws you in. You know you have to go.

In the 1950s the anthropologist William Stanner coined
the term "everywhen." It was his attempt to help us grasp
the notion of The Dreaming, a term anthropologists came
up with to help them understand the creation beliefs of Aus-
tralian Indigenous people. *Everywhen*. Never a was. Never
a will be. Past, present, and future, in an always: eternity in
a conceptual nutshell. It's a way of looking at what we've
always known that sets us free.

I take warm comfort from the thought that we're all united
in the everywhen. If time has no beginning and no end, any
manner of evolution is possible. A recently discovered black
hole explosion ripped a hole in our universe big enough to
swallow fifteen of our Milky Way galaxies. It happened several

hundred million years ago and several hundred million light years away, but still. Life as we know it might turn out to be a paltry thing by comparison with what has evolved in these other galaxies, and, when we first meet, maybe we won't be able to communicate very well. But I'd like to hope that we'd get along. We could show them what we call art, and ask them what they think of it, and do they have anything like it. You never know, do you?

Every generation has a chance — an obligation — to do better, to imagine and create a world that works for all of us.

To me, doing better begins with culture — the point at which the arts, sciences, and society intersect. When scientists from dozens of countries join hands to unlock a mystery of our universe; when a filmmaker or musician lifts up voices and stories from the margins; when museums and universities and concert halls reimagine their purpose and redefine the communities they serve based on values like access, curiosity, and collaboration — then we are taking action for a better future ...

If you do not consider yourself a cultural being, I challenge you to think differently: we are all cultural citizens, and culture will be the engine of our reconstruction, as it always has been. We have come back to this first principle again and again in times of fracture, that culture leads us to seek truth, build trust, and act in service of one another. Culture is the foundation on which we will imagine and build a world in which we reaffirm our commitment to equality and safety for all, we act with empathy, and we know that we can always do better.

— Yo-Yo Ma, *Time* magazine, October 21, 2020

Bibliography

Most of the books, documents, and articles in this list are referred to in the text. A few are included because they provide pertinent additional reading.

BOOKS

Bamford, Anne. *The wow Factor*. Münster/New York: Waxmann, 2006.

Brault, Simon. *No Culture, No Future*. Translated by Jonathan Kaplansky. Toronto: Cormorant Books, 2010.

Brook, Orian, Dave O'Brien, and Mark Taylor. *Culture Is Bad for You: Inequality in the Cultural and Creative Industries*. Manchester: Manchester University Press, 2020.

Crean, Susan. *Who's Afraid of Canadian Culture?* Toronto: General Publishing, 1976.

Deresiewicz, William. *The Death of the Artist: How Creators Are Struggling to Survive in the Age of Billionaires and Big Tech*. New York: Henry Holt, 2020.

Diamond, David. *Theatre for Living: The Art and Science of Community-Based Dialogue*. Victoria, BC: Trafford Publishing, 2007.

Egan, Kieran. *Teaching and Learning Outside the Box: Inspiring Imagination Across the Curriculum*. New York: Teachers College Press, 2007.

Egan, Kieran. *An Imaginative Approach to Teaching*. New York: Jossey-Bass, 2005.

Egan, Kieran. *Teaching as Story Telling: An Alternative Approach to Teaching and Curriculum in the Elementary School*. Chicago: University of Chicago Press, 1989.

Eisner, Elliot. *The Arts and the Creation of Mind*. New Haven, CT: Yale University Press, 2002.

Fletcher, Angus. *Wonderworks: The 25 Most Powerful Inventions in the History of Literature*. New York: Simon & Schuster, 2021.

Gardner, Howard. *Frames of Mind: The Theory of Multiple Intelligences*. New York: Basic Books, 1983.

Gattinger, Monica. *The Roots of Culture, The Power of Art*. Montreal: McGill-Queen's University Press, 2017.

Massey, Vincent. *On Being Canadian*. Toronto: J. M. Dent, 1948.

Patteson, Ann, and Steven Campbell. *Creative Insights: A Handbook for Assessing the Impacts of Arts and Learning*. Toronto: Canadian Network for Arts and Learning, n.d.

Russell, Bertrand. *Education and the Good Life*. New York: Boni & Liveright, 1926.

Schafer, D. Paul. *The Age of Culture*. Oakville, ON: Rock's Mills Press, 2014.

Schafer, D. Paul. *The Secrets of Culture*. Oakville, ON: Rock's Mills Press, 2015.

Tapscott, Don, and Anthony D. Williams. *Macrowikinomics*. New York: Portfolio, 2012.

Tippett, Maria. *Making Culture: English-Canadian Institutions and the Arts Before the Massey Commission*. Toronto: University of

Toronto Press, 1990.

Tonelli, Guido. *Genesis: The Story of How Everything Began.* New York: Farrar, Straus & Giroux, 2021.

Tusa, John. *Art Matters: Reflecting on Culture.* London: Methuen, 2000.

URB_ART *Storybook: A Compendium of Storytelling Resources through Urban Arts Education.* Reykjavík, Iceland: Reykjavík Ensemble, 2022.

Walling, Savannah, Terry Hunter, and John Endo Greenaway. *From the Heart of the City.* Vancouver: Vancouver Moving Theatre, 2015.

Woodcock, George. *Strange Bedfellows: The State and the Arts in Canada.* Vancouver/Toronto: Douglas & McIntyre, 1985.

GOVERNMENT REPORTS, ACADEMIC ANALYSIS, JOURNALS

Allcott, Hunt, Matthew Gentzkow, and Lena Song. "Digital Addiction." NBER Working Paper Series, National Bureau of Economic Research, Cambridge, MA, March 2022. http://www.nber.org/papers/w28936.

British Council. *Culture: The Missing Link to Climate Action.* In collaboration with Julie's Bicycle. London: British Council, 2021.

Business/Arts. *Culture Track: Canada.* In collaboration with LaPlaca Cohen and Nanos. Toronto: Business/Arts, 2022.

Con, Adam J., Betty Younker, and Kyle Zavitz. *Everything Is Connected: A Landscape of Music Education in Canada, 2021.* Toronto: The Coalition for Music Education, 2022.

Crossick, Geoffrey, and Patrycja Kasdynska. *Understanding the Value of Arts and Culture.* London: Arts and Humanities Research Council, 2016.

Danyluk, Stephanie, and Rebecca MacKenzie. *Moved to Action: Activating UNDRIP in Canadian Museums.* Ottawa: Canadian Museums Association, 2022.

Department of Canadian Heritage. *Canadian Artists and Content Creators Economic Survey Report.* Ottawa: Government of Canada, 2022. https://www.canada.ca/en/canadian-heritage/services/copyright-policy-publications/results-survey-artist-content-creators.html.

Department of Finance Canada. *Measuring What Matters: Toward a Quality of Life Strategy for Canada.* Ottawa: Government of Canada, 2021. https://www.canada.ca/en/department-finance/services/publications/measuring-what-matters-toward-quality-life-strategy-canada.html.

External Advisory Committee on Cities and Communities. *From Restless Communities to Resilient Places: Building a Stronger Future for All Canadians.* Ottawa: Government of Canada, 2006. https://ccednet-rcdec.ca/resource/from-restless-communities-to-resilient-places-building-a-stronger-future-for-all-canadians.

Fancourt, Daisy, and Saiorse Finn. *What is the evidence on the role of the arts in improving health and well-being? A scoping review.* Copenhagen: WHO Regional Office for Europe, 2019. https://apps.who.int/iris/handle/10665/329834.

Helliwell, J. F., Richard Layard, Jeffrey D. Sachs, Jan-Emmanuel De Neve, Lara B. Aknin, and Shun Wang, eds. *World Happiness Report 2022.* New York: Sustainable Development Solutions Network, 2022.

Herrington, Gaya. "Update to limits to growth: Comparing the World3 model with empirical data." *Journal of Industrial Ecology* 25, no. 3 (November 2020). https://onlinelibrary.wiley.com/doi/10.1111/jiec.13084.

Herrington, Gaya. "Data check on the world model that forecast global collapse." *Club of Rome* (blog), July 26, 2021. https://www.clubofrome.org/blog-post/herrington-world-model.

Hill Strategies Research Inc. *A Statistical Profile of Artists in Canada in 2016*. Hamilton, ON: Hill Strategies Research Inc., 2019. https://hillstrategies.com/resource/statistical-profile-of-artists-in-canada-in-2016.

Hill Strategies Research Inc. *Canadians' Arts Participation, Health, and Well-Being*. Hamilton, ON: Hill Strategies Research Inc., 2021. https://hillstrategies.com/resource/canadians-arts-participation-health-and-well-being.

Himelfarb, Alex. "Austerity is no solution for inflation." *The Monitor* (Canadian Centre for Policy Alternatives), May 3, 2022. https://monitormag.ca/articles/austerity-is-no-solution-for-inflation.

Himelfarb, Alex. "Power, profit, and the politics of inflation." *The Monitor* (Canadian Centre for Policy Alternatives), September 1, 2022. https://monitormag.ca/articles/power-profit-and-the-politics-of-inflation.

Kisida, Brian, and Daniel H. Bowen. "Investigating Causal Effects of Arts Education Experiences: Experimental Evidence from Houston's Arts Access Initiative." Houston, TX. Kinder Institute for Urban Research, Rice University, 2019.

Maggs, David. *Art and the World After This*. Toronto: Metcalf Foundation, June 2021.

Moore, Mavor. "Commerce, Culture and Identity after NAFTA: Prospects at the Millennium." *Canadian Review of American Studies* 27, no. 3 (1997): 127-134. https://muse.jhu.edu/article/681440.

Piper, Martha. "Building a Civil Society: A New Role for the Human Sciences." Toronto: Killam Trusts annual lecture, 2002.

Ragsdale, Diane. "Artistic Leadership and Aesthetic Value(s) in a Changed World." Keynote speech at the Canadian Arts Summit, Banff Centre for Arts and Creativity, April 2018.

Rathje, Steve, Leor Hackel, and Jamil Zaki. "Attending live theatre improves empathy, changes attitudes, and leads to pro-social behavior." *Journal of Experimental Social Psychology* 95 (2021). https://doi.org/10.1016/j.jesp.2021.104138.

Rodríguez-Pose, Andrés. "The Rise of Populism and the Revenge of the Places That Don't Matter." LSE *Public Policy Review* (London) 1, no. 1 (2020): Article 4. https://doi.org/10.31389/lseppr.4.

Statistics Canada. *Provincial and Territorial Culture Indicators, 2017.* Ottawa: Statistics Canada, 2019. https://www150.statcan.gc.ca/n1/daily-quotidien/190425/dq190425b-eng.htm.

Statistics Canada. *Sense of Meaning and Purpose in Canada, October to December 2021.* Ottawa: Statistics Canada, 2022. https://www150.statcan.gc.ca/n1/daily-quotidien/220330/dq220330b-eng.htm.

Tufekci, Zeynep. "How social media took us from Tahrir Square to Donald Trump." *MIT Technology Review*, August 14, 2018. https://www.technologyreview.com/2018/08/14/240325/how-social-media-took-us-from-tahrir-square-to-donald-trump.

NEWSPAPERS, MAGAZINES, ONLINE PUBLICATIONS

Alter, Alexander, and Elizabeth A. Harris. "Attempts to Ban Books Are Accelerating and Becoming More Divisive." *The New York Times*, September 16, 2022. https://www.nytimes.com/2022/09/16/books/book-bans.html.

Aratani, Lauren. "America is entering the great experiment of hybrid work." *The Guardian*, March 29, 2022. https://

www.theguardian.com/us-news/2022/mar/29/hybrid-work-experiment-post-pandemic.

Armitstead, Claire. "Grayson and Philippa Perry: 'Fantasy isn't all unicorns and rainbows – it's a refuge.'" *The Guardian*, February 14, 2021. https://www.theguardian.com/artanddesign/2021/feb/14/grayson-perry-philippa-art-club-channel-4-interview.

Beausoleil, Angèle. "Hiring more social scientists could be the solution to Canada's innovation issue." *The Conversation*, February 16, 2023. https://theconversation.com/hiring-more-social-scientists-could-be-the-solution-to-canadas-innovation-issue-199664.

Berger, Kevin. "Literature Should Be Taught Like Science." *Nautilus*, February 24, 2021. https://nautil.us/literature-should-be-taught-like-science-238135.

Brooks, David. "The Awesome Importance of Imagination." *The New York Times*, November 11, 2021. https://www.nytimes.com/2021/11/11/opinion/imagination-empathy.html.

Carr, Nicholas. "How to Fix Social Media." *The New Atlantis*, Fall, 2021. https://www.thenewatlantis.com/publications/how-to-fix-social-media.

Chagas, Caterina. "Changing lives through music: The lessons we can learn." *Research at Queen's* (Queen's University), July 17, 2020. https://www.queensu.ca/research/features/changing-lives-through-music-lessons-we-can-learn.

Callard, Agnes. "Art Is for Seeing Evil." *The Point* (website), July 15, 2022. https://thepointmag.com/examined-life/art-is-for-seeing-evil.

Davenport, Thomas H., and Nitin Mittal. "How Generative AI Is Changing Creative Work." *Harvard Business Review*, November 14, 2022. https://hbr.org/2022/11/how-generative-ai-is-changing-creative-work.

Dekel, Jonathan. "'This is going to change the look and feel of the city': Mayor John Tory on Toronto's Year of Public Art and his plan to keep artists from decamping." *Toronto Star*, October 30, 2021. https://www.thestar.com/entertainment/visualarts/2021/10/30/this-is-going-to-change-the-look-and-feel-of-the-city-mayor-john-tory-on-torontos-year-of-public-art-and-his-plan-to-keep-artists-from-decamping.html.

Doolittle, Lisa, and Jean Harrowing. "Performing and Complex Social Change." *Complex Social Change*. Edited by Josephine Mills. University of Lethbridge Art Gallery, 2015.

Dubb, Steve. "Arts, Culture, and Economy: Where Are the Points of Leverage?" *Non-Profit Quarterly*, March 10, 2021. https://nonprofitquarterly.org/arts-culture-and-economy-where-are-the-points-of-leverage.

Edsall, Thomas B. "Where Does All That Hate We Feel Come From?" *The New York Times*, April 27, 2022. https://www.nytimes.com/2022/04/27/opinion/rich-poor-immigration-fear.html.

Glueck, Grace. "Art in Review; Brian Jungen." *The New York Times*, December 23, 2005. https://www.nytimes.com/2005/12/23/arts/art-in-review-brian-jungen.html.

Harris, Holly. "How The Royal Conservatory Avoided a Disaster." *Ludwig Van*, June 9, 2021. https://www.ludwig-van.com/toronto/2021/06/09/feature-how-the-royal-conservatory-avoided-a-pandemic-disaster.

Harris, Lawren. "Fallacies About Art." In "Literature & the Visual Arts," edited by Joan Murray. *Canadian Literature*, Summer/Autumn 1987.

Herklots, Lawrence. "Imagining Physics — A Teacher's Experience." In "STEAM Edition," edited by Gillian Judson and Jailson Lima. *Circe Magazine* (Simon Fraser University), January 2019.

Kahre, Andreas. "Islands in the Mind: A Conversation with James Gnam." *Dance Central* (Vancouver), September/October 2016.

Kheiriddin, Tasha. "Political extremism fuelled by high levels of illiteracy." *National Post*, November 1, 2022. https://nationalpost.com/opinion/tasha-kheiriddin-political-extremism-fuelled-by-high-levels-of-illiteracy.

Klein, Ezra. "The Imminent Danger of AI Is One We're Not Talking About." *The New York Times*, February 26, 2023. https://www.nytimes.com/2023/02/26/opinion/microsoft-bing-sydney-artificial-intelligence.html.

Kloster, Darron. "Royal BC Museum closing 3rd floor for 'decolonization' effort that will remove settler displays." *Vancouver Sun*, November 4, 2021. https://vancouversun.com/news/local-news/royal-bc-museum-closing-3rd-floor-for-decolonization-effort.

Litzenberger, Shannon. "How Our Disembodied Culture Is Keeping Us Stressed and What We Can Do About It." *Medium*, May 12, 2021. https://shannonlitzenberger.medium.com/how-our-disembodied-culture-is-keeping-us-stressed-and-what-we-can-do-about-it-8b98dd0dc8f4.

Litzenberger, Shannon. "State of emergence: Why we need artists right now." *The Philanthropist Journal*, May 3, 2022. https://thephilanthropist.ca/2022/05/state-of-emergence-why-we-need-artists-right-now.

Lopez-Claros, Augusto. "Economic Governance in a Post-COVID World." *Darwinian* (Cambridge), Summer 2021. https://darwin-college-cambridge.shorthandstories.com/darwin-and-sustainabilityeconomic-governance-in-a-post-covid-world/index.html.

McGlone, Peggy. "New chair of the NEA, Maria Rosario Jackson, wants Americans to live artful lives." *The Washington Post*, February 1, 2022. https://www.washingtonpost.com/arts-entertainment/2022/02/01/nea-chair-maria-rosario-jackson.

Natanson, Hannah. "Teens fight for the right to read with 'banned-book clubs' and lawsuits." *The Washington Post*, May 3, 2022. https://www.washingtonpost.com/education/2022/05/03/teens-books-ban-clubs-protest.

O'Kelly, Lisa. "Margaret Atwood: 'It would be fun to talk to Simone de Beauvoir.'" *The Guardian*, March 11, 2023. https://www.theguardian.com/books/2023/mar/11/margaret-atwood-it-would-be-fun-to-talk-to-simone-de-beauvoir-old-babes-in-the-wood.

Perry, Nick. "New Zealand arts funder rejects Shakespeare as 'imperialism.'" *The Associated Press*, October 17, 2022. https://apnews.com/article/education-new-zealand-government-and-politics-5f7ad68f8772f3dc60d9405bff6ac076.

Pollin, Robert, and Gerald Epstein. "Neoliberalism's Bailout Problem." *Boston Review*, June 24, 2021. https://www.bostonreview.net/articles/neoliberalisms-bailout-problem.

Powell, Alvin. "Will ChatGPT supplant us as writers, thinkers?" *The Harvard Gazette*, February 14, 2023. https://news.harvard.edu/gazette/story/2023/02/will-chatgpt-replace-human-writers-pinker-weighs-in.

Schwab, Klaus, and Thierry Malleret. "The Power of Narrative." *Nautilus*, April 8, 2022. https://nautil.us/the-power-of-narrative-238456.

Shivaram, Deepa. "More Republican leaders try to ban books on race, LGBTQ issues." *National Public Radio*, November 13, 2021.

https://www.npr.org/2021/11/13/1055524205/more-republican
-leaders-try-to-ban-books-on-race-lgbtq-issues.

Smith, Janet. "Indian Summer offers $25,000 bursary for new Culture Lab: Artist as Healer program." *Stir*, November 16, 2021. https://www.createastir.ca/articles/basic-template-k4whd.

Smith, Andrea. "How to Talk to Your Racist Relatives about Indigenous Rights." *The Tyee*, February 14, 2023. https://thetyee.ca/News/2023/02/14/How-Talk-About-Indigenous-Rights.

Stein, Leigh. "BookTok Is Good, Actually: On the Undersung Joys of a Vast and Multifarious Platform." *Lit Hub*, February 13, 2023. https://lithub.com/booktok-is-good-actually-on-the-undersung-joys-of-a-vast-and-multifarious-platform.

Suzuki, David. "On the Urgency of Scientific Education in an Era of Climate Emergency." *Lit Hub*, September 8, 2022. https://lithub.com/david-suzuki-on-the-urgency-of-scientific-education-in-an-era-of-climate-emergency.

Taylor, Kate. "Whose Art Is It Anyway? Issues Shaping the Arts and Culture Sector." *The Philanthropist Journal*, October 14, 2019. https://thephilanthropist.ca/2019/10/whose-art-is-it-anyway-issues-shaping-the-arts-and-culture-sector.

Thomas, Colin. "A Healing Assembly." *Fresh Sheet*, July 15, 2021.

Toope, Stephen J. "This idea must die: The arts are less important than the sciences." CAM (University of Cambridge), July 13, 2021. https://magazine.alumni.cam.ac.uk/this-idea-must-die-the-arts-are-less-important-than-the-sciences.

Verjee, Zainub. "The Great Canadian Amnesia." *Canadian Art*, June 20, 2018. https://canadianart.ca/essays/massey-report-the-great-canadian-amnesia.

Weng, Xiaoyu. "Sun Yuan and Peng Yu: Can't Help Myself." Solomon R. Guggenheim Museum (website). https://www.guggenheim.org /artwork/34812.

Wilhelm, Kelly. "A balancing act: Supporting the arts in Canada." *The Philanthropist Journal*, May 27, 2019. https://thephilanthropist .ca/2019/05/a-balancing-act-supporting-the-arts-in-canada.

Wolff, Benjamin. "The Arts and Humanities Deliver Untapped Value for the Future of Work." *Forbes*, April 6, 2021. https:// www.forbes.com/sites/benjaminwolff/2021/04/06/the-arts-and-humanities-deliver-untapped-value-for-the-future-of-work.

Woodend, Dorothy. "The Art of Empathy." *The Tyee*, June 24, 2021. https://thetyee.ca/Culture/2021/06/24/Art-of-Empathy.

Woolf, Marie. "CBC signals plans to go full streaming, ending traditional TV and radio broadcasts." *The Globe and Mail*, February 7, 2023. https://www.theglobeandmail.com/politics/article-cbc-digital -streaming.

Thanks and Acknowledgements

TO MARC CÔTÉ, the animating force behind Cormorant Books, I owe several debts of gratitude. The first is for his wholehearted support of the book's frankly idealistic call for a radical makeover of the Canadian cultural support system. The second is for his enthusiastic welcome of this book to the Cormorant list. The third is for his meticulous and insightful editing commentary. His candour and generosity have been particularly helpful in shaping the book's argument.

Over the years, my thinking about these issues has also been sharpened by conversations and exchanges with many friends and colleagues, among them Norman Armour, Nini Baird and Bob Smith, Anne Bamford, Katherine Berg, Martin Bragg, Dean Brinton, Roch Carrier, Ray and Toshi Chatelin, Angela Elster, John Goldsmith, Alex Himelfarb, John Hobday, Linda Johnston, Keith Kelly, David Lemon, Judith and Richard Marcuse, Scott and Corky McIntyre, Larry O'Farrell, Riki Turofsky, Claude Schryer, Zainub Verjee, David Walden, Chris Wootten, Yosef Wosk, Mirna Zagar, Joyce Zemans, and others who have sadly left us, particular among them Hugh

Davidson, Jocelyn Harvey, Peter Herrndorf, Mavor Moore, Timothy Porteous, Jean-Louis Roux, Carol Shields, Shirley Thomson, and Milton Wong. I am grateful to them and many others for sharing their views with me, but I emphasize that they bear no responsibility for what I have written here.

My thanks for specific help go to Sarah Cooper, the eagle-eyed Christina Turner, and Sarah Jensen at Cormorant Books, David Diamond, Allen and Karen Kaeja, Kim Selody, and especially Victoria Wyatt at the University of Victoria, who generously shared valuable insights from her own research regarding Indigenous worldviews, Alex Himelfarb, who clarified for me his views on government spending, and Larry O'Farrell, the guiding light of the arts and education movement in Canada, who provided valuable consultation on my education chapters.

Most important of all has been the sustained support of my wife, Susan Mertens, also a writer on the arts, but also by training and inclination a philosopher of both aesthetics and matters of the mind, and therefore rigorously objective where it counts. This would have been a different book without her.

AUTHOR PHOTO: YUKIKO ONLEY

Max Wyman is one of Canada's foremost cultural commentators. He was the arts columnist and critic for *The Vancouver Sun*, *The Province*, and CBC Radio for over thirty years, and launched and edited the *Vancouver Sun* Review of Books.

The Compassionate Imagination is his seventh book on the arts in Canada. He is an Officer of the Order of Canada, a former member of the board of the Canada Council for the Arts, and a former President of the Canadian Commission for UNESCO. He lives in Lions Bay, near Vancouver, BC.

maxwyman.com

We acknowledge the sacred land on which Cormorant Books operates. It has been a site of human activity for 15,000 years. This land is the territory of the Huron-Wendat and Petun First Nations, the Seneca, and most recently, the Mississaugas of the Credit River. The territory was the subject of the Dish With One Spoon Wampum Belt Covenant, an agreement between the Iroquois Confederacy and Confederacy of the Ojibway and allied nations to peaceably share and steward the resources around the Great Lakes. Today, the meeting place of Toronto is still home to many Indigenous people from across Turtle Island. We are grateful to have the opportunity to work in the community, on this territory.

We are also mindful of broken covenants and the need to strive to make right with all our relations.